Landscape in Britain *c.*1750–1850

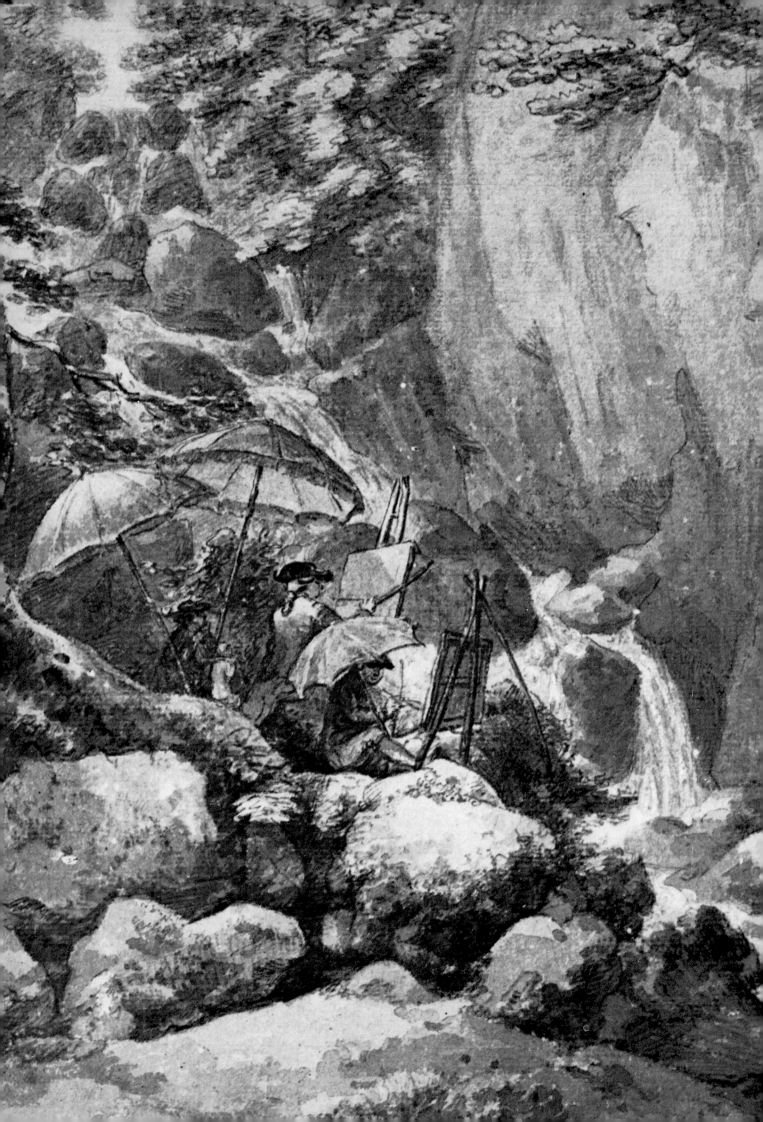

Leslie Parris

LANDSCAPE IN BRITAIN
c.1750-1850

The Tate Gallery 1973

Exclusively distributed in France and Italy by Idea Books
24 rue du 4 Septembre, Paris (2e) and Via Cappuccio 21, 20123 Milan

ISBN 0 900874 70 8 Cloth 0 900874 71 6 Paper
Published by order of the Trustees 1973
for the Exhibition of 20 November 1973 – 3 February 1974
Copyright © 1973 The Tate Gallery
Designed and published by the Tate Gallery Publications Department,
Millbank, London SW1P 4RG
Printed in Great Britain by Balding & Mansell Ltd, Wisbech, Cambs.

Contents

Cover/Jacket
Front: 247. G. R. Lewis, *Harvest Scene, Afternoon*
1815 (detail)
Back: 210. Robert Wallis after J. M. W. Turner
Bolton Abbey, 1827 (detail)

Frontispiece
146a. Thomas Hearne, *Sir George Beaumont and Joseph
Farington painting a Waterfall* (detail)

Colour Plates

Foreword

Two of our previous winter exhibitions, *The Elizabethan Image* and *The Age of Charles I*, were concerned chiefly with portraiture, the predominant art-form of the sixteenth and seventeenth centuries in Britain. Our third major survey is devoted to British landscape during the period of its greatest development, the second half of the eighteenth and first half of the nineteenth centuries. This is a wide-ranging exhibition which provides a unique opportunity to examine one of the central themes of British art. It also sets the scene for the exhibitions to be devoted to Turner and Constable in their respective bicentenary years, 1975 and 1976.

Our principal debt, as always, is to the many owners who have so generously lent to the exhibition. Their names appear at the end of the catalogue, but I would like to thank especially those who have contributed large groups of works: Her Majesty the Queen, the Trustees of the British Museum, the Victoria and Albert Museum, and Miss Armide Oppé and Mr D. L. T. Oppé.

Landscape in Britain has been selected and catalogued by Leslie Parris, Assistant Keeper at the Tate Gallery. The Introduction is by Conal Shields, Head of the Department of Art History and Allied Studies at the Camberwell School of Art and co-author of two Tate Gallery publications on Constable. The installation of the exhibition has been designed by the architect Christopher Dean of the firm of Castle Park Dean Hook.

NORMAN REID

Preface

This exhibition does not pretend to be a history of British landscape art. It is, rather, a broad survey, aimed at bringing out the variety and complexity of the subject. The desire has been to explore areas usually neglected, as well as to re-present familiar territory, and to invite discussion instead of offering ready-made solutions. The field, of course, is enormous and, to make it at all manageable in the space and time available, the selection is limited (with few exceptions) to works done in this country. A number of artists are therefore more partially treated than others, and some quite important figures are not included at all. Coverage of closely related genres, for example townscape, is not attempted.

Without the encouragement of Conal Shields and Ian Fleming-Williams this exhibition would not have been possible. I am especially grateful to the former for agreeing to write the Introduction and for help with many other parts of the catalogue, including the sections dealing with the literature of landscape and the Pre-Raphaelites. Ian Fleming-Williams has drawn to my notice much of which I would otherwise have been unaware. I would also like to thank Charlotte Frank, Armide Oppé, Francis Greenacre, John Murdoch, Dudley Snelgrove, Andrew Wilton and the many others who have answered my enquiries or shown me works in their care.

L.P.

Introduction

The rise of landscape painting in Britain during the eighteenth and nine-teenth centuries is, surely, amongst the most remarkable episodes of cultural history: yet it is a phenomenon for which, so far, no convincing account can be given. There are monographs on some of the artists concerned and these, often to a blatant degree, suffer from the want of a genuinely comprehensive grasp of the topic. On the other hand, works of a general kind—and they are rare enough—altogether lack a feel for the *minutiae*, the real texture of things. Major issues rear themselves in the literature and are, *pro tem*, set aside. What, for example, was the precise *motivation* of artist and/or patron? How did the social and economic aspects of life, how did art politics, bear upon creativity? Why and wherefore came pictures to look as they look and not otherwise?

Publication of documentary materials has indeed begun but there is far to go. R. B. Beckett's monumental *John Constable's Correspondence*, in conse-quence of which the received image of Constable—a key figure—must be radically redrawn, demonstrates the value of such publication. An edition of Turner's letters, though, is only now aweigh and the mass of his lecture manu-scripts remains a blank except to the tiny few. And Turner is—by a reasonable guess—*the* pivot of the landscape art story.

There is good cause for the present position. The subject, over and above *lacunae*, is formidably complex. While we know very little about the day-to-day linkage of artists and patrons, what we do know points to a multitude of circumstances, a host of more or less distinct publics with their artists more or less in tow. Examine the 'patron class' and you find, rather than a type, a whole range of people: those for whom 'nature' was nearly, if not quite, some-thing to be ignored: those for whom it was to be subdued or transformed: those for whom it was to be gazed at and enjoyed. Matters are further com-plicated because at any given moment in any two places what, say, the 'trans-formation of nature' meant was likely to be different and perhaps contradic-tory. And, horror of horrors (art historians tend to ignore this), 'nature' itself was a supremely problematical concept.

However: though the coming and goings of idea and ideal, demand and response, in their labyrinthine plenitude are still mysterious, that certain large developments in the business of landscapery occurred during the period under consideration is relatively clear. From humble (some would say, contemptible) beginnings landscape became an important—to many an artist and his audi-ence, the principal—area of art. We can, even now, trace a revolution in taste.

Jonathan Richardson, whose essays were, for nearly a hundred years, the cultured (or would-be cultured) Briton's chief guide to the fine arts, found landscape of wretchedly small account when measured against *History* (pic-tures of mythological and biblical events). In *The Connoisseur* (1719) Richard-son declares:

> A History is preferable to a Landscape, Sea-piece, Animals, Fruit, Flowers, or any other Still-Life, pieces of Drollery, &c.; the reason is, the latter Kinds may Please, and in proportion as they do so they are Estimable but they cannot Improve the Mind, they excite no Noble Sentiments. . . .[1]

Richardson's line was, pretty well, the line toed by Sir Joshua Reynolds in his Royal Academy *Discourses*, the central text of this country's art officialdom during the latter part of the century. But we may think Sir Joshua actually more accommodating than his public utterances suggest. To colleagues he 'frequently declared, that whatever preparatory assistance he might admit in the draperies or other parts of his figures, he always made it a point to keep the arrangement of the scenery, the disposition and ultimate finish of the background to himself.'[2] He owned a quantity of landscapes—by Claude, Gaspard and Poussin but also by Teniers, Ruisdael, Canaletto, Wilson and others—and produced at least one landscape himself.

Of Reynolds' successors, several modified his rules and regulations. James Barry (Professor of Painting 1782–99) could state, despite a profound attachment to the academic hierarchy of genres:

> There is no department of art which might not become interesting in the hands of a man of sensibility. Who does not feel this in the landscapes of N. Poussin, sometimes verging to sublimity, and always engaging from their characteristic unity, graceful simplicity, or ethical associations.

And he was able to spare a word for less elevated efforts:

> Allowing for a little unnecessary rags and vulgarity; who is not also delighted with the serenity and innocent simplicity of many of the scenes of Berghem, Both, Claude, Swanefeld, and Wilson? the simple, laborious, honest, hinds; the lowing herds, smooth lakes, and cool extended shades; the snug, warm cot, sufficient and independent, the distant hamlet; and the free, unconfined association between all the parts of nature, must ever afford a grateful prospect to the mind. No doubt much of our satisfaction results from contrasting this state of things with the dark, insidious, hypocritical disguises; the hateful enormities, vanities, affectations, and senseless pageantries, so frequently found in the courts of the great, and in large cities. . . .

We may, Barry continues, echo Virgil:

> 'O Fortunatos nimium, sua si bona nôrint, Agricolas!' [Georgics, ii, 458][3]
> ('Oh happy, if he knew his happy State! The Swain'—trans. Dryden)

J. H. Fuseli (Professor of Painting 1799–1805, 1810–25) allowed that the 'background' to a history picture could be of signal value and, in several cases, the leading feature. And he was ready, after a splenetic slap at homely types, to admit a short list of landscapists to the ranks of the great: to portrait painting (which at its current level he rightly castigated)

> we subjoin, as the last branch of uninteresting subjects, that kind of landscape which is entirely occupied with the tame delineation of a given spot; an enumeration of hill and dale, clumps of trees, shrubs, water, meadows, cottages and houses, what is commonly called Views. These, if not assisted by nature, dictated by taste, or chosen for character, may delight the owners of the acres they enclose, the inhabitants of the spot, perhaps the antiquary or the traveller, but to every other eye they are little more than topography. The landscape of Titian, of Mola, of Salvator, of the Poussins, Claude, Rubens, Elzheimer, Rembrandt and Wilson, spurns all relation with this kind of mapwork. To them nature disclosed her bosom in the varied light of rising, meridian, setting suns; in twilight, night and dawn. Height, depth, solitude, strike, terrify, absorb, bewilder, in their scenery. We tread on classic or romantic ground, or wander through the characteristic groups of rich congenial objects.[4]

While Professor of Perspective at the Royal Academy, Turner seized the

chance to speak about 'Backgrounds' in his closing oration, and he pushed home Fuseli's remarks on the 'accessory' power of landscape. Why, he enquired, if it were ever the major element in an *History* might it not stand alone ?

But it was C. R. Leslie (Professor of Painting 1847–52), the devoted encomiast of Constable, who finished off this chapter of the tale. He delivered, without apology, an entire lecture *On Landscape* and stood the academic hierarchy on its head. Our intellectual tastes, he declares,

> should elevate and purify . . . ; but, in some directions, they are not inapt to degenerate into mere luxurious indulgences, and a long catalogue might be made out of gross and selfish men, who have yet been patrons of Art. But the love of Landscape is a love so pure, that it can never associate with the relishes of a mere voluptuary, and wherever such a love is native, it is the certain indication of a superior mind. . . . The right appreciation of this lovely branch of Painting has suffered, like all the others, by classification. Sir Joshua Reynolds, who does justice to the genius of Gainsborough, refuses to rank his landscape with poetic Art, and this could only arise from its not being connected, like the landscape of Poussin and Sebastian Bourdon, with classic incident; for if Burns, in describing the banks of the Doon, writes as a poet, why may not Gainsborough, with his extreme sensibility to every beauty of Nature, paint like one, though he take for his subject the most familiar scenery of his own country ?[5]

Within the academic tradition, obviously, attitudes had shifted. We ought, however, to confess that the vocabulary of the debate from which our passages derive *and*, what is truly significant, its promptings, its drives, are equivocal or downright opaque.

Beyond *academe* acceptance of landscape as emotionally and intellectually respectable went along apace. A glance at the statistics, so to speak, will help to mark the boundaries of this revolution in taste. Books about the genre and its practitioners appeared and were read. Philip Thicknesse's memoir of Gainsborough (1788) was brief and, seemingly, limited in appeal. But by the middle of the nineteenth century several publishers were dispensing meaty tomes—Thomas Wright's *Wilson* (1824), Leslie's *Constable* (1843), Fulcher's *Gainsborough* (1856), Thornbury's *Turner* (1862). What should, certainly, be termed the most influential—widely read and seriously attended to—of treatises on art, John Ruskin's *Modern Painters*, began to appear in 1843 (Vol.II followed in 1846, Vols.III and IV 1856, Vol.V 1860) and this focused decisively upon landscape. For Ruskin, investigation of the natural world was, in numerous senses, the ultimate activity, the noblest and most mind-enriching pursuit of all. *Modern Painters* was at once a thorough-going exposition of Turner's virtues and a magnificently pretentious destruction of the old hierarchy in favour of landscape art.

The number of landscapists increased steadily during the hundred years or so after 1750. And eventually a clutch of specialist bodies—bodies with landscape of one kind or another as their *raison d'être*—came to birth. The best-known (though still rather mysterious) of the early groupings, the 'academy' of Dr Thomas Munro (a gentleman amateur, Physician to Bethlem Hospital), an informal and irregular assembly which included Turner and Girtin, got going *c*.1793. 'Dr. Munro's patronage of young artists was not confined to giving them access to his pictures and portfolios, and letting them make copies, and assisting them with his own judicious advice. He had a pleasant way of bringing them together on a system which combined the benefit of this kind of study with mutual instruction, and with a small pecuniary profit. . . . In winter evenings, he encouraged young men to make a studio of his house. There they put their sketches into pictorial shape under the doctor's eye, and

he gave them their supper and half a crown apiece. . . .'[6] In 1799 'The Brothers', among them Girtin (and soon Cotman) met

> for the purpose of establishing by practice a school of Historical Landscape, the subjects being original designs from poetick passages.[7]

And in 1808 Francis Stevens with John James and Alfred Edward Chalon formed a Society for the Study of Epic and Pastoral Design, of which Cornelius Varley was a member. Outside the metropolis, too, there were signs of professional self-consciousness. Under the *aegis* of John Crome a Norwich Society of Artists—landscapists/topographers—emerged and could generate enough energy to spawn a splinter-group.

Exhibitions devoted, or mainly devoted, to landscape became a prominent feature of the art scene. Gainsborough had hung pastorales in his own gallery from 1784 to his death. Turner opened a private showroom in 1804 and, at different addresses, kept the thing going for the whole of his career. Francis Towne put on a display of 191 'picturesque scenes' and 'views' in 1805. At the same date, the Society of Painters in Water-Colours—with a hard core of landscapists—mounted its first show and had 'approximately' 11,542 paying visitors in seven weeks: by 1810 there was 'an all but absolute dominion' of landscape.[8] A rival crew, the Associated Artists in Watercolours, surfaced in 1808, and an observer was struck by

> the overwhelming proportion of landscapes, a proportion almost as unreasonable as that of the portraits at Somerset House [the R.A.]. In pacing round the rooms the spectator experiences sensations somewhat similar to those of an outside passenger on a mail-coach making a picturesque and picturizing journey to the North. Mountains and cataracts, rivers, lakes, and woods, deep romantic glens and sublime sweeps of country, engage his eye in endless and ever-varying succession.[9]

Underwritten by a veritable army of 'people of rank' and with the King as Patron, the British Institution (1805 on), which sought to attract for this country's painters 'the homage and respect of foreign nations', offered in 1812, after three premiums for Historical or Poetical Composition, a prize of 100 guineas for 'the best Landscape' and gave over its rooms to major retrospectives of Wilson and Gainsborough in 1814. In 1819 Walter Fawkes' fine collection of British Landscape, built around sixty specimens of Turner's genius, was thrown open to the public. And thus the story runs.

Our knowledge of collecting between 1750 and 1850 is wonderfully imperfect; sales figures and commission details are difficult to gather at a significant level, but they tend to support the revolution of taste thesis. Landscapes from abroad were a fairly safe investment: Claude's pair *Morning* and *Evening* cost £223.13s. in 1754, £6,300 in 1806. And British pictures, though never matching this rate, did appreciate markedly. Richard Wilson—to subsequent generations the great founder of the native school—received at the start of his career in the 1750s between £3 and £10 per canvas: in 1758, following his return from Italy, he was able to get 51 guineas for *Croome Court*: and he appears to have reached a peak *c.*1766 with 222 guineas for a Claudian phantasy. Around 1755 Gainsborough could manage 15 or 21 guineas for a 'Landscape for a Chimney piece': by 1785 a pastorale is said to have commanded £89.6s. from the Prince of Wales; and only two years later *The Market Cart* brought him 350 guineas. Gainsborough's reputation moved to a mid-nineteenth century top of £651 when *The Harvest Wagon* was bought in at auction. Amongst the next generation, several artists, labouring like mad, achieved high financial status, and the case of Turner (not wholly typical) may stand for this. From the half-a-crown and oysters evening he rose to the splendiferous heights of £1,050 for *Palestrina* (exhibited 1830, sold 1844)—'I

shall open my mouth wide ere I part with it'.[10] Earlyish works drew ever larger sums on their journeys through the sale-room: the *Walton Bridges* bought by Sir John Leicester in 1807 for 200 guineas had gone by 1845 to what a newspaper called 'the enormous price' of £703.10s. Turner's biographer Thornbury maintains that a syndicate of connoisseurs, Sir Robert Peel and Lord Hardinge *et al.*, decided to offer the old artist £5,000 for *Dido building Carthage* and *The decline of the Carthaginian Empire* which would then be presented to the nation and, if a fiction, it is credible.[11] Again, Turner is said to have been offered by the trade, and more than once, £100,000 for the contents of his studio.[12] On his death in 1851 he left an estate valued at roughly £140,000.

However: this is no chronicle of success unalloyed—quite the contrary There were, along the way, halts, devious turns galore, and the odd *cul de sac*: that gathering for the Study of Epic and Pastoral Design rapidly became the Bread and Cheese Society. And while the quantity of landscapists grew, instances of commercial failure multiplied. Anecdote upon anecdote in letters, diaries, volumes of reminiscence, emphasise the awkwardness, the sheer uncertainty, of the landscape artist's existence: 'the feild of Waterloo', wrote Constable, 'is a feild of mercy to ours'.[13] Artist was only too easily exacerbated by patron. A 'gentleman near Ipswich' commissioned from Gainsborough a picture of gypsies, saw it two-thirds complete and 'said he did not like it. Then, said Gainsborough, "You shall not have it;" ' and he knifed the canvas: 'It was a terrific gash, and Gainsborough must have been in a flaming passion. . . .'[14] But Mr Gainsborough started the design anew for his casual master. More than a few of those whom historians now laud were scarcely better than menials to their employers. In 1802, shortly before the bright and busy Girtin died, Lord Elgin (of Elgin Marbles fame) offered him

> 30*l.* a year, to go with him to Constantinople; and as Lady Elgin possessed a taste for drawing, he wished to know whether he would engage to assist her in decorating fire-skreens, work-tables, and such other elegancies. Girtin replied, 'that for that department he greatly feared that he was an unfit person; and he must add, that the salary proposed was too small.' His Lordship remarked, 'that he was poor'. . . . In the course of this negociation, Girtin had spent many useless hours *impatiently*, by waiting between the hall and the presence-chamber, and had the mortification to learn a severe lesson,—that his talents were not estimated at half the value of those of his Lordship's valet de chambre.[15]

The really ambitious artists were, frequently, the most vulnerable, and the manic depressive condition of both Turner (the star of the picture sales) and Constable (a near-flop in market terms) must afford painful proof of the cultural disequilibrium with which the landscapist had to contend. Constable is, according to some, charity personified, and, to others, a vicious epigrammatist whose conversation reeked with the bitterness born of continuous competition—the 'restless poison of envy oozed perpetually from his tongue'[16]. And consider the conflict in Turner's stance toward his own achievement. 'I am the great lion of the day', he once told a friend.[17] He left instructions in his Will for a Turner museum, the grandest monument an artist ever planned for himself, and to this end bought back work after work, so that his variety and depth might be fully grasped. Yet his private gallery was, increasingly, a damp, dingy, rat-infested place to which entry was often denied. He wished his *Dido building Carthage* to hang beside the masterpieces of Claude but also wanted it to wrap his corpse and vanish from the sight of man.

CONAL SHIELDS

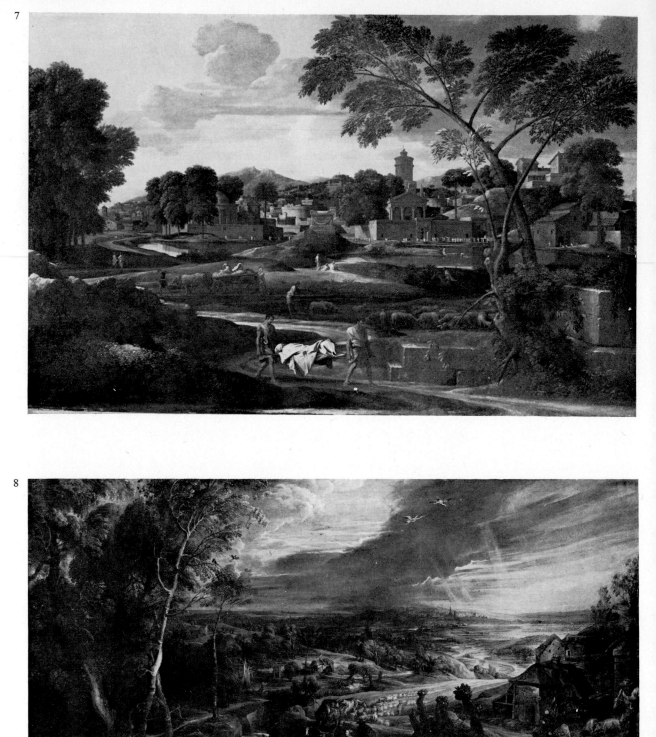

The Old Masters

What Constable used to call the 'Old Men', the masters of earlier days and, for the most part, other countries were, throughout the period covered by this exhibition, of fundamental interest. They provided, constantly, points of reference both for artists and the public, examples of what could be done, in the stricter sense, but, more than this, were forces which shaped the native vision—what it was actually possible to *see*. This is not to say that everybody agreed about their status. They were variously esteemed in various places at various times, liable to revaluation, *pro* and *con*, as the years passed. The devotion of some connoisseurs was narrowly exclusive, and these wanted, if a native product at all, the straightest possible pastiche. Others, however, and in piecemeal fashion to be sure, looked further and the great exemplars functioned as starting-points for a host of more worthy efforts, ultimately playing a part in the creation of emphatically British works.

The Richardsons (*An Account of the . . . Pictures in Italy, France, &c.*, 1722) write:

of all the Landskip-Painters *Claude Lorrain* has the most Beautiful and Pleasing Ideas; the most Rural, and of our own Times. *Titian* has a Style more noble. So has *Nicolas Poussin*, and the Landskips of the Latter are usually Antique, as is seen by the Buildings, and Figures. *Gaspar's* Figures are Such, otherwise he has a Mixture of *Nicolas* and *Claude*. *Salvator Rosa* has generally chosen to represent a sort of wild, and savage Nature; his Style is Great, and Noble; *Rubens* is pleasant, and loves to enrich his Landskip with certain Accidents of Nature, as Winds, a Rain-Bow, Lightning, &c. All these Masters are Excellent in their Several kinds. . . .

The list gives a good impression of the Old Master league table. Such evidence of picture sales as is presently available conveys an indication of who was in favour when and, crudely enough, to what degree. Claude, indubitably, remained at the league's head throughout the period. At the Duke of Portland's sale in 1722 three major examples went for £151, £200 and £280. In 1795 'The Enchanted Castle' changed hands for £546, in 1807 for £1,050 and in 1848 for £2,100. The two 'Altieri' pictures moved from £6,825 the pair in 1799 to a phenomenal £12,600 in 1808. Rubens, rarely available, was not far behind. Sir William Lowther bought 'Landskip with a Shower of Rain' for 290 guineas in 1756, Lady Beaumont the 'Chateau de Steen' for £1,500 in 1803; in 1823 'The Rainbow' fetched £2,730. At the other end of the scale, Ruisdael, Wijnants and Hobbema began to appear on the market in the 1740s and examples could be had for a few pounds. They followed the leaders at a respectful distance, a Ruisdael making £685 in the Holderness sale in 1802 and a Hobbema realizing a record £420 in 1806. This information is scanty indeed. But in fact knowledge of the Old Masters was disseminated largely—and 'largely' is the word—in the form of prints, and the movement of engravings and etchings is, for the moment, uncharted. Constable, no rich man, put together a collection of around 5,000 prints, dispersed in a three-day sale after his death: on the last day Cotman arrived in time to acquire 176 items for his own collection. To clear his debts in 1812 Crome was obliged to sell 449 prints. And as collectors the artists were probably a good way behind their patrons.

CLAUDE (1600–82)

'CLAUDE LORRAIN . . . was convinced, that taking nature as he found it seldom produced beauty. His pictures are a composition of the various draughts which he had previously made from various beautiful scenes and prospects. . . . That the practice of Claude Lorrain, in respect to his choice, is to be adopted by Landscape Painters, in opposition to that of the Flemish and Dutch schools, there can be no doubt, as its truth is founded upon the same principle as that by which the Historical Painter acquires perfect form. But whether landscape painting has a right to aspire so far as to reject what the painters call Accidents of Nature, is not easy to determine. It is certain Claude Lorrain seldom, if ever, availed himself of those accidents; either he thought that such peculiarities were contrary to that style of general nature which he professed, or that it would catch the attention too strongly, and destroy that quietness and repose which he thought necessary to that kind of painting.'

<div style="text-align: right">SIR JOSHUA REYNOLDS, 1771 [1]</div>

'Pure as Italian air, calm, beautiful and serene springs forward the works and with them the name of Claude Lorrain. The golden orient or the amber-coloured ether, the midday ethereal vault and fleecy skies, resplendent valleys, campagnas rich with all the cheerful blush of fertilization, trees possessing every hue and tone of summer's evident heat, rich, harmonious, true and clear, replete with all the aerial qualities of distance, aerial lights, aerial colour, where through all these comprehensive qualities and powers can we find a clue towards his mode of practice? As beauty is not beauty until defin'd or science science until reveal'd, we must consider how he could have attained such powers but by continual study of parts of

nature. Parts, for, had he not so studied, we should have found him sooner pleased with simple subjects of nature, and [would] not [have], as we now have, pictures made up of bits, but pictures of bits. Thus may be traced his mode of composition, namely, all he could bring in that appear'd beautifully dispos'd to suit either the side scene or the large trees in the centre kind of composition. Thus his buildings, though strictly classical and truly drawn from the Campo Vaccino and Tivoli, are so disposed of as to carry with them the air of composition.

But in no country as in England can the merits of Claude be so justly appreciated, for the choicest of his work are with us, and may they always remain with us in this country.'

J. M. W. TURNER, 1811 [2]

1. **Landscape: Hagar and the Angel** 1646
 Oil on canvas, $20\frac{3}{4} \times 17\frac{1}{4}$ in.
 English provenance: ?Matthew Duane, sold Greenwood, 23 April 1785(66); . . .Sir George Beaumont by c.1795 and left by him to the National Gallery 1828.
 The National Gallery (61)

Included by Beaumont in the collection which he gave to the nation in 1823 but returned so that he could continue to enjoy it during his lifetime. 'He dealt with it almost as a man might deal with a child he loved', said his friend Lord Monteagle, 'He travelled with it, carried it about with him, and valued it beyond any picture he had'.[3] The 'Hagar' was copied by Constable, who, wrote C. R. Leslie, 'looked back on the first sight of this exquisite work as an important epoch in his life'.[4]

2. **Landscape with the Father of Psyche Sacrificing to Apollo** 1662
 Oil on canvas, $69 \times 87\frac{3}{4}$ in.
 English provenance: Altieri Palace, Rome until 1798/9 when brought to England with its pendant, 'Landscape with the Arrival of Aeneas at Pallanteum'; bought on arrival by William Beckford ($£6,825$ the pair); sold June 1808 to Hart Davis through the dealer Harris (12,000 gns. the pair); Sir Philip Miles, Bt., sold Christie's 28 June 1884; R. B. Brassey, sold Christie's 3 May 1940; H.R.H. the Duchess of Kent, sold Christie's 14 March 1947, bt. Lord Fairhaven, who bequeathed both pictures to the National Trust 1967.
 The National Trust (Fairhaven Collection, Anglesey Abbey)

Before taking them to Fonthill, Beckford showed the 'Altieri' Claudes in May 1799 at his London house, where they were eagerly studied by artists, Girtin, Constable and Turner among them. Turner paid at least two visits and said of No.2 that 'He was both pleased & unhappy while He viewed it,—it seemed to be beyond the power of imitation'.[5]

3. **Tree Trunks in the Campagna** c.1638–41
 Wash over chalk, $8\frac{3}{4} \times 13$ in.
 English provenance: bequeathed to the British Museum by Richard Payne Knight 1824.
 The Trustees of the British Museum (Oo.7–215)

4

ARTHUR POND (*c.*1705–58) after CLAUDE

4. **The Repose on the Flight into Egypt** 1734
 Etching with colour applied from wood-blocks,
 $6\frac{3}{8} \times 8\frac{7}{8}$ in.
 The Trustees of the British Museum

One of a series of imitations of old master drawings pro-
duced by Arthur Pond and Charles Knapton between
1732 and 1736. The original drawing in this case be-
longed to Pond himself.

RICHARD EARLOM (1743–1822) after CLAUDE

5. **Liber Veritatis. or, a Collection of Two
 Hundred Prints, after the Original Designs
 of Claude le Lorrain** 1777
 The Trustees of the British Museum

Claude's 'Liber Veritatis', now in the British Museum,
is a book of drawings made by him as a record of his
completed paintings. It was acquired by the 2nd Duke
of Devonshire about 1720 and was probably at Devon-
shire House, London, until at least 1835, thereafter at
Chatsworth. Earlom's mezzotint versions of the draw-
ings appeared in two volumes in 1777: the second
volume is shown here.

GASPARD DUGHET (1615–75)

'with respect to *real views* from Nature in this Country
he [Gainsborough] has never seen any Place that
affords a Subject equal to the poorest imitations of
Gaspar or Claude'

THOMAS GAINSBOROUGH, *c.*1764 [6]

'the landscapes of Gaspar Poussin (whose works
contain the highest feeling of Landscape painting yet
seen—such a union of patient study with a poetical
mind)'

JOHN CONSTABLE, 1821 [7]

6. **Landscape with Eurydice**
 Oil on canvas, $60 \times 87\frac{1}{2}$ in.
 English provenance: bought by Horace Mann for
 Henry Hoare from the Arnaldi collection 1758.
 The National Trust (Stourhead)

For Henry Hoare and Stourhead see Nos.45–50. Mann
wrote to Horace Walpole from Florence on 3 June 1758:
'There are some fine Poussins, *paysages*, with figures of
Nicolò, his brother, larger than any I believe, except
some at Versailles. I have mentioned them to Mr
Hoare instead of Claud Lorrain's, which he desired I
would seek for at almost any price, but of the latter
none are to be found. The above two have suffered a
little and are rather dark. They [the Arnaldi] have al-
ways asked great prices: one Patch, a painter here,
offered some time ago 3,000 for the late Sir William
Lowther, though now I should think they may be had
for about, or less than, 1,200 crowns.'[8] On 19 August
Mann told Walpole of his purchase of the pictures for
Hoare, in the face of stiff competition from the agents
of Sir Richard Grosvenor and Sir Nathaniel Curzon: 'I
was lucky in executing a commission for Mr Hoare out
of the Arnaldi collection some hours before those

mighty bidders went there to buy the very pictures which Mr Hoare wanted. One is the large picture of Carlo Maratti. . . . The others are two very large *paysages* of Gaspero Poussin which you may probably remember by their size as well as their beauty.'[9] The second Gaspard is also at Stourhead today. The price estimated for the two, 1,200 crowns, is reckoned as the equivalent of about £300 at the time.

6

NICHOLAS POUSSIN (?1594–1665)

'To Nicholas Poussin let me direct your observation. His love for the antique prompted his exertion and that love for the antique emanates through all his works. It clothes his figures, rears his buildings, disposes of his materials, arranges the whole of his picture and landscape. . . . The six pictures generally called his landscapes, formerly in the Louvre, are now *dispersed*. One of them, the Roman Youth in the collection of Sir Watkin Williams-Wynn, The Burial of Phocion in Mr. Hope's and the Street Scene in the late Desenfans' collection, are with us as powerful specimens of his Historic Landscape. A slight view of them is sufficient to demand our admiration and enforce respect for their purity of conception uncharg'd with colour or of strained effects.'

J. M. W. TURNER, 1811[10]

7. **Landscape with the Body of Phocion carried out of Athens** 1648
 Oil on canvas, 45 × 69 in., repr. on p.14
 English provenance: Lord Clive by 1774; by descent to the present owner.
 The Earl of Plymouth

Peter Paul Rubens (1577–1640)

'I could wish you to call *upon any pretence* any day after next Wednesday at the Duke of Montagu, because you'd see the Duke and Duchess in my *last* manner; but not as if you thought anything of mine worth that trouble, only to see his Grace's Landskip of Rubens, and the 4 Vandykes. . . .'

THOMAS GAINSBOROUGH, 1768[11]

'there is such an airiness and facility in the landscapes of Rubens, that a painter would as soon wish to be the author of them, as those of Claude, or any other artist whatever.'

SIR JOSHUA REYNOLDS, 1781[12]

'Rubens, Master of every power of handicraft and mechanical excellence, from the lily of the field to animated nature, disdained to hide, but threw around his tints like a bunch of flowers. Such is the impression excited in his Fête in the Louvre, wholly without shadow compar'd to Rembrandt's mode, obtaining everything by primitive colour, form and execution, and so abundantly supplied by the versatility of his genius with forms and lines, could not be happy with the bare simplicity of pastoral scenery or the immutable laws of nature's light and shade, feeling no compunction in making the sun and full moon as in the celebrated picture of the Landscape with the Waggon, or introducing the luminary in the Tournament, while all the figures in the foreground are lighted in different directions. These trifles about light are so perhaps in Historical compositions, but in Landscape they are inadmissable and become absurdities destroying the simplicity, the truth, the beauty of pastoral nature in whose pursuit he always appears lavish of his powers. Full of colour, the rapidity of his pencil bears down before it in multitudes of forms, not the wild incursions full of Grandeur as Salvator Rosa, but [the] swampy vernality of the Low Countries.'

J. M. W. TURNER, 1811[13]

8. **Summer** *c.*1620
 Oil on canvas, $57\frac{1}{2} \times 89$ in., repr. on p.14
 English provenance: George Villiers, 1st Duke of Buckingham, who died 1628; sold in Antwerp 1648;. . . acquired by Frederick, Prince of Wales by 1747.
 Her Majesty Queen Elizabeth II

9. **Tree Trunk and Brambles** *c.*1618–20
 Chalk and pen and ink, touched with colour, $13\frac{3}{4} \times 11\frac{3}{4}$ in.
 English provenance: presumably acquired by the 2nd Duke of Devonshire with the Flinck collection 1723.
 Devonshire Collection, Chatsworth. Lent by the Trustees of the Chatsworth Settlement
 Rubens' inscription has been translated as 'fallen leaves and in some places green grasses peep through'.

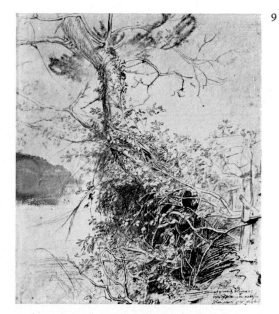

9

SALVATOR ROSA (1615–73)

'Precipices, mountains, torrents, wolves, rumblings, Salvator Rosa—the pomp of our park and the meekness of our palace! Here we are, the lonely lords of glorious desolate prospects.'

HORACE WALPOLE, 'From a hamlet among the mountains of Savoy', 1739[14]

'The wildness of Salvator Rosa opposes a powerful contrast to the classic regularity of Poussin. Terrific and grand in his conceptions of inanimate nature, he was reduced to attempts of hiding by boldness of hand, his inability of exhibiting her impassioned, or in the dignity of character; his line is vulgar: his magic visions, less founded on principles of terrour than on mythologic trash and caprice, are to the probable combinations of nature, what the paroxysms of a fever are to the flights of vigorous fancy.'

HENRY FUSELI, 1801[15]

'Salvator Rosa is a great favourite with novel writers, particularly the ladies'

JOHN CONSTABLE, 1836[16]

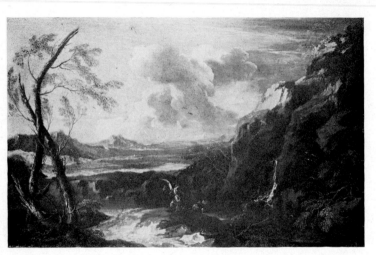

10

10. **Landscape with Tobias and the Angel**
Oil on canvas, 58 × 88 in.
English provenance: Hon. James Ansell, sold Christie's 6–7 April 1773(89), bt John Martin; Edward Holland-Martin, sold Christie's 25 June 1959(78), bt D. A. Hoogendijk and from him by the National Gallery.
The National Gallery (6298)

JACOB VAN RUISDAEL (1628 or 1629–82)

' "Ruysdael. . . . delighted in, and has made delightful to our eyes, those solemn days, peculiar to his country and to ours, when without storm large rolling clouds scarcely permit a ray of sunlight to break the shades of the forest. By these effects he enveloped the most ordinary scenes in grandeur. . . ."

'Constable pointed to a copy of a small evening winter-piece by Ruysdael. "This picture," he said, "represents an approaching thaw. The ground is covered with snow, and the trees are still white; but there are two windmills near the centre, the one has the sails furled, and is turned in the position from which the wind blew when the mill left off work; the other has the canvass on the poles, and is turned another way, which indicates a change in the wind; the clouds are opening in that direction, which appears by the glow in the sky to be the south, (the sun's winter habitation,) and this change will produce a thaw before the morning. The concurrence of these circumstances shows that Ruysdael *understood* what he was painting. He has here told a story; but in another instance he failed, because he attempted to tell that which is out of the reach of the art. In a picture which was known, while he was living to be called 'An Allegory of the Life of Man,' (and it may therefore be supposed he so intended it,)—there are ruins to indicate old age, a

stream to signify the course of life, and rocks and precipices to shadow forth its dangers;—but how are we to discover all this ?" '

JOHN CONSTABLE, 1836, reported by C. R. Leslie[17]

11. **The Windmill** *c.*1655
Oil on canvas, 31 × 40¼ in.
English provenance: Earl of Halifax, sold Christie's 25 June 1808(100); Walsh Porter, sold Christie's 14 April 1810(8), bt. Lord Yarmouth for the Prince Regent.
Her Majesty Queen Elizabeth II
Constable saw this picture when it was exhibited at the British Institution in 1821 and afterwards wrote to his friend Archdeacon Fisher: 'The beautiful Ruisdael of the "Windmill and log-house" which we admired at the Gallery is left there for the use of students—I trust I shall be able to procure a memorandum of it'.[18]

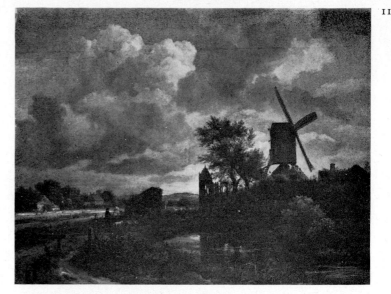

11

AERT VAN DER NEER (1603 or 1604–77)

FRANCOIS VIVARES (1709–80) after AERT VAN DER NEER
12. **Moon-light** 1751
Line engraving, 14⁷⁄₁₆ × 19³⁄₈ in.
The Trustees of the British Museum (X.8–26)
Published by Arthur Pond 1751, when the painting belonged to Christopher Batt. The plate was reissued by Boydell in 1775.

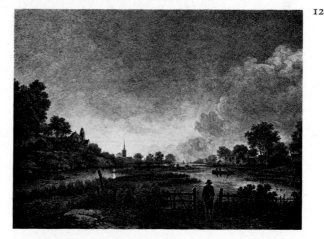

12

REMBRANDT (1606–69)

'REMBRANDT'S excellency, as a painter, lay in colouring; which he possessed in such perfection that it almost screens every fault in his pictures. His prints, deprived of this palliative, have only his inferior qualifications to recommend them. These are expression, and skill in the management of light, execution and sometimes composition. . . . While he keeps within the sphere of his genius, and contents himself with low subjects, he deserves any praise. But when he attempts beauty, or dignity, it were good-natured to suppose, he means only burlesque and caricature.'

WILLIAM GILPIN, 1768[19]

'Rembrandt depended upon his chiaroscuro, his bursts of light and darkness to be *felt*. He threw a mysterious doubt over the meanest piece of Common; nay more, his forms, if they can be called so, are the most objectionable that could be chosen, namely, the Three Trees and the Mill, but over each he has thrown that veil of matchless colour, that lucid interval of Morning dawn and dewy light on which the Eye dwells as completely enthrall'd, and it seeks not for its liberty, but as it were, thinks it a sacrilege to pierce the mystic shell of colour in search of form.'

J. M. W. TURNER, 1811[20]

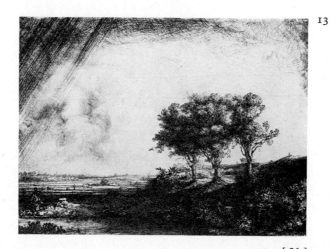

13

14

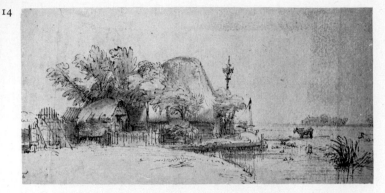

13. **The Three Trees** 1643
Etching, $8\frac{7}{16} \times 11$ in.
English provenance: bequeathed to the British
Museum by the Rev. C. M. Cracherode 1799;
subsequently stolen by Robert Dighton, who
applied his collector's mark to it.
The Trustees of the British Museum

14. **A Farmstead by a Stream** *c.*1652–3
Pen and ink and wash, $4\frac{1}{4} \times 8$ in.
English provenance: acquired by the 2nd Duke of
Devonshire with the Flinck collection 1723.
*Devonshire Collection, Chatsworth. Lent by the
Trustees of the Chatsworth Settlement*

15

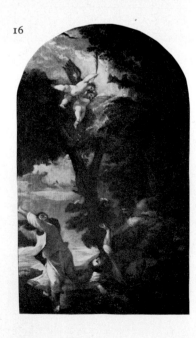

16

TITIAN (died 1576)

MARTINO ROTA (*c.*1520–83) after TITIAN
15. **The Martyrdom of St. Peter**
Line engraving, $15\frac{5}{16} \times 10\frac{9}{16}$ in.
The Trustees of the British Museum (1874–8–8–
1941)

ALFRED STEVENS (1817–75) after TITIAN
16. **The Martyrdom of St. Peter** 1839 or 1840
Oil on canvas, $31\frac{1}{2} \times 19$ in.
Ronald Shaw Kennedy, Esq.

Titian's 'St. Peter Martyr', painted between 1526 and
1530 for SS. Giovanni e Paolo in Venice, where it was
destroyed by fire in 1867, was revered in England as
the work in which landscape first justified itself: land-
scape ceased to be merely background and became a
vital element in creating the mood of a history picture.
'Landscape,' Fuseli told the Royal Academy in 1801,
'whether it be considered as the transcript of a spot, or
the rich combination of congenial objects, or as the
scene of a phenomenon, dates its origin from him'.[21]
Ten years later Turner told the same body: 'the highest
honour that landscape has as yet, she received from the
hands of Titian, which proves how highly he con-
sidered its value not only in employing its varieties of
contrast, colour and dignity in most of his Historical
Pictures; but the triumph even of Landscape may be
safely said to exist in his divine picture of St. Peter
Martyr.'[22] Constable, although he had not seen the
original painting, regarded it as 'the foundation of all
the styles of landscape in every school of Europe in the
following century'[23]: 'In the representation of this
subject Titian has brought together a rich assemblage
of picturesque objects producing a felicitous combina-
tion of the two most important walks of art,—history
and landscape; and contrasting them so as to enhance
the sentiment of each.'[24]

ALBRECHT DÜRER (1471–1528)

'Let me remember always, and may I not slumber in
the possession of it, Mr. Linnell's injunction (delightful
in the performance), "Look at Albert Dürer."'

<div align="right">SAMUEL PALMER, 1825 [25]</div>

17. **The Flight into Egypt** c.1503–5
Woodcut, $11\frac{9}{16} \times 8\frac{3}{16}$ in.
The Trustees of the British Museum (1895–1–22–
634)

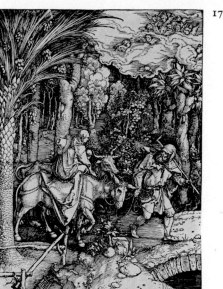

17

Ascribed to JAN PROVOOST (died 1529)

18. **The Virgin and Child in a Landscape**
Oil on panel, $23\frac{3}{4} \times 19\frac{3}{4}$ in.
English provenance: in the Œttingen-Wallerstein
collection, exhibited at Kensington Palace 1848
and bought with the rest of the collection by the
Prince Consort; presented to the National Gallery
by Queen Victoria 1863.
The National Gallery (713)

Serious interest in England in the early Italian, Ger-
man and Flemish painters—the 'primitives'—dates
from the late eighteenth and early nineteenth centuries,
when Roscoe, Cumberland, Ottley, Aders, Fox-
Strangways and others were formimg collections or
writing on the subject. One or two landscapists re-
sponded to this interest. In Wales with G. R. Lewis in
1813, Linnell 'saw realized what had always charmed
him in. . . . the backgrounds of Raphael and Titian'[26]
but within a few years he was looking even further back,
advising Palmer to study Dürer and Lucas van Leyden
—'Look for Van Leydenish qualities in real landscape,
and look hard, long and continually', Palmer wrote in
his notebook in 1823.[27] In 1826 Linnell made a large
etching after part of an early copy in Aders' collection
of Van Eyck's Ghent altarpiece. About the same time
Dyce was in Rome and in touch there with the leaders
of the German primitivist movement, the Nazarenes.
By the 1840s the taste for early art was becoming well
established and there was a special burst of activity dur-
ing the decade, with publications from Mrs Jameson,
Lord Lindsay and Ruskin; the foundation of the Arundel
Society, devoted to publishing examples of early paint-
ing; and two exhibitions in 1848, at the British Insti-
tution and Kensington Palace. The Pre-Raphaelite
Brotherhood, founded the same year, looked to 'primi-
tive' art for a model of the 'patient devotedness' to
nature which its own members sought. 'That this
movement is an advance,' claimed F. G. Stephens in
1850, 'and that it is of nature herself, is shown by its
going nearer to truth in every object produced, and by
its being guided by the very principles the ancient
painters followed. . . . These principles are now revived,
not from them, though through their example, but
from nature herself'.[28]

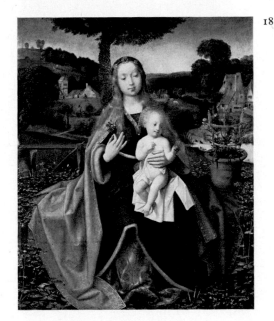

18

Retrospect

This section is intended to show, briefly and in the simplest fashion, what was going on in landscape in this country before the middle of the eighteenth century. Two main sorts of work are illustrated: in Nos. 19–22, topography, including the depiction of country estates (a kind of architectural 'face-painting') and the related business of recording antiquities; in Nos.23–4, 'ideal' landscape, usually pastiching the old masters. Nos.25–9 represent early attempts to come to grips with British scenery. The proportion of foreign artists included is typical of the period: the best topographers still came from the Continent, and Continental taste dominated the more pretentious type of landscape. In the 1740s landscape of any sort was still a fairly marginal part of the English art scene. George Vertue wrote with some pride of the situation in 1743, but his remarks show clearly how thin on the ground native landscapists were: 'some large prints lately published after paintings landskips done by . . . Smith are of a good manner and taste is worthy of commendation. and does honour to the Art of Painting in that kind in England. because now there is several eminent and ingenious professors of that branch of painting. Mr. Wooton. Mr. Lambert of Common Garden. Mr Taverner & this . . .Mr. Smith. and others.'[1]

WENCESLAUS HOLLAR (1607–77)

19. **Four Views at Albury** 1645
 Etchings, each 3 3/16 × 6 in.
 Her Majesty Queen Elizabeth II

Hollar was born in Prague and worked in Germany and the Netherlands before coming to England under the patronage of the Earl of Arundel in 1636. Until the Civil War he was employed largely by Arundel and followed him into exile in Antwerp, where these views of the environs of the Earl's house in Surrey were etched. In Antwerp Arundel wrote nostalgically of Albury, 'where I hope to be ere long & ende my dayes there'[2] and it was presumably to evoke the place for him that Hollar made these prints. Later Hollar worked mainly for print-sellers and publishers, but despite a vast output—he etched over 2,500 plates in his lifetime—died in poverty.

JOHANNES KIP (1653–1722)
after LEONARD KNYFF (1650–1722)

20. **Badminton**
 Line engraving, 12 3/4 × 18 1/2 in.
 The Trustees of the British Museum (M.21–9)

Plate X of the *Nouveau Theatre de la Grand Bretagne*, Vol.I, in the four-volume edition of 1724. The work, known also as *Britannia Illustrata*, originally appeared in one volume, comprising 80 views of royal palaces and country seats, in 1707 or 1708. After Knyff had visited Badminton to make his drawings, the dowager Duchess of Beaufort wrote to her daughter, presumably referring to the prints which were to be made: 'my designe when these are all done is to have some of them bound in books & give them to friends indeed my cheife aime is to show what a noble place my deare Lord has left'.[3]

CANALETTO (1697–1768)

21. Warwick Castle from the River Avon
Pen and ink and wash, $12\frac{1}{2} \times 22\frac{3}{4}$ in.
Lord Brooke

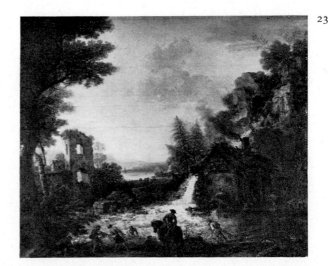

21

Canaletto came to England in 1746, apparently because the War of the Austrian Succession had limited the flow of British tourists to Italy, thereby cutting off the market upon which he principally depended. Vertue reports an initial disappointment with Canaletto's English work, which led to 'a conjecture that he is not the veritable Cannalleti of Venice'[4] but, apart from two return visits to Venice, he remained until 1755 or 1756, widely employed by old and new patrons in painting country houses and views of London and the Thames. This drawing, related to a painting of the same view at Warwick Castle, is supposed to carry on the back an inscription, now hidden, stating that it was made with a *camera obscura*.

SAMUEL (1696–1779)
or NATHANIEL BUCK (active 1727–53)

22a. 'The South West View of Lantphey-Court, near Pembroke.' *c.*1740
b. 'The South-East View of Mannorbeer-Castle, in Pembrokeshire.' *c.*1740
Pen and wash, each $8\frac{1}{4} \times 16\frac{1}{4}$ in.
The Trustees of the British Museum (1886-10-12-510...511)

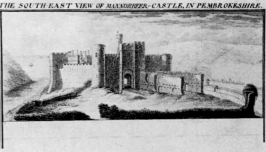

22b

The Buck brothers' mammoth project of illustrating the 'Venerable Remains of above 400 Castles, Monasteries, Palaces, etc., etc.' got underway in the 1720s. Prints were published in instalments up to the 1740s and the whole eventually appeared in three volumes as *Buck's Antiquities* in 1774. The South Wales sections were first issued in 1740–1.

JOHN WOOTTON (*c.*1682–1764)

23. Landscape with Fishermen 1753
Inscribed 'J. Wootton 1753'
Oil on canvas, $39\frac{1}{8} \times 47\frac{7}{8}$ in.
The City of Manchester Art Galleries

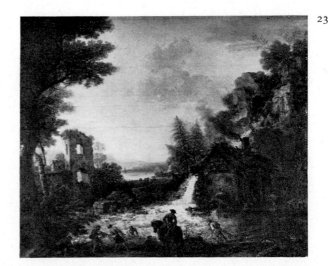

23

Wootton was primarily a painter of horses and sporting subjects, but he added Gaspardesque and Claudian landscape compositions to his repertoire as his patrons' taste for 'classical' landscape grew. In this picture Flemish elements are also introduced.

24

GEORGE LAMBERT (1700–65)

24. **Classical Landscape** 1745
 Inscribed 'G. Lambert 1745'
 Oil on canvas, 40¾ × 46 in.
 The Tate Gallery (T.211)

Vertue described Lambert in 1722 as 'a young hopefull Painter in Landskape. . . . much in imitation of Wotton. manner of Gasper Poussin'.[5] By the 1730s, however, he seems to have been as often employed to paint country houses and there are two paintings in which the English countryside itself emerges as the subject (see No.29).

25

JAN SIBERECHTS (1627–1703)

25. **Landscape with a View of Henley-on-Thames**
 1692
 Inscribed 'J. Siberechts. 1692'
 Oil on canvas, 17 × 20 in.
 Lord Middleton

26. **Hilly Landscape with Ferns in the Foreground**
 Watercolour and bodycolour, 9 × 14 in.
 Miss Oppé

Siberechts came to England from Flanders some time between 1672 and 1674. He painted views of country houses, but for one patron at least, Sir Thomas Willoughby, he also produced landscapes of English scenery, including No.25. A related 'Landscape with a Rainbow, Henley-on-Thames' is in the Tate Gallery (T.899). The study of ferns, No.26, was presumably made for Siberechts' own reference; it was later owned by Paul Sandby.

26

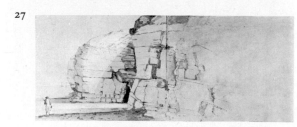

27

FRANCIS PLACE (1647–1728)

27. **Sketchbook** 1699–1717
 67 leaves, 6⅜ × 8 in.
 The Victoria and Albert Museum (E.1496–1931)

Open at pp.118–19, a pen and wash study of cliffs at Scarborough, made in 1717.

28. **Easby Abbey**
 Wash, 5¾ × 17⅛ in.
 The Trustees of the British Museum (1850–2–23–814)

Place was, in Vertue's words, 'an Ingenious Gent.'[6], a gentleman amateur who pursued a variety of interests, collecting curiosities, making prints, experimenting with potting, etc. His early drawings are linear and topographical, in the manner of Hollar (with whom he studied), but his later work shows a tentative interest in natural phenomena. In the Scarborough study shown here he notes the fall of 'Sun Shine' and the shadows it casts on the cliffs.

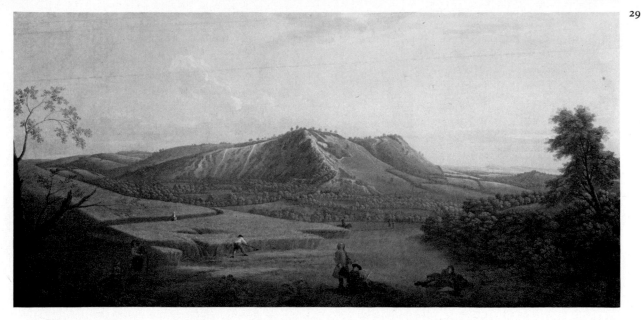

George Lambert (1700–65)

29. **Hilly Landscape with a Cornfield** 1733
 Inscribed 'G. Lambert 1733'
 Oil on canvas, $35\frac{3}{4} \times 72\frac{1}{2}$ in.
 The Tate Gallery (5981)

See also No.24. This picture and a companion, now in
the collection of Mrs E. O. Evans, came from Woburn
Abbey but no details of their commission are known.
It has been suggested that the figures in the foreground
might be engaged in a land survey[7] and that the location
could be the Dunstable Downs.

Landscape in Britain
c. 1750–1850

RICHARD WILSON (1714–82)

Wilson had a notion of landscape painting, and of himself as a landscape painter, which would have been foreign to his predecessors. It could hardly have been said of Wootton or Lambert, as it was of Wilson, that 'He had little respect for what are called connoisseurs, and did not conciliate their regard by any flattery or attention, but sarcastically ridiculed their attachment of old pictures'.[1] This is Farington, one of his pupils; another, Thomas Jones, reports Wilson's laconic observation to his idling students: 'Gentlemen—this is not the way to rival Claude'.[2] He was, said Beechey, 'a man full of information and anecdote, and no less full of satire. He had a deep feeling of the importance of his art and of his own importance as a professor of it. Humour him but upon this point and he would be most agreeable.'[3]

Few of his contemporaries took him at his own estimate. Initially successful, his career came unstuck and he had finally to be bailed out by the Royal Academy, which gave him the sinecure of Librarian at £50 a year in 1776. About twenty years after his death opinions changed and a full-scale Wilson revival got underway. 'He is now numbered with the classics of the art,' said Fuseli in 1801, 'though little more than the fifth part of a century has elapsed since death relieved him from the apathy of cognoscenti, the envy of rivals, and the neglect of a tasteless public'.[4] In 1811 one such rival, Zuccarelli, was castigated by Turner for having 'defrauded the immortal Wilson of his right and snatched the laurel from his aged brow. . . . In acute anguish he retired, and as he lived he died neglected'.[5] By 1814, when 88 pictures by (or attributed to) him were exhibited at the British Institution, Wilson was fully instated, with artists at least, as the founder of the British school of landscape and its first martyr.

Lit: W. G. Constable, *Richard Wilson*, 1953

30. **The Murder** 1752
Inscribed 'R W [. . . .]'
Oil on canvas, 27½ × 37¾ in.
Lit: Constable, pp.157–8, pl.12b
The National Museum of Wales, Cardiff

It was during his years in Italy (1750–*c*.1757) that Wilson, encouraged by Zuccarelli and Vernet, turned seriously to landscape after spending most of his earlier career as a portrait painter. His Italian years provided pictorial material which he exploited until his death, as well as the immediate patronage of a number of Englishmen making the Grand Tour. This Salvator-like 'Murder' is one of two 'landskips with banditti' painted at Rome for one such collector, Ralph Howard, later Viscount Wicklow, who paid about £10 for it. In all, Howard bought seven paintings from Wilson in Italy, in addition to works by other artists, but does not appear to have patronised him on his return to England —a pattern repeated in other cases.

WILLIAM WOOLLETT (1735–85) after WILSON
31. **Niobe** 1761
Line-engraving and etching, 17 × 22¾ in.
Lit: Constable, pp.160–3, pl.19a
The Trustees of the British Museum (1868–8–22–1967)

The subject is found in Ovid's *Metamorphoses* and elsewhere: Niobe refuses to worship Leto, believing herself more than equal to the goddess, especially as a mother; in punishment Leto sends her two children, Apollo and Diana, to massacre Niobe's seven sons and seven daughters.

The painting engraved by Woollett may have been exhibited at the Society of Artists in 1760 and it was

31

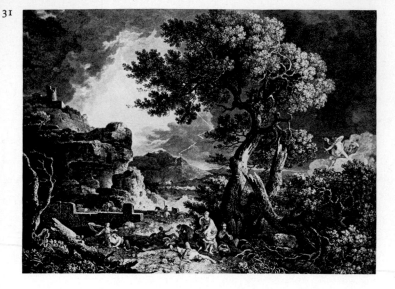

definitely bought about that time by William, Duke of Cumberland (one source has it that Thomas Sandby obtained a commission from the Duke for Wilson to paint it, for 80 guineas[6]). That version of the painting is now in the collection of Mr and Mrs Paul Mellon. Another, formerly belonging to the sculptor Joseph Wilton, was presented to the National Gallery by Sir George Beaumont in 1826, but destroyed by enemy action in 1944, while a third was acquired from Wilson by the Duke of Bridgewater and is in the Ellesmere collection today. According to W. G. Constable, Wilson did not long continue to find private, let alone royal or aristocratic, patronage for his historical landscapes: from the later 1760s such works went instead to dealers or engravers. The apparent success of Woollett's 'Niobe' print may have been a stimulus here. Certainly John Boydell later made great claims for this, his first major venture in print publishing. He told J. T. Smith that he had commissioned Woollett to engrave the plate for 100 guineas, at that time 'an unheard-of price', and during the course of the work was obliged to advance a further £50—in all, nearly twice the sum Wilson is said to have received for the painting. But when the print was published, at five shillings, 'it succeeded so much beyond my expectation, that I immediately employed Mr. Woollett upon another engraving, from another picture by Wilson'.[7] John Pye said that Boydell made £2,000 from 'Niobe'.[8] However, this may not say very much for the English market for prints after Wilson because Boydell had commissioned the engraving specifically for export to France, to offset the large number of prints of Vernet's 'Storm' which he had been importing and for which until then he had had to pay in cash.[9] And in 1782 Boydell himself published an engraving of the Vernet, presumably commissioned to meet a continuing demand for the subject (see the next item).

DANIEL LERPINIÈRE (?1745–85) after CLAUDE-JOSEPH VERNET (1714–89)

32. **The Storm** 1782
Line-engraving and etching, 17 × 22¾ in.
The Trustees of the British Museum (1917-12-8 2367)
Published by Boydell 1782. In 1760 Boydell had seen Wilson's 'Niobe' as England's answer to Vernet but twenty years later the English audience for Vernet had still to be reckoned with.

Kew Gardens: The Ruined Arch c.1760–2
33. Chalk, 11⅛ × 16⅞ in.
The Glynn Vivian Art Gallery, Swansea (Deffett Francis Collection)

34. Chalk, 9¾ × 13¼ in.
The Visitors of The Ashmolean Museum, Oxford

35. Oil on canvas, 18½ × 28⅝ in.
Exh: Society of Artists 1762(130)
Lit: Constable, pp.178–9, pl.41a
Brinsley Ford, Esq.
The ruined arch in Kew Gardens was designed by Sir William Chambers and erected in 1759–60 as part of his transformation of the gardens for Augusta, Dowager Princess of Wales. For over a century Wilson's painting

32

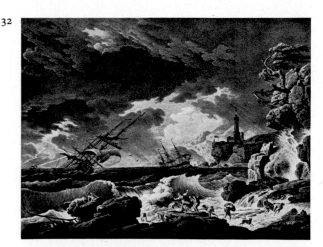

33

of the sham ruin was thought to represent an actual Roman ruin, the title 'Villa Borghese' first appearing on Thomas Hastings' etching of the picture in 1822. Benjamin Booth, writing in about 1790, said that this was one of the pictures Chambers 'wish'd His Majesty to see & to purchase—They were shewn Him, but a party for Zucharelli and Flemish artists getting the better of his Judgmt He did not express that Approbation of them as was wisht nor ever employed Him'.[10]

Holt Bridge on the River Dee *c.*1762

36. Chalk, 13¼ × 20¾ in.
The City Museum and Art Gallery, Birmingham

34

37. Oil on canvas, 58½ × 76 in., repr. on p.33
Exh: ?Society of Artists 1762(135)
Lit: Constable p.175, pl.35a
The Tate Gallery (6196)

'Kew Gardens: The Ruined Arch' is an extreme case of English landscape seen through classical eyes. A more casual but equally pervasive sense of Italy and the classical past underlies many of Wilson's English and Welsh landscapes, and there is often no difference in kind between them and the Italian subjects which he continued to paint after returning to England. No.37 and, for example, the more or less contemporary 'River Scene ("On the Arno")' in the Southampton Art Gallery differ in topographical detail, but are remarkably similar in general feeling and in composition. Three versions of Wilson's subject picture 'Diana and Callisto' use Lake Nemi as their background, but a fourth introduces Dolbadern Castle and Snowdon. The point of this assimilation of Britain to Italy was lost on some of the generation which followed Wilson. Edward Edwards found Wilson's English views 'rather too much Italianized, to produce a correct similitude to the scenes, from which they were drawn',[11] and another writer complained in 1814 that 'Many of his landscapes of English views are not congenial to the soil and climate of England. They partake too much of southern skies, and lose the character which ought to belong to them, to acquire that of another quarter of the globe'.[12] Wilson's departure from strict topography in No.37 is solemnly vouched for by Martin Davies, who 'could not get to the right spot' from which the view might have been seen: 'the foreground seems clearly to have been invented; and the general character of the scene has been somewhat changed by Wilson, the hills in particular being made to look higher than they do.'[13]

35

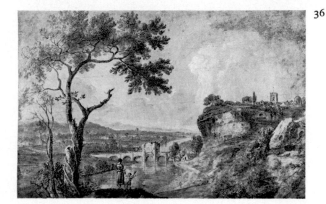

36

38
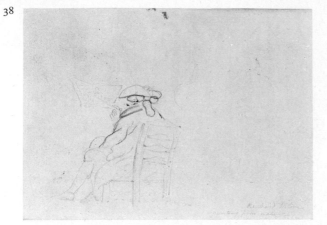

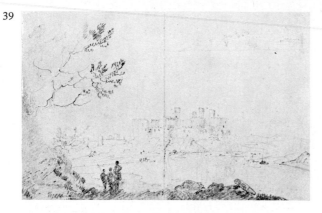
39

JOSEPH FARINGTON (1747–1821)

38. 'Richard Wilson painting from nature in Moor-Park—1765'

In sketchbook, $8\frac{5}{16} \times 6\frac{1}{2}$ in.

The Victoria and Albert Museum (P.75–1921)

Farington was a pupil of Wilson from 1763 to 1766. Some of the drawings in this sketchbook are corrected by Wilson and one or two may actually be by him.

Wilson was commissioned by Sir Lawrence Dundas to paint three large views of Moor Park, Hertfordshire, and these are now in the collection of the Marquis of Zetland. In his diary Farington later referred to Wilson having made preparatory drawings in the park (see Constable, p.181) and it is not clear whether he is, in fact, painting or drawing in Farington's sketch.

For other works by Farington see Nos.147–50.

39. Conway Castle

Pencil, $8 \times 12\frac{3}{4}$ in.

The National Library of Wales, Aberystwyth

On two pages from a sketchbook.

40. Tabley House *c.*1774

Oil on canvas, $39\frac{1}{2} \times 49\frac{1}{2}$ in.

Exh: R.A.1780(152)

Lit: Constable, pp.186–7, pl.56a

Lord Ashton of Hyde

Painted for Sir Peter Leicester, whose son was later to commission paintings of Tabley from Turner and James Ward (see Nos.206, 219). When exhibited in 1780

40
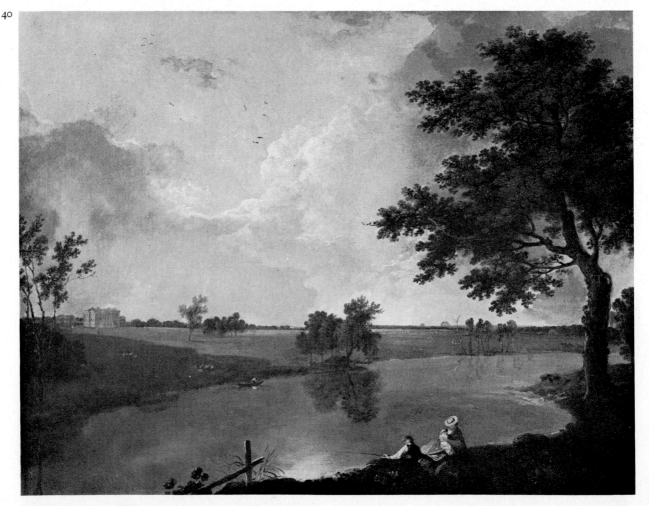

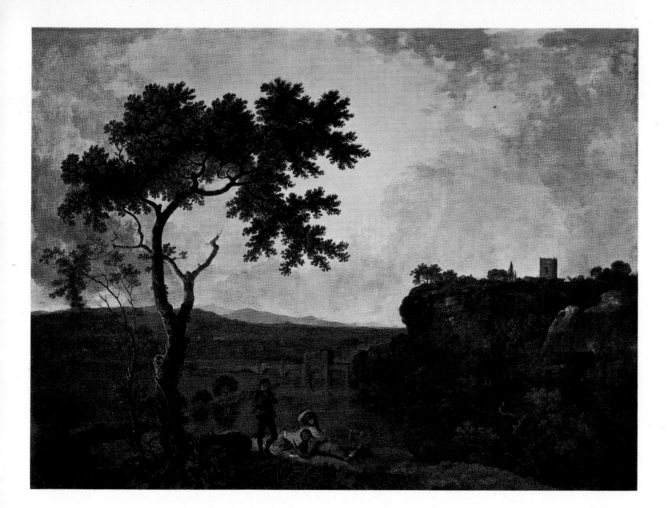

37. Richard Wilson
Holt Bridge on the River Dee *c.*1762

a critic described it as 'an old picture, painted in his prime'.[14] W. G. Constable ascribes it to *c*.1774 on a stylistic comparison with the painting of Bourne Park dated that year. The house itself only just figures in No.40 and in this respect also it is like 'Bourne Park' and unlike Wilson's earlier house pictures, for example 'Croome Court' of 1758 or even 'Moor Park' of 1765–7. It would be interesting to know whether Wilson's increasing emphasis on landscape at the expense of architectural portraiture was approved by his patrons, whether, in fact, a larger view—in all senses—of their estates was what they as well as the artist wanted. While there is no clear evidence on this sort of question, it does appear that Wilson was getting comparatively little work in the 1770s and that his finances were going into a decline from which they never recovered.[15] Competition from Barret (see Nos.41–2) may have played a part in this and, if its effect was exaggerated by the Wilson enthusiasts of the next generation, there is some evidence that Wilson himself felt it keenly. William Harvey of Catton told Beechey that he had never known Wilson 'out of temper except when talking of Barret, who was then the great favourite and universally patronized, so that he rode in his carriage while Wilson could scarcely get his daily bread'.[16]

GEORGE BARRET (?1732–84)

41. **Burton Constable Hall and Park from the South-West**
Watercolour, 16¼ × 24 in.
Mr and Mrs J. Chichester-Constable

42. **Burton Constable Hall: the East Front** 1777
Oil on canvas, 46¾ × 66¾ in.
Mr and Mrs J. Chichester-Constable
William Constable paid Barret £63 for 'a Journey from London making drawings' in August 1776 and £50 the following March 'upon Acct of three Landscape Paintings, Views of Burton Constable'[17], of which No.42 is one and No.41 the study for another. It does not seem clear whether the drawings referred to were studies for the paintings—and the payment of £63 perhaps partly on account of the latter—or whether they represent a different commission. Dr Ivan Hall has pointed out that in his view from the south-west 'Barret was painting the landscape of the house seen from the lake, before the lake could have had any water in it': the bed was still being dug out in 1777. The house itself had been the subject of another deception a few years earlier, when the brickwork had been painted with yellow ochre: 'Painted thus, it was hoped that the house would look like Burghley or Longleat which were of golden-coloured stone'.[18]

FRANCESCO ZUCCARELLI (1702–88)

43. **Et in Arcadia ego (The Arcadian Shepherds)** 1760
Inscribed 'Zucharelli f.1760'
Oil on canvas, 30 × 35½ in.
Sir James Fergusson, Bt.
Zuccarelli shows the Arcadians discovering the tomb of a former compatriot, whose words, 'I too was in Arcadia', they read in the inscription. Erwin Panofsky demonstrated how, following the second of Poussin's two treatments of the subject, the original and correct meaning, 'I'—that is, Death—'too am in Arcadia', was corrupted into this gentler, more elegaic message.[19] Zuccarelli presents an ideal pastoral world which is indeed hardly disturbed by the thought of death. The

43

painting was commissioned by Sir Adam Fergusson of Kilkerran through George Keate, who later wrote a dramatic poem on the same theme (*The Monument in Arcadia*, 1773). The artist was paid 20 guineas. In a letter to Sir Adam in 1761 Keate wrote: 'It gives me much satisfaction to find you approve your picture. I perceive its execution fully answers, only you hint in regard to the design, that the tomb is too conspicuous. If it was almost obscured with trees the story could not tell itself so well, and Poussin hath placed it in the centre of his picture, as well as Zucharelli; it no way I apprehend takes from the probability of the story as accident might not have led them into that part of Arcadia before, or they might have passed it frequently without being affected with it. For in real life if reflection was always awake, we should be stopped by many monuments of mortality which are placed in our paths, tho' we dance by them regardless of the truths they witness'.[20] The present owner says that there is 'nothing in Sir Adam's correspondence, nor indeed in his character' to support the idea which has appeared in print several times in recent years that Sir Adam commissioned the painting to symbolise that his Grand Tour days were over.

Zuccarelli, like Barret, is said to have made a good living while Wilson was neglected. Wilson's apprentice William Hodges said that soon after his master's return from Italy 'Mr. Zuccarelli arrived here, when Mr. Wilson finding the light airy manner of that painter pleased the world, he changed his style; but disgusted with what he considered as frivolity, he soon returned to his old pursuit formed in the School of Rome'.[21] Hodges' dates are wrong, since Zuccarelli was already in England when Wilson returned, but it is clear that some of the more influential patrons preferred the Italian's 'light airy manner': George III bought nothing from Wilson but had thirty paintings by Zuccarelli, mostly acquired *en bloc* with Consul Smith's collection in 1762, but some bought direct from the artist.

SIR JOSHUA REYNOLDS (1723–92)

44. **The Thames from Richmond Hill** before 1788
Oil on canvas, $27\frac{1}{2} \times 35\frac{3}{4}$ in.
The Tate Gallery (5635)
Engraved by William Birch and published 'July 1 1788' as 'View from Sir Joshua Reynolds's House Richmond Hill. Painted by himself'.

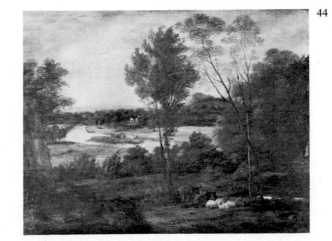

44

STOURHEAD, Wiltshire

A good deal, perhaps most, of the countryside which faced the artist was man-made, manufactured on the basis of literary or pictorial models, or transformed in the name of agricultural efficiency. Stourhead and Hafod (nos.123–8) exemplify such manufactory at its most emphatic.

The ancestral manor of Stourton was purchased in 1717 by the trustees of Henry Hoare, son of the founder of Hoare's Bank. Henry Hoare demolished the old house and commissioned Colen Campbell to build a new one in the Palladian style. On his death in 1725 Stourhead, as it had been renamed, passed to his widow and on her death in 1741 to their son Henry Hoare II (1705–85). It was he who created the celebrated 'classical' landscape of Stourhead, with its complex of temples and grottoes around a lake. The general inspiration of the painters Hoare admired—Claude, Gaspard, Poussin—is apparent, while inscriptions from Virgil and Ovid on the Temple of Flora and the Grotto suggest that there may have been a literary programme of sorts. The evidence here is rather slender but Mr Woodbridge thinks that Hoare may have had in mind an allegory of Aeneas' journeys and the founding of Rome. From the 1760s onwards Hoare introduced gothic and oriental features which gave the grounds a more eclectic appearance, though an earlier theme may have been continued in Alfred's Tower, erected on a hill two miles from the house to commemorate 'The Founder of the English Monarchy and Liberty'. In 1783 Henry Hoare made over Stourhead to his grandson Richard Colt Hoare (1758–1838), topographer, antiquarian and one of Turner's earliest patrons. Stourhead is now the property of the National Trust.

Lit: Kenneth Woodbridge, *Landscape and Antiquity, Aspects of English Culture at Stourhead 1718 to 1838,* 1970.

45. **Stourton Estate Map** 1722
The Wiltshire County Record Office (383.316), *lent with the permission of the National Trust*
The house built by Campbell for Henry Hoare I is shown with its formal forecourt and walled garden. To the south-west of the house and separated from it by pasture lies the village of Stourton and in the valley below it a series of ponds formed by the springs of the Stour.

46. **Stourton Estate Map** (survey by John Charlton) 1785
The Wiltshire County Record Office (135/4)
In place of pastures and ponds Henry Hoare II's great lake and the serpentine dam which holds it back are clearly visible. Around the lake paths link the architectural features and carefully calculated vistas. The walled garden to the south-west of the house has gone and the house is now connected to the pleasure grounds by a long stretch of grass which continues above the north-east side of the lake as a wooded terrace.

45
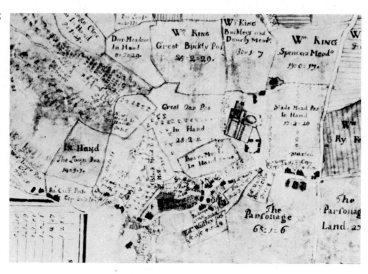

46
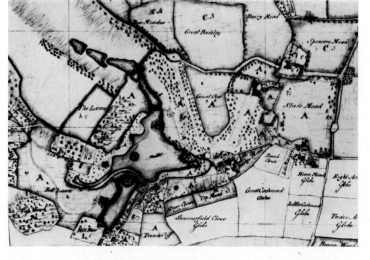

COPLESTONE WARRE BAMPFYLDE (1720–91)

47. The Lake at Stourhead seen from the Cross
*c.*1775
Watercolour, 14¾ × 21½ in.
The National Trust (Stourhead)

On the far shore is the Pantheon designed by Henry Flitcroft and built in 1753–4, and on the hillside at the left the same architect's Temple of Apollo of 1765, derived from an illustration in Robert Wood's *Ruins of Balbec* (1757). Nos.47–8 were engraved by Vivares in 1777.

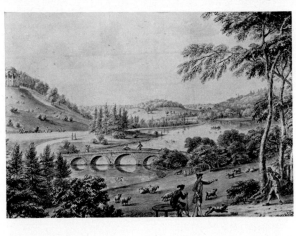

47

COPLESTONE WARRE BAMPFYLDE (1720–91)

48. The Lake at Stourhead seen from near the Grotto *c.*1775
Inscribed 'C W. Bampfylde'
Watercolour, 14¾ × 21½ in.
The National Trust (Stourhead)

Flitcroft's Temple of Flora (formerly Ceres) of *c.*1745 can be seen on the opposite bank. Below it at the water's edge is a rock-work arch which originally housed the figure of a river god. This marked the source of the spring known as Paradise Well. To the right are the Stone Bridge (1762) and the ancient parish church of Stourton. The effect looked for at this point, where the valley in which the village is situated runs down to the lake, is described by Hoare in a letter of 1762: 'The Bridge is now about. It is simple & plain. I took it from Palladios Bridge at Vicenza, 5 arches, & when you stand at the Pantheon the water will be seen thro the Arches & it will look as if the River came thro the Village & that this was the Village Bridge for publick use; the View of the Bridge, Village & Church altogether will be a Charmg Gaspd picture at that end of the water' (Woodbridge, p.53). Beside the church is the 14th.-century Cross which Hoare transported from Bristol and set up at Stourhead in 1765. For one of Hoare's pictures by Gaspard see no.6.

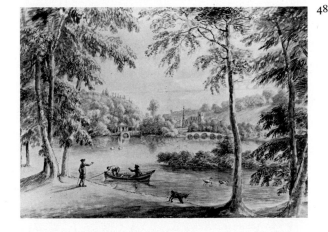

48

FRANCIS NICHOLSON (1753–1844)

49. Interior of the Grotto at Stourhead *c.*1813–14
Watercolour, 16½ × 21¾ in.
The Trustees of the British Museum (1944-10-14-127)

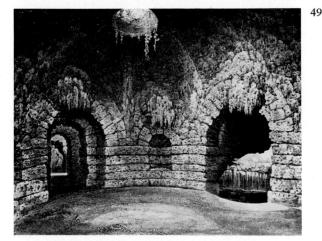

49

FREDRIK MAGNUS PIPER (1746–1824)

50. Section of the Grotto at Stourhead 1779
Pen and wash, 8 1/16 × 11 in.
The Royal Academy of Fine Arts, Stockholm

The Grotto was constructed in 1748 over springs on the opposite side of the lake to the Temple of Flora. Nicholson's drawing shows John Cheere's River God (1751) on the left and the Nymph, probably also by Cheere, on the right. Quotations from Virgil, Ovid and Pope inscribed at various points in the grotto underlined its sacred character as the home of the river god and the nymphs. The ingenious mechanics of the place are well illustrated in the drawings made by the Swedish architect Piper when he visited Stourhead in 1779.

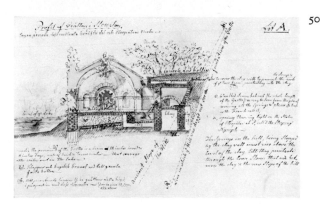

50

THOMAS GAINSBOROUGH (1727–88)

'I'm sick of Portraits', Gainsborough wrote to his musician friend William Jackson, 'and wish very much to take my Viol da Gamba and walk off to some sweet Village when I can paint Landskips and enjoy the fag End of Life in quietness and ease.'[1] Whether or not this really was what Gainsborough wanted, it remained only an ambition. There was not the audience to sustain a full-time landscape painter of his pretension. Fairly early on landscape had anyway become for him a matter of retreating not so much to sweet villages as to the studio, where rural idylls could be worked out on a table with candle-lit models. As he told Lord Hardwicke, 'if his Lordship wishes to have anything tolerable of the name of G, the subject altogether, as well as figures etc. must be of his own Brain'[2]. In the midst of Bath society Gainsborough saw himself 'confined *in Harness* to follow the track, whilst others ride in the waggon, under cover, stretching their Legs in the straw at Ease, and gazing at Green Trees & Blue skies'[3]. As he became increasingly a metropolitan figure, this dream of Arcadian release was no doubt ever more necessary to Gainsborough. The carefully informative Suffolk landscapes gave way to soft-edged pastoral scenes, mysterious but never threatening: as in his thoughts the working countryside receded, everyone could stretch their legs and ride on the wagon.

Lit: Ellis Waterhouse, *Gainsborough*, 1958
 John Hayes, *The Drawings of Thomas Gainsborough*, 1971
 Mary Woodall, *The Letters of Thomas Gainsborough*, 1963

51. **Gainsborough's Forest ('Cornard Wood')**
 1748
 Oil on canvas, 48 × 61 in., repr. on p.40
 Lit: Waterhouse No.828
 The National Gallery (925)

In the last year of his life Gainsborough remembered with fondness his 'first imitations of little Dutch Landskips'[4] and the Dutch origins of his landscape style are indeed apparent in this and the following items. The taste for Ruisdael, Wijnants, Hobbema and others was, however, a novelty in the 1740s and there was as yet almost no market for English 'imitations'. When Boydell paid 75 guineas for 'Gainsborough's Forest' at an auction in 1788 the artist wrote to his friend Henry Bate: 'It may be worth remark that though there is very little idea of composition in the picture, the touch and closeness to nature in the study of the parts and *minutiae* are equal to any of my latter productions. In this explanation I do not wish to seem vain or ridiculous, but do not look on the Landskip as one of my riper performances. It is full forty years since it was first delivered by me to go in search of those who had *taste* to admire it! Within that time it has been in the hands of twenty picture dealers, and I once bought it myself during that interval for *Nineteen Guineas*. Is not that curious?'[5]. After Boydell the painting belonged to David Pike Watts, in whose nephew John Constable it must at last have found someone 'who had *taste* to admire it'.

52. **Landscape after Ruisdael** later 1740s
Chalk, $16\frac{1}{16} \times 16\frac{5}{8}$ in.
Lit: Hayes No.80
*The Whitworth Art Gallery, University of
Manchester*

A copy of Jacob van Ruisdael's painting 'The Forest',
now in the Louvre. Gainsborough's large early painting
known as 'Drinkstone Pond' (Waterhouse No.826) is
more loosely based on the same Ruisdael.

53. **Study of Mallows** later 1750s
Pencil, $7\frac{1}{2} \times 6\frac{1}{8}$ in.
Lit: Hayes No.177
H. Cornish Torbock, Esq.

54. **Peasant with Two Horses** 1755
Inscribed 'TG'
Oil on canvas, $37\frac{1}{4} \times 41\frac{1}{4}$ in.
Lit: Waterhouse No.833
*The Trustees of the Bedford Estates and His Grace
the Duke of Bedford*

One of a pair purchased by the 4th Duke of Bedford
either for Woburn or his London house. They were
paid for in 1755, Gainsborough receiving 15 guineas for
this picture and 21 for the other, 'Woodcutter Courting
a Milkmaid'. The latter was referred to as 'A Landscape
for a Chimney piece'[6] and 'Peasant with Two Horses'
may have been intended for a similar position. Gains-
borough painted other works for chimney pieces about
this time, but such commissions, on a level with
furnishings and decoration, can have offered little scope
for his ambitions in landscape.

55. **Wooded Landscape with Figures and Distant
Mountain** early 1760s
Watercolour and bodycolour, $11 \times 14\frac{3}{4}$ in.
Lit: Hayes No.265
The Visitors of the Ashmolean Museum, Oxford

56. **Wooded Landscape with Herdsman Driving
Cattle Downhill** early 1770s
Chalk, wash and oil, varnished, $8\frac{5}{8} \times 12\frac{7}{16}$ in.
Lit: Hayes No.346
*The City Museum and Art Gallery, Birmingham,
lent by courtesy of Col. P. L. M. Wright*

57. **The Harvest Wagon** c.1767
Oil on canvas, $47\frac{1}{4} \times 57$ in., repr. on p.40
Exh: ? Society of Artists 1767(61)
Lit: Waterhouse No.907
*The Barber Institute of Fine Arts, University of
Birmingham*

The landscapes which he painted during his years at
Bath (1759–74), where he went in search of—and found
—a better living as a portrait painter, show Gains-
borough attempting a grander style which, while still
owing something to Dutch examples, reveals a new
enthusiasm on his part for Rubens. The figure group
here is based on that artist's 'Deposition from the
Cross', of which Gainsborough made a copy, probably
from a version then at Corsham Court near Bath; the
swinging rhythms and feathery foliage are also Ruben-
sian, but the energy, the boisterousness, the vulgarity
even, of Rubens are conspicuously absent. Bath was
scarcely more interested in his landscapes than Suffolk

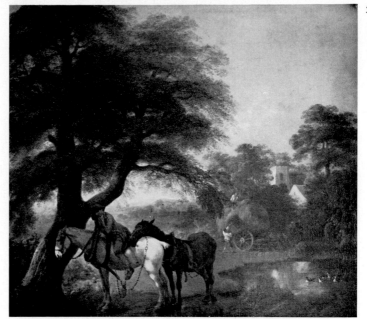

54

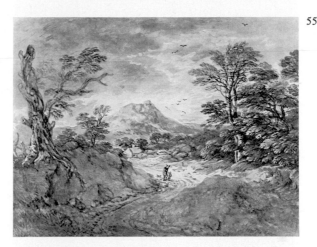

55

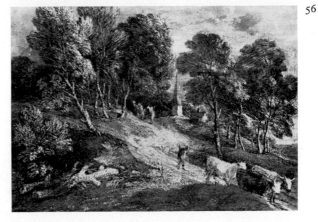

56

51

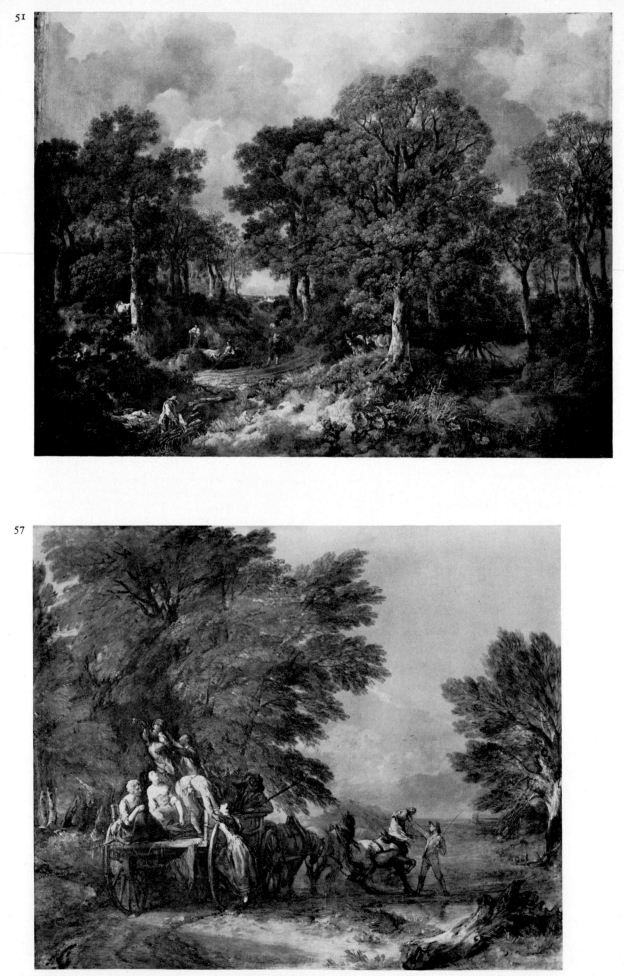

57

had been. Gainsborough 'was so disgusted', wrote Prince Hoare, 'at the blind preference paid to his powers of portraiture, that, for many years of his residence at Bath, he regularly shut up all his landscapes in the back apartments of his house, to which no common visitors were admitted'.[7] Gainsborough disposed of this picture by giving it in 1774 to the Bath carrier, Walter Wiltshire, by whose 'flying waggons' he sent his works to London for exhibition. Wiltshire had refused 50 guineas from Gainsborough for a grey horse he had given him (apparently the one shown in No.57) and the artist presented him with the painting instead.[8]

58. Model of a Horse
Plaster, 7 × 9¾ × 3 in.
R. G. Constable, Esq.

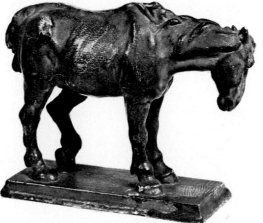

58

Gainsborough worked extensively from models when composing his landscapes. Reynolds described the process in his fourteenth *Discourse* delivered to the Royal Academy shortly after Gainsborough's death: 'from the fields he brought into his painting-room, stumps of trees, weeds, and animals of various kinds; and designed them, not from memory, but immediately from the objects. He even framed a kind of model of landskips, on his table; composed of broken stones, dried herbs, and pieces of looking glass, which he magnified and improved into rocks, trees, and water'.[9] Another account indicates that he worked in this way while at Bath, using such things as cork, coal and broccoli,[10] while his friend William Jackson mentions 'little laymen for human figures' and model horses and cows.[11] Of these aids the model horse seems to have enjoyed quite a reputation after Gainsborough's death. A newspaper of 1788 speaks of 'a cast in the plaster shops from an old horse that he modelled, which has peculiar merit',[12] and one such cast appeared in the sale in 1803 of the stock of the plaster-cast shop run by John Flaxman's father.[13] George Morland had another.[14] The one shown here belonged to John Constable.

59. Rocky Landscape *c.*1783
Oil on canvas, 45¾ × 56½ in., repr. on p.44
Exh: ?R.A.1783(34)
Lit: Waterhouse No.966
The National Gallery of Scotland, Edinburgh

60. The Market Cart 1786–7
Oil on canvas, 72½ × 60¼ in.
Exh: Schomberg House 1786–7
Lit: Waterhouse No.1002
The Tate Gallery (80)

The tradition that Gainsborough moved to London in 1774 because the market for portraits in Bath was declining leaves a good deal unexplained and the real reasons for the move are not very clear.[15] He seems to have had difficulty at first in establishing himself in London, but patronage by the royal family from 1777 onwards made him immensely fashionable as a portraitist and brought him a new independence. He added 'fancy pictures'—rustic figures treated on the scale of portraits—and seascapes to his repertoire, commenced a mythological subject and experimented with new media (see Nos.61–3). Pastorals, culminating in 'The Market Cart', were joined by pictures of wilder, mountain scenery. In 1783 he told his friend Pearce that he

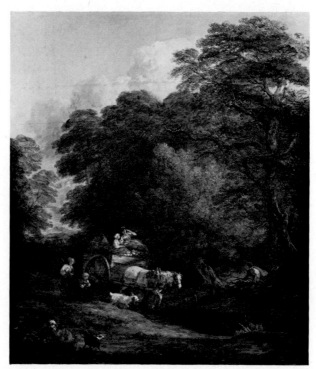

60

planned 'to visit the Lakes in Cumberland & Westmorland; and purpose when I come back to show you that your Grays and Dr. Brownes were tawdry fan-Painters. I purpose to mount all the Lakes at the next Exhibition, in the great stile; and you know if the People don't like them, 'tis only jumping into one of the deepest of them from off a wooded Island, and my reputation will be fixed for ever'.[16] His visit took place in the summer of 1783 but 'the great stile'—the style of Gaspard, Salvator and, perhaps, de Loutherbourg—is already apparent in No.59, thought to have been exhibited earlier that year.

1783 was the last year in which Gainsborough exhibited at the Royal Academy. Before the next exhibition opened he quarrelled with the Academy over the hanging of a portrait, withdrew his works and later that year opened a gallery in his own house, Schomberg House. No.59 remained with him until his death and was bought by Lord Gower for 120 guineas at the Gainsborough sale in 1789. 'The Market Cart' was shown at Schomberg House in December 1786, but Gainsborough continued work on it, adding the man with faggots in January 1787. Sir Peter Burrell bought it from him for 350 guineas in May 1787; the companion picture, 'A peasant smoking at his cottage door' (Waterhouse No.1011) remained unsold for several years after the artist's death.

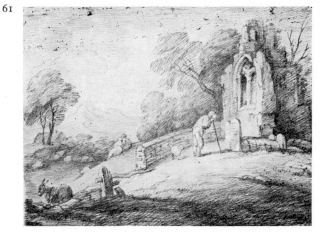

61. A Wooded Landscape with a Peasant reading a Tombstone *c.*1780
Soft-ground etching, $11\frac{11}{16} \times 15\frac{1}{2}$ in.
Lit: John Hayes, *Gainsborough as Printmaker*, 1971, No.10
The Tate Gallery (2717)

Always interested in the possibilities offered by new techniques, Gainsborough seems to have been especially fascinated by the idea of imitating one medium in another. At the Royal Academy in 1772 he exhibited ten 'landscapes, drawings, in imitation of oil painting' and he took readily to two new print-making methods which imitate chalk and wash respectively: soft-ground etching and aquatint. Both are first known to have been used in this country in 1771. Gainsborough adopted them sometime in the 1770s and produced 19 prints in one or other medium or a combination of the two.

This soft-ground etching is related in subject, but not in composition, to a painting exhibited by Gainsborough at the Royal Academy in 1780. Only two fragments of that work are known today (Waterhouse Nos.942 and 1000a) but the whole composition is recorded in an aquatint by M. C. Prestal published in 1780. Although the opening lines of Gray's 'Elegy' appear beneath Prestal's print, Professor Waterhouse rejects the idea that the painting was intended to evoke the poem. William Jackson said that Gainsborough 'scarcely ever read a book', yet we know from a letter of 1783 (see under No.60) that he had some knowledge of Gray. The man leaning on a stick in the soft-ground etching may even echo the figure in Bentley's illustration to the 'Elegy' (see No.155), etched by Grignion about the time he assisted Gainsborough with one of his own early etchings, 'The Suffolk Plough'.

62. Gainsborough's Showbox *c.*1783
The Victoria and Albert Museum

63. **A Cottage in the Moonlight** *c.*1783
Oil painting on glass, 11 × 13¼ in.
Lit: Waterhouse No.971
The Victoria and Albert Museum

'The machine consists of a number of glass panes, which are moveable, and were painted by himself, of various subjects, chiefly landscapes. They are lighted by candles at the back, and are viewed through a magnifying lens, by which means the effect produced is truly captivating, especially in the moon-light pieces, which exhibit the most perfect resemblance of nature.'
EDWARD EDWARDS, *Anecdotes of Painters*, 1808, p.141

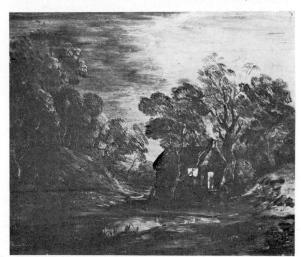

63

Gainsborough's 'acquaintance with De Loutherbourg, the celebrated scene-painter,' wrote W. H. Pyne, 'first led him to these amusing experiments'.[17] In particular, Gainsborough was an enthusiastic spectator of de Loutherbourg's 'Eidophusikon', a miniature theatre which opened in London in 1781, in which illusionistic effects were created with moving scenery, lights and sounds. Pyne, who enjoyed 'a constant admittance behind the curtain', said that for a time Gainsborough 'thought of nothing else—he talked of nothing else—and passed his evenings at that exhibition in long succession. Gainsborough, himself a great experimentalist, could not fail to admire scenes wrought to such perfection by the aid of so many collateral inventions'.[18] Edward Edwards, however, attributed the immediate inspiration of the showbox to Thomas Jarvis' (or Jervais') exhibition of stained glass in Cockspur Street in 1776, which seems to have included panes with moonlight and firelight effects.

64. **Landscape** later 1780s
Wash, 9½ × 14¹¹⁄₁₆ in.
Lit: Hayes No.809
*Staatliche Museen Preussischer Kulturbesitz
Kupferstichkabinett, Berlin (West)*

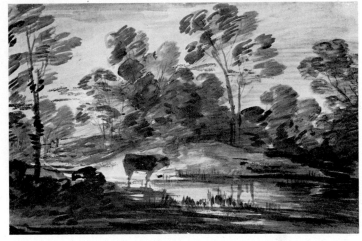

64

PAUL SANDBY (1730–1809)

Lit: A. P. Oppé, *The Drawings of Paul and Thomas Sandby in the Collection of His Majesty the King at Windsor Castle*, 1947.

65. **Distant View of Leith** 1747
Inscribed 'Lieth NB. P.S.1747'
Watercolour and pencil, 6¾ × 17¹³⁄₁₆ in., repr. on p.46
The Visitors of the Ashmolean Museum, Oxford

Although by no means the only person active in the field (see Nos.75–7 for two others), Paul Sandby was the first English artist to establish a respectable and varied body of work in watercolour and it was largely through him that the medium acquired some sort of status in relation to oil painting. With his brother Thomas he played an important role in the attempts during the 1750s and '60s to form an exhibiting society for artists and was a founder member of the Royal Academy (which appointed Thomas its first Professor of Architecture). A versatile figure, whose work ranged from military map-making to historical landscape painting in oil (see under

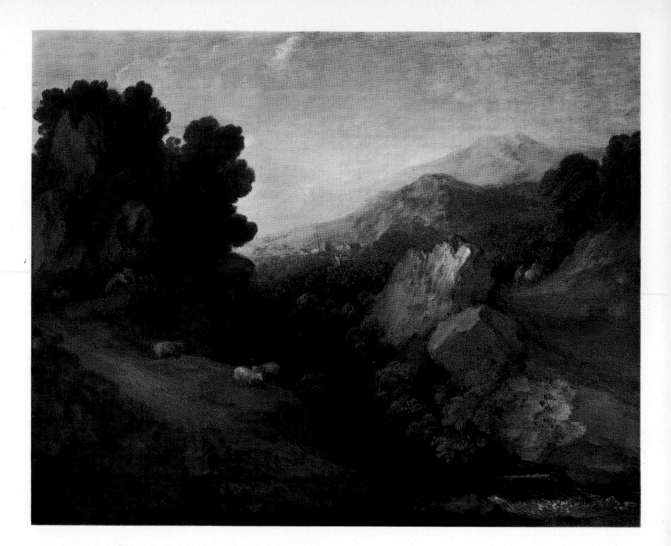

59. Thomas Gainsborough
Rocky Landscape *c.*1783

[44]

No.94), Sandby nevertheless had to depend on teaching for a living and finally on a pension from the Academy. In 1806 he told his friend James Gandon: 'like a fox, I have many shifts, but none will make me independent, so that I must drive on until death drops me in a hole.'[1]

No.65 was made during his period of service as draughtsman to the Military Survey of Scotland, 1746–c.1751. His brother had already worked in Scotland in a similar capacity, recording the Duke of Cumberland's campaigns. This atmospheric drawing suggests, however, that even from an early date Sandby was interested in more than simple topography.

?PAUL SANDBY after THOMAS SANDBY (1723–98)

66. **Virginia Water: The Cascade and Grotto**
c.1754
Etching with wash additions, $12\frac{1}{4} \times 22$ in.
Lit: Oppé, under No.115
Her Majesty Queen Elizabeth II

When he returned from Scotland in 1746 William, Duke of Cumberland, was appointed Ranger of Windsor Forest and either then or soon afterwards made Thomas Sandby his unofficial deputy. As such Thomas was involved in the major landscaping schemes carried out at Windsor, including the creation of Virginia Water. He continued as deputy to the Duke's successors. In December 1754 Paul Sandby issued a prospectus for a series of eight prints after drawings by his brother, himself and others of the works at Virginia Water. No.66 is a touched proof of an unpublished plate connected with the series.

67. **The North Front of Windsor Castle from Datchet Lane near Romney Lock** 1768
Inscribed 'P Sandby 1768'
Gouache, $18\frac{3}{4} \times 28\frac{5}{8}$ in.
Exh: ?Society of Artists 1768 (145, 'View of Windsor on a Rejoicing Night')
Lit: A. P. Oppé, *English Drawings. . . . in the Collection of His Majesty the King at Windsor Castle*, 1950, no. S.430
Her Majesty Queen Elizabeth II

68. **View of the Seat near the Terrace and a View of the Adjacent Country**
Pencil, watercolour and bodycolour, $10\frac{7}{8} \times 22\frac{1}{2}$ in.
Lit: Oppé No.51, repr. on p.46
Her Majesty Queen Elizabeth II

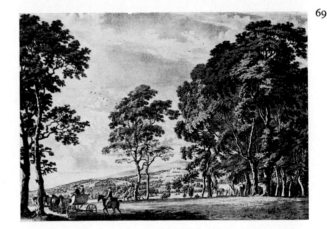

Paul Sandby frequently stayed with his brother at Windsor and he exhibited drawings of the castle at the Society of Artists and the Royal Academy between 1763 and 1775. But none of his Windsor work entered the royal collection until the Prince Regent began collecting it, probably in 1799. The best of such work, including No.68, was bought from Sandby by the great naturalist Sir Joseph Banks, who amassed about seventy drawings.

69. **'Chirk Castle &c from Wynnstay Park'** 1776
Aquatint, $8 \times 11\frac{3}{8}$ in.
The Trustees of the British Museum (1904–8–19–651)

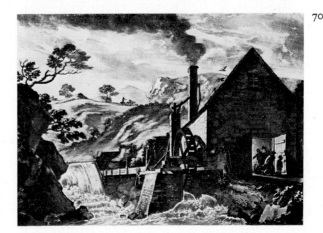

65

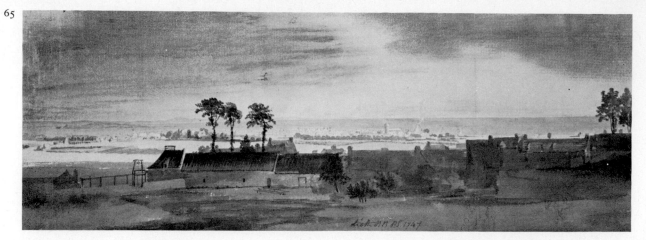

68

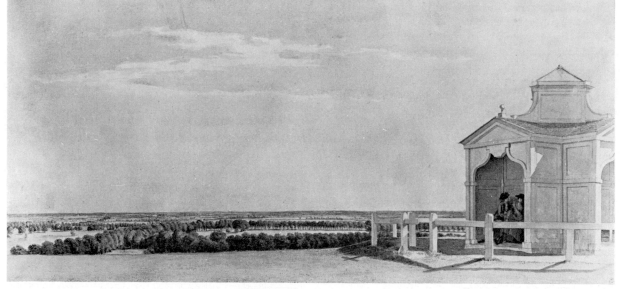

70. **'The Iron Forge between Dolgelli and Bar-mouth in Merioneth Shire'** 1776
Aquatint, $8\frac{1}{2} \times 11\frac{3}{4}$ in.
The Trustees of the British Museum (1904–8–19–654)

Plates 3 and 6 respectively of Paul Sandby's *XII Views in North Wales being part of a Tour through that Fertile and Romantick Country under the Patronage of the Honorable Sir Watkin Williams Wynn Bart.*, published in 1776. The tour referred to took place in 1771 and was one of the earliest of its kind in North Wales. It was an elaborate affair involving '5 Gentlemen 9 servants and 13 horses'.[2] Sandby was the first English artist of any consequence (the very first being P. P. Burdett in 1771) to use the aquatint process. His first series of prints in that medium, *Twelve Views in Aquatinta, from Drawings taken on the Spot in South Wales*, appeared in 1775 with a dedication to Joseph Banks and the Hon. Charles Greville.

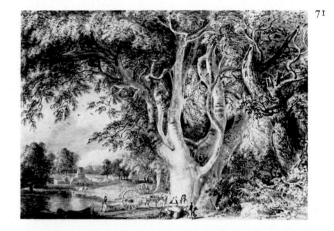

71. **View in the Forest** 1796
Inscribed 'P.S. R A Winsor Forest' and 'P. Sandby, 1796'
Watercolour, gouache, gum and soot, $15\frac{3}{4} \times 22\frac{1}{2}$ in.
Lit: Oppé No.97
Her Majesty Queen Elizabeth II

72. **The Rainbow**
Gouache, $21\frac{3}{4} \times 30$ in.
Nottingham Castle Museum

Sandby worked in gouache as well as watercolour throughout almost the whole of his career, using the thicker medium especially for his exhibition set-pieces —landscape compositions of the kind seen in Nos.71–2. Despite the inscription on 'View in the Forest', topography is clearly not the aim of either of these late works. In No.71 Sandby revels in the fantastic shapes of forest trees, creating, as Paul Oppé put it, the perfect 'background for a goblin adventure in a pantomime'. No.72 is a Rubensian rainbow landscape, no doubt modelled on the picture now in the Wallace Collection which the dealer Buchanan imported in 1802.

Brigadier-General ROBERT LAWSON (died 1816)

73. **Garrison Gun Carriages for Sea Lines and Barbet Batteries with Platforms and Stands for Firing over the Parapets of Fortifications** *c.*1790
The Royal Artillery Institution, Woolwich

Paul Sandby was chief drawing master at the Royal Military Academy, Woolwich, from 1768 to 1796, receiving £100 a year for one day's teaching a week. His influence is seen in operational reports, artillery manuals and other illustrated military documents of the period, including this manuscript treatise by Lawson. Lawson's proposals were tried out at Woolwich in 1790.

74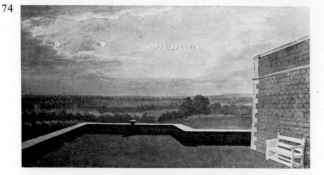

74. **The Meteor of 18 August 1783, seen from the Terrace at Windsor Castle** 1783
Inscribed 'Windsor Terrace'
Watercolour, $11\frac{1}{4}$ × 18 in.
The Trustees of the British Museum (1904-8-19-34)
On the following page of the album from which this watercolour is taken there is a complementary design showing the same scene without the sky or landscape, but with a group of figures watching from the terrace. A drawing in the Royal Collection (Oppé No.53) combines both elements of the design and the whole scene appears again in an aquatint dedicated to Joseph Banks which Paul Sandby published in 1783. This print attributes the drawing from which it was taken to Thomas Sandby. Oppé believed the Windsor drawings to be by Thomas and the two British Museum designs to be by Paul. Thomas Sandby viewed the meteor in the company of Tiberius Cavallo, Dr James Lind, Dr Lockman and others. Cavallo published an account of the phenomenon in the Royal Society's *Philosophical Transactions* in the following year.

75

WILLIAM TAVERNER (1703–72)

75. **Sandpits, Woolwich**
Gouache, $14\frac{1}{4}$ × $27\frac{5}{8}$ in.
The Trustees of the British Museum (1890-5-12-140)
By profession a lawyer, Taverner appears to have devoted as much time to painting, acquiring quite a reputation for his landscapes. In 1743 Vertue said he had 'an extraordinary Genius in drawing and painting Landskips. equal if not superior in some degree to any painter in England'.[3] Very little of his work survives and even less is dated, but he seems to have been one of the first English artists to work at all generally in pure watercolour and also one of the earliest to use gouache. Martin Hardie believed No.75, which at one time was in Paul Sandby's collection, was probably an early work, being on three pieces of paper joined together[4] (i.e. towards the end of Taverner's life single sheets of sufficient size would have been available) but Taverner's 'Leg of Mutton Pond, Hampstead Heath', dated 1770 (Victoria and Albert Museum), is also on three joined sheets, and No.75 could be equally late.

76

JONATHAN SKELTON (c.1735–59)

76. **A Part of Blackheath** 1757
Inscribed on the back of the mount 'A Part of Blackheath. J. Skelton. 1757'
Watercolour, gouache and pencil, $9\frac{5}{8}$ × $21\frac{1}{4}$ in.
Denys Oppé, Esq.

77

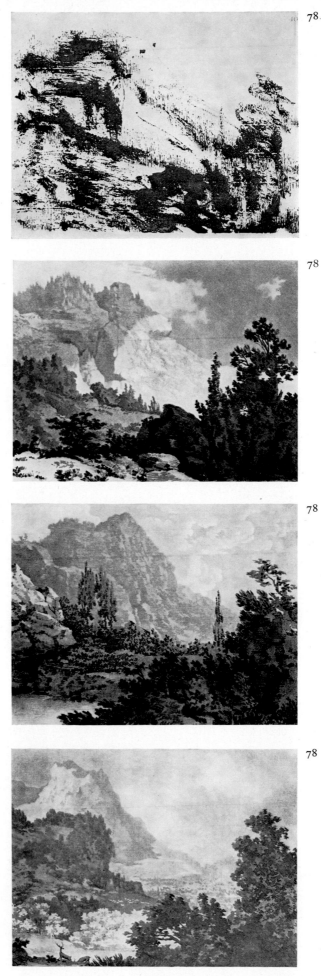

77. **Greenwich Park** 1757
Inscribed on verso 'The Parts of this Drawing are
in Greenwich Park But Grouped together at fancy.
J. Skelton 1757'
Watercolour, $9\frac{3}{4} \times 21\frac{3}{8}$ in.
Denys Oppé, Esq.

Skelton's surviving works date from a period of only
four years, from 1754 to 1758. He went to Italy in 1757
and died there in January 1759. Like Sandby and
Taverner, he is known to have painted also in oils but
nothing by him in this medium has been found.

ALEXANDER COZENS (*c*.1717–86)

Lit: A. P. Oppé, *Alexander & John Robert Cozens*, 1954

WILLIAM PETHER (?1738–1821) after ALEXANDER
COZENS

78. Plates 40–3 from **A New Method of Assisting
the Invention in Drawing Original
Compositions of Landscape** 1785
Aquatint or mezzotint or both, $9\frac{1}{4} \times 12\frac{1}{4}$ in.
(Plate 40), $9\frac{1}{2} \times 12\frac{1}{2}$ in. (Plates 41–3)
Denys Oppé, Esq.

Cozens was drawing master at Christ's Hospital from
1749 to 1754 and at Eton College (where his pupils in-
cluded Sir George Beaumont) from *c*.1763 until at
least 1774. In addition he had private pupils, among
them, in the later 1770s, William Beckford and the
Princes William and Edward. But he did not teach in
the conventional manner, in the way that, for example,
Paul Sandby is presumed to have taught, by setting a
pupil to painstakingly imitate his own work. As the full
title of the *New Method* indicates, Cozens was con-
cerned to encourage originality: 'it cannot be doubted,
that too much time is spent in copying the works of
others, which tends to weaken the powers of invention;
and I scruple not to affirm, that too much time may be
employed in copying the landscapes of nature herself'.[1]
Study of this kind was indispensable, but he proposed
that the student should temporarily suppress the know-
ledge thus acquired and with ink and brush make rapid,
semi-random 'blots', whose novel and suggestive con-
figurations could then be traced on to other sheets and
elaborated. Plates 40–3 in his treatise illustrate three
different landscapes derived from one blot. Cozens him-
self proffered a collection of landscape types from
which the blotter could proceed. In the *New Method* he
described 16 sorts: 'The tops of hills or mountains, the
horizon below the bottom of the view'; 'A close or con-
fined scene, with little or no sky', etc., and the examples
of blots reproduced in his book correspond with these
types. To help him work up his blots into finished land-
scapes Cozens also illustrated 20 types of sky which the
student could adapt to his designs. In earlier works he
had displayed *The Various Species of Composition in
Nature* and, in 1771, *The Shape, Skeleton and Foliage,
of Thirty two Species, of Trees*. Cozens was, Beckford
said in 1781, 'almost as full of Systems as the Universe'.[2]
Nos.79–81 are relics of other, unpublished systems.

79

80

81

82

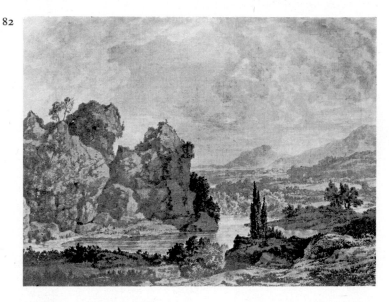

83

79. **Study of Sky No.1**
Inscribed '6'
Wash on varnished paper, 8⅝ × 12⅛ in.
Lit: Oppé pp.98–100
Denys Oppé, Esq.

80. **'Spring'**
Inscribed 'Spring' and '6'
Pen and ink on varnished paper, 8½ × 12¼ in.
Lit: as No.79
Denys Oppé, Esq.

Nos.79–80 are from a series of connecting skies and grounds, drawn on paper which had been varnished to allow for tracing.

81. **Notes for 'Principles of Landskip'**
Pencil, 4 sheets, each 7¼ × 4 in.
Lit: Oppé pp.72–4
The Trustees of the British Museum (1888–1–16–9–2. . .5)

Four of five sheets containing in all 112 miniature sketches and two larger ones. The leaves shown here comprise 'Historical Landskips' and 'Circumstances of Landskip', the latter divided into '4 Accidents 4 Seasons 8 Characters'.

82. **Classical Landscape**
Wash on varnished paper, 17½ × 22 in.
Denys Oppé, Esq.

83. **High Tor, Matlock** 1756
Inscribed 'A Cozens 1756'
Oil on canvas, 28 × 36 in.
H. G. Balfour, Esq.

Of works by Cozens now known only by their titles a number are thought to have been oil paintings, including two views near Rome, an historical landscape and a piece of panoramic topography, 'The South View of the City of London extending from Chelsea to Limehouse taken from Dulwich Hill', all of which appeared at exhibitions in the 1760s. 'High Tor, Matlock', a companion picture (also in the Balfour collection) and four small works in the Oppé collection (see Nos.84–5) are, however, the only oils by him known today. Benedict Nicolson suggests that No.83 may possibly have been at Kedleston when Joseph Wright was painting portraits there around 1765.[3] Wright's earliest surviving Derbyshire landscape of the period after his return from Italy shows the same view as No.83.

84. **Close of Day**
Oil on paper, 6⅛ × 7¼ in.
Denys Oppé, Esq.

85. **Wooded Coast Scene**
Oil on paper, 6¼ × 8⅜ in.
Lit: Oppé pp.83–4
Denys Oppé, Esq.

Two of a set of four imaginary landscapes. Oppé thought they might owe something to works by Donati Credi which Cozens could have seen in Rome.

84

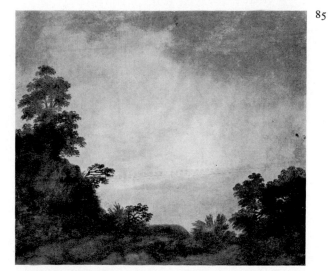

85

86

87

89

90

86. **View in North Wales**
Inscribed 'Alexr.Cozens' on the mount
Pencil and wash, $4\frac{1}{4} \times 8\frac{7}{8}$ in.
Lit: Oppé p.38
Denys Oppé, Esq.

Cozens exhibited a 'View in North Wales, taken from Wynstay, the seat of Sir Watkin Williams Wynn' at the Royal Academy in 1781. The painting was probably based on this early drawing of the view, which is squared for enlargement.

JOHN MALCHAIR (1729–1812)

87. **Shotover Hill, Oxford** 1765
Inscribed '1765'
Pencil and wash, $7\frac{3}{4} \times 10$ in.
The Visitors of the Ashmolean Museum, Oxford

88. **'Observations On Landskipp Drawing with many and various Examples Intended for the use of beginners'** 1791
Private Collection

Malchair was born in Cologne and trained there as a singer. He came to London in 1754, played as an orchestral violinist and taught music and drawing. In 1759 he was appointed leader of the Oxford Music Room orchestra, a post he held until 1792, and to supplement his income he taught drawing to undergraduates. Like Cozens he was an unconventional drawing master but in a different way: the aim of Malchair's teaching was to get his pupils drawing from nature. The 'Observations' which he wrote in 1791, but never published, describe the preliminary instruction which they received indoors. The pupil was shown the various sorts of touch he could obtain with a pencil, the use of smudging and rubbing to create tone and how to use these touches and techniques to copy progressively complicated lessons set by the master. Malchair led his pupils gently through the early stages, adapting his own example to their level of ability: the teacher's style, he wrote, 'must gradualy improve as the pupil advances; he must even seeme to learne the arte rather than to teach it'. The basic instruction over, 'The scholar then must draw from Nature, which will soone convince him that the paines he has hitherto taken within doores were not bestowed in vain, but he will bee surprised to finde, that all he has as yet done, was only acquiring the alphabet of a Languich, and By carefully loocking at nature, he will readly account for every touch he has learned'. As the student progressed, so an aesthetic was instilled: 'Landskipp drawing has for its employment a Great Variety of objects, for ever differing in thire form and apearance, but as all thiese Variations are not equaly elegant. . . . Some Sense and much taste is required to make a judicious choice for the Picture'.

Among Malchair's pupils were the Earl of Aylesford (see Nos.142–3) and Sir George Beaumont (see Nos. 144–6). Through another, William Crotch, Constable may have become acquainted with Malchair's methods and with his habit, from the late 1760s, of noting times of day and meteorological details on his drawings.

FRANCIS WHEATLEY (1747–1801)

89. **The Harvest Wagon** 1774
Inscribed 'F.Wheatley 1774'
Oil on canvas, 50½ × 40 in.
Nottingham Castle Museum
Based on Gainsborough's 'Harvest Wagon' of *c*.1767
(No.57). In a very chequered career Wheatley turned
his hand to most kinds of painting, from history and
portraiture to fancy pictures and rustic genre, but he
does not appear to have attempted landscape on this
scale again. He did, however, produce a number of
landscape watercolours of a more straightforward kind
and these were often intended for engraving.

90. **Lake Scene with Ferry** 1788
Inscribed 'F W.1788'
Watercolour, 12⅛ × 18¾ in.
Leeds City Art Galleries

91

ALEXANDER RUNCIMAN (1736–85)

91. **Landscape from Milton's 'L'Allegro'** 1773
Inscribed 'AR' and on verso 'ARunciman p. 1773'
Oil on canvas, 25 × 30 in.
Sir Steven Runciman

?JOHN CLERK of ELDIN (1728–1812) after
ALEXANDER RUNCIMAN
92. **Landscape from Milton's 'L'Allegro'**
Etching, 3 ¹³⁄₁₆ × 4½ in.
The National Gallery of Scotland, Edinburgh
The passage illustrated, and identified by the etched in-
scription on No.92, is the celebrated one beginning
'Straight mine eye hath caught new pleasures, Whilst
the landskip round it measures'. Corydon and Thyrsis
are served their dinner by 'neat-handed Phillis': beyond
them, Milton's landscape of meadows, mountains,
towers, brooks and rivers. No.91 is known in the family
as 'View near Perth' and the distant bridge and church
are, it has been said, recognisable as those of that city.
Other landscapes by Runciman of the Tay Valley are in
Sir Steven's collection. In addition to Milton and Scot-
land, the picture clearly calls to mind Rubens. Runci-
man's devotion to landscape is the subject of a quotation
from Allan Cunningham inscribed on the back of the
stretcher: 'Other men talked meat & drink, but Runci-
man talked Landscape'.

92

JOHN HAMILTON MORTIMER (1740–79)

93. **Beaching a Fishing Boat in a Gale** 1770s
Pen and ink, 7⅞ × 11 in.
Mr Cyril Fry and Mrs Shirley Fry
Mortimer, seen by some of his contemporaries as the
English Salvator Rosa, developed the genre of 'banditti'
or brigand subjects which Wilson had introduced in

93

95. Thomas Jones
Pencerrig 1772

such works as 'The Murder' (No.30). His few landscape drawings are also consciously Rosa-esque—the blasted tree in this example epitomizes the 'savage' quality the English admired in Salvator's work.

THOMAS JONES (1742–1803)

94. **The Bard** 1774
Inscribed 'THO.JONES P MDCCLXXIV'
Oil on canvas, 45½ × 66 in.
Exh: Society of Artists 1774(123)
The National Museum of Wales, Cardiff

94

Thomas Gray's 'The Bard. A Pindaric Ode', first published in 1757, was founded, the poet said, 'on a Tradition current in Wales, that EDWARD THE FIRST, when he completed the Conquest of that country, ordered all the Bards, that fell into his hands, to be put to death.' Gray's heroic Bard, who prophesises the destruction of Edward and his line before plunging to his own death from the mountain top, captured the imagination of many artists, including Blake, de Loutherbourg, Fuseli and Martin. Paul Sandby's 'An Historical Landskip, representing the Welch bard, in the opening of Mr. Gray's celebrated ode', exhibited at the Society of Artists in 1761, appears to have been the first painting on the theme but is now lost.

Thomas Jones, a pupil of Wilson from 1763 to 1765, looks back to his master's 'Niobe' as well as to Salvator Rosa in this work. The two oil sketches, Nos.95–6 below, show the more personal idiom upon which his modern reputation rests. Although Wilson may have painted directly from nature (see No.38), there is no precedent in his surviving work for this kind of sketch. Pencerrig in Radnorshire is the family seat to which Jones retired as squire after his eldest brother's death in 1787.

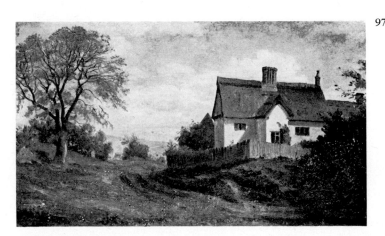

96

95. **Pencerrig** 1772
Inscribed on verso 'penkerrig 1772'
Oil on paper, 9 × 12 in.
The City Museum and Art Gallery, Birmingham

96. **View of Carnedde Mountain from Pencerrig**
1790s
Oil on paper, 11½ × 19½ in.
Mrs J. Evan-Thomas

97

GEORGE GARRARD (1760–1826)

97. **The Cottage**
Oil on paper, 8¼ × 14½ in.
Denys Oppé, Esq.

98. **Mr. Taylor's Barn at Marlow**
Oil on paper, 7¾ × 9¼ in.
Denys Oppé, Esq.

Garrard was primarily an animal painter and sculptor, but a number of small landscape studies (and a few

98

100
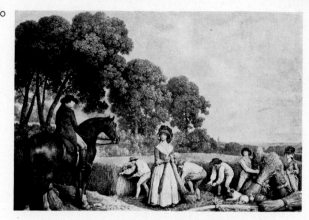

101
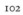

103

102
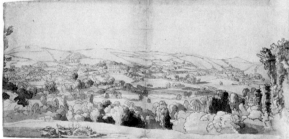

104
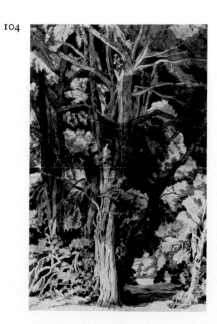

105

larger efforts) by him survive, some datable to the 1790s. Often these have no direct connection with his animal portraiture, but No.98, as an inscription on the old mount records, is 'the original study for the background of the picture of Taylors Fat Cow.'

GEORGE STUBBS (1724–1806)

99. **Newmarket Heath, with the Rubbing-Down House** *c.*1764–5
 Oil on canvas, 12 × 16¼ in.
 Lit: Basil Taylor, *Stubbs*, 1971, pl.34 and note
 Private Collection

Landscape plays an important rôle in all Stubbs' outdoor subjects but only two 'pure' landscape studies by him survive, this and a similar painting in the collection of Mr and Mrs Paul Mellon. Stubbs used No.99 for the background of 'Gimcrack on Newmarket Heath' in 1765 and 'Hambletonian being rubbed down' in 1799.

100. **The Reapers** 1791
 Mezzotint, 20⅝ × 27⅝ in.
 Lit: Basil Taylor, *The Prints of George Stubbs*, 1969, No.16
 The Trustees of the British Museum (1865-1-14-906)

Based on an oil painting of 1784, which is one of three treatments by Stubbs of the subject. This print and its companion 'Hay-Makers' were advertised in 1788 at £2.10s. the pair to subscribers, but not published until 1791. Like all Stubbs' prints they seem to have had a very limited market: as Basil Taylor says, 'The figures do not drop an eye or a tear or raise a petticoat in the direction of any city-bred amateur of country simplicities and coyness'.

FRANCIS TOWNE (1739 or 1740–1816)

101. **Haldon Hall, near Exeter** 1780
 Inscribed 'F Towne 1780'
 Oil on canvas, 31½ × 49½ in.
 The Tate Gallery (T.1155)

102. **Study for No.101**
 Pen and wash, 8 × 16 in.
 James Holloway, Esq.

103. **The Salmon Leap, from Pont Aberglaslyn** 1777
 Inscribed 'No.23.F.Towne delt 1777' and on verso: 'a view of the Salmon Leap from Pont Aberglasllyn. Drawn on the Spot by Francis Towne 1777, Leicester Sqre., London. Morning Light from the Right Hand.'
 Pen and watercolour, 11 × 8¼ in.
 Exh: ?Towne's exhibition, 20 Lower Brook Street 1805(30)
 Miss Scott-Elliott, C.V.O.

104. **The Avenue** *c.*1800
 Pen and watercolour, 15 × 9 in.
 Sir William Worsley, Bt.

Towne spent much of his life in Exeter, where he lived by teaching drawing and executing commissions for pictures of country houses (e.g. No.101) and the like. In 1796 or 1797 he was reported to be making £500 a year in this way[1] and in 1810 to have saved £10,000 by extreme economy.[2] Although he exhibited oil paintings at the Society of Artists and the Royal Academy over a long period, his reputation remained distinctly local. He failed eight times to be elected an A.R.A. and complained bitterly of being thought a 'provincial drawing master'.[3] Towne seems to have staked his reputation on his oil paintings, claiming in 1803 'I never in my life exhibited a *Drawing*',[4] but he made an exception in 1805 when he put a collection of 191 watercolours on show in London. They appear to have made little impact, however—that the exhibition took place is only known because W. T. Whitley discovered a catalogue for it in the 1920s. Very few of what are today regarded as Towne's best works, the watercolours made in Italy and Switzerland on his one journey abroad in 1780–1, ever left his hands, and the same is true of the two British examples shown here.

Despite his extensive teaching practice, the work of few of Towne's pupils is known. Of these only the Exeter surgeon John White Abbott has much claim to notice.

JOHN WHITE ABBOTT (1763–1851)

105. **Study of Undergrowth at Chudleigh, Devon** 1798
 Inscribed 'Chudleigh Sepr. 21. 1798 –'
 Pencil and wash, 5¾ × 8¼ in.
 C. L. Loyd, Esq.

Antiquities, Travel and the Picturesque

During the period covered by this exhibition a sizable and complicated literature of landscape developed which both grew out of specific needs and helped to shape subsequent responses to these. At one end of the scale, antiquarianism satisfied an interest in historical events and personages, centring on battlefields, monuments, buildings and the like: when it came in at all, the natural setting was of minimal importance. Out of this close but narrow enthusiasm grew that wider-ranging, and at best enormously impressive, genre, the local history, with its sense of cultural and economic wholes: an attempt to integrate a mass of diverse material into the image of a parish or county. Running alongside, and often interacting with, these developments was the literature of tourism, expanding rapidly from the late 1770s as Wales and the Lake District were opened up. In all this, the Picturesque movement has a special and rather freakish place. Picturesque theory was not simply, as its protagonists claimed, the attempt to introduce a new aesthetic category to fill the gap between the Sublime and the Beautiful, but the building into experience of the countryside of a comfortable myth, imposing upon the more troublesome aspects of that experience a set of rules which quickly bred its own scholasticism. The Picturesque tourists trained themselves to see the world about them not only *via* pictorial models but, with wilful editing, actually as pictures: the gypsy could then be an interesting piece of local colour rather than a peripatetic threat to the *status quo*, the decaying cottage and the neglected wood textural variations of an 'abstract' theme: for all the praise of 'roughness' as against 'smoothness', edges were blurred, centres softened. It was a holding operation, by and for the squirearchy which had lost ground and continued to lose ground in the dynamic of country life. Landscape architects, in the main for patrons higher up the social scale, were engaged in a more substantial effort of a not dissimilar kind. The rural scene (or as much of it as was visible from the country house) was sometimes drastically done over in the cause of heartsease.

FRANCIS GROSE (?1731–91)
106. **Lanercost Priory** 1774
Inscribed 'Lanecost Abby Cumberland'
Pen and watercolour, $7\frac{1}{2} \times 14\frac{7}{8}$ in.
Dudley Snelgrove, Esq.

107. **Lanercost Priory**
Watercolour, $4\frac{1}{4} \times 6\frac{1}{4}$ in.
The Society of Antiquaries of London

108. **The Antiquities of England and Wales,** vol.I
Dudley Snelgrove, Esq.
Grose's *Antiquities* appeared in parts between 1773 and 1787 and in various collected editions. Scotland was treated in further volumes in 1789–91. Grose used a number of drawings by other artists but supplied the majority of the illustrations himself. No.107 is the

[58]

reduction he made for the engraver, Sparrow, from his original drawing, No.106. According to the published text the latter was made in 1774.

THOMAS HEARNE (1744–1817) and WILLIAM BYRNE (1743–1805)
109. **Antiquities of Great Britain,** Vol.I, 1807
The Trustees of the British Museum
The plates were issued from 1778 onwards and collected in two volumes in 1807. Hearne supplied 52 of the 84 illustrations and Byrne was the principal engraver. Farington records some of the business arrangements: 'Byrne called to-day.—He pays Hearne 10 guineas each for the drawings. . . . and He becomes the sole proprietor of the 2nd volume. He sells the drawings for 8 guineas.' Byrne also said 'that He & Hearne, joint proprietors of the first volume. . . . had sold the work to Cadell & Davis, and that He had also sold the eight numbers finished of a second volume of Antiquities, in which Hearne had no share. Cadell & Davis gave £1600 for the whole work. . . .'[1]. Clearly the project was, or was thought to be, a very profitable one. With a text in French as well as English, a foreign market was obviously also expected.

THOMAS WEST (1720–79)
110. **A Guide to the Lakes, in Cumberland, Westmorland, and Lancashire,** 2nd edition 1780
The Trustees of the British Museum
The most popular guide to the Lakes, West's book was first published in 1778 and had run through ten editions by 1812. West listed specific 'stations' from which the lakes were to be viewed and described what was to be seen from each. The 'stations' were often marked on the ground as well, by crosses cut in the turf or by shelters of various kinds.[2] The second and later editions contained as a substantial appendix Thomas Gray's journal of his Lake District tour of 1769.

THOMAS PENNANT (1726–98)
111. **A Tour in Wales, 1770,** 1778
The Trustees of the British Museum
Illustrated by Moses Griffith (1747–1819), a self-taught Welsh artist who produced about two thousand topographical drawings for Pennant and his son.

HENRY PENRUDDOCKE WYNDHAM (1736–1819)
112. **A Tour through Monmouthshire and Wales,** 2nd edition 1781
The Trustees of the British Museum
Illustrated by S. H. Grimm (see No.119)

WILLIAM GILPIN (1724–1804)
113. **Observations on the River Wye, and several parts of South Wales, &c. relative chiefly to Picturesque Beauty; made in the Summer of the Year 1770,** 1782
The National Library of Wales, Aberystwyth
This copy is extra-illustrated with 34 of Gilpin's pen and wash drawings, extracted by himself from one of his manuscripts of the Wye tour. Gilpin's accounts of his various Picturesque tours circulated widely in manuscript during the 1770s before he was persuaded to begin publishing them. The Wye tour was the first to

106

appear. Although dated 1782 on the title-page, difficulties with the engraving of the plates delayed publication until 1783. The first edition of 700 copies sold very well, but many mistook the purpose of the illustrations. 'As a drawer of existing scenes you are held as the greatest of *infidels*', William Mason told Gilpin, 'If a Voyager down the river Wye takes out your Book, his very Boatman crys out, "nay Sr you may look in vain there. no body can find one Picture in it the least like." '³ Gilpin replied: 'I did all I could to make people believe they were *general ideas*, or *illustrations*, or any thing, but, what they would have them to be, exact portraits; which I had neither time to make, nor opportunity, nor perhaps ability; for I am so attached to my picturesque rules, that if nature gets wrong, I cannot help putting her right.'⁴ Gilpin's wilfulness comes across clearly in his account of Tintern Abbey:

> 'it does not make that appearance as a *distant* object which we expected. Though the parts are beautiful, the whole is ill-shaped. No ruins of the tower are left, which might give form, and contrast to the walls, and buttresses, and other inferior parts. Instead of this, a number of gabel-ends hurt the eye with their regularity; and disgust by the vulgarity of their shape. A mallet judiciously used (but who durst use it?) might be of service in fracturing some of them; particularly those of the cross isles, which are not only disagreeable in themselves, but confound the perspective.'

Nearer to, however, it was 'a very inchanting piece of ruin. Nature has now made it her own. Time has worn off all traces of the rule: it has blunted the sharp edges of the chisel; and broken the regularity of opposing parts.'

WILLIAM GILPIN (1724–1804)
114. **Three Essays: On Picturesque Beauty; On Picturesque Travel; and On Sketching Landscape** 1792
 a. *The Trustees of the British Museum*
 b. *Colonel J. H. Constable*

Gilpin's two plates illustrating a non-Picturesque and a Picturesque mountain landscape are shown: 'It is the intention of these two prints to illustrate how very adverse the idea of *smoothness* is to the *composition* of landscape. In the second of them the *great lines* of the landscape are exactly the same as in the first; only they are *more broken*.' Near the beginning of the volume Gilpin explained that '*roughness* forms the most essential point of difference between the *beautiful*, and the *picturesque*; as it seems to be that particular quality, which makes objects chiefly pleasing in painting. . . . why does an elegant piece of garden-ground make no figure on canvas? The shape is pleasing; the combination of the objects, harmonious; and the winding of the walk in the very line of beauty. All this is true; but the *smoothness* of the whole, tho right, and as it should be in nature, offends in picture. Turn the lawn into a piece of broken ground: plant rugged oaks instead of flowery shrubs: break the edges of the walk: give it the rudeness of a road: mark it with wheel-tracks; and scatter around a few stones, and brushwood; in a word, instead of making the whole *smooth*, make it *rough*; and you make it also *picturesque*.'

114

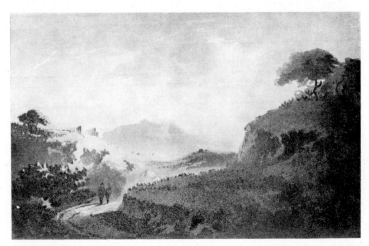

114

UVEDALE PRICE (1747–1829)

115. An Essay on the Picturesque, As Compared with the Sublime and the Beautiful, and on the Use of Studying Pictures, for the Purpose of Improving Real Landscape 1794
The Trustees of the British Museum

'Among trees, it is not the smooth young beech, nor the fresh and tender ash, but the rugged old oak, or knotty wych elm that are picturesque: nor is it necessary they should be of great bulk; it is sufficient if they are rough, mossy, with a character of age, and with sudden variations in their forms. . . . If we next take a view of those animals that are called picturesque, the same qualities will be found to prevail. The ass is generally thought to be more picturesque than the horse; and among horses, it is the wild and rough forester, or the worn-out cart-horse to which the title is applied. . . . the Pomeranian, and the rough water-dog, are more picturesque than the smooth spaniel, or the greyhound; the shaggy goat than the sheep: and these last are more so when their fleeces are ragged and worn away in parts, than when they are of equal thickness, or when they have lately been shorn. . . . In our own species, objects merely picturesque are to be found among the wandering tribes of gypsies and beggars; who in all the qualities which give them that character, bear a close analogy to the wild forester and the worn out cart-horse, again to old mills, hovels, and other inanimate objects of the same kind.'

RICHARD PAYNE KNIGHT (1750–1824)

116. The Landscape, a Didactic Poem in Three Books. Addressed to Uvedale Price, Esq. 1794
The Trustees of the British Museum

Illustrated with two etchings after Thomas Hearne, showing in one a Palladian house with its landscape of 'shaven lawns', serpentine lines and 'Chinese' accessories, all that Knight most abhors in contemporary landscape gardening, and in the other an Elizabethan mansion in its irregular, overgrown Picturesque setting:

> 'Prim gravel walks, through which we winding go,
> In endless serpentines that nothing show;
> Till tir'd, I ask, *Why this eternal round?*
> And the pert gard'ner says, '*Tis pleasure ground.*
> This pleasure ground! astonish'd, I exclaim,
> *To me Moorfields as well deserve the name:*
> Nay, better; for in busy scenes at least
> Some odd varieties the eye may feast,
> Something more entertaining still be seen,
> Than red-hot gravel, fring'd with tawdry green.
> O! waft me hence, to some neglected vale. . . .'

HUMPHRY REPTON (1752–1818)

117. Sketches and Hints on Landscape Gardening [1795]
The Trustees of the British Museum

Repton, 'Capability' Brown's successor, was the most sought-after 'improver' of the country house vista at the turn of the eighteenth century. No.117, his first published work, was based on the so-called Red Books which he prepared for clients, in which he illustrated proposed transformations by means of watercolours with movable flaps. More than 50 of these books had been produced by 1795. He steered a middle course be-

116
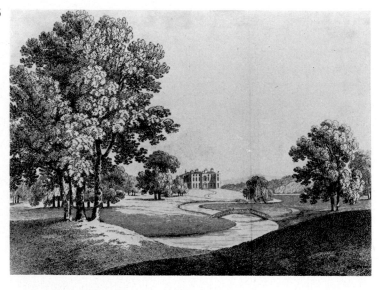

116
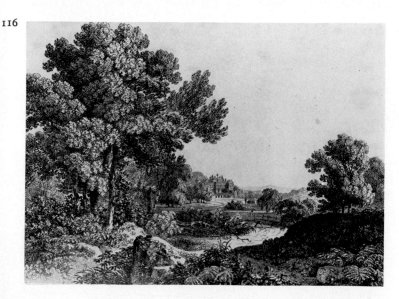

tween the older tradition of landscape design and the new Picturesque theories: 'Extremes are. . . to be avoided; and I trust that the taste of this country will neither insipidly slide into the trammels of that smooth-shaven "*genius* of the bare and bald," which [Knight] so justly ridicules, nor enlist under the banners of that shaggy and harsh-featured *spirit*, which knows no delight but in the scenes of Salvator Rosa.' By the end of his life he had 'improved' over 400 estates, including his own modest place near Romford, 'the humble cottage', he says in *Fragments on the Theory and Practice of Landscape Gardening* (1810), 'to which, for more than thirty years, I have anxiously retreated from the pomp of palaces, the elegance of fashion, or the allurements of dissipation; it stood originally within five yards of a broad part of the high road: this area was often covered with droves of cattle, of pigs, or geese. I obtained leave to remove the paling twenty yards further from the windows; and, by this *appropriation* of twenty-five yards of garden, I have obtained a frame to my landscape; the frame is composed of flowering shrubs and evergreens; beyond which are seen, the cheerful village, the high road, and that constant moving scene, which I would not exchange for any of the lonely parks that I have improved for others.' Repton illustrates this early suburban garden with his usual exquisite 'before' and 'after' plate, but one wonders how cheerfully the village took the appropriation of its land, what became of the cows, the pigs, the geese, and where the one-legged, one-armed, one-eyed beggar, cap in hand at the paling in the 'before' scene, actually went when Repton pulled down the flap.

JAMES MILLER (exhibited 1773–91)

118. **Thames-side View with an Artist Sketching**
?1760s
Watercolour, $7\frac{3}{4} \times 12\frac{3}{8}$ in.
Dudley Snelgrove, Esq.

A James Miller who exhibited views of London, Chatham, etc, between 1773 and 1791 is presumed to be identical with the artist of several watercolours of such subjects, one signed and dated 1776, in the Victoria and Albert Museum. Other works, including the sketchbook from which No.118 is taken, are attributed to him by comparison with these. No biographical information has been discovered apart from the fact that he taught drawing in Marsham Street, Westminster.

SAMUEL HIERONYMUS GRIMM (1733–94)

119. **View of the Pass from the Pont Aberglaslyn**
1777
Inscribed on verso '25. View of the Pass from the Pont Aberglaslyn.'
Pen and wash, 19×12 in.
The National Library of Wales, Aberystwyth

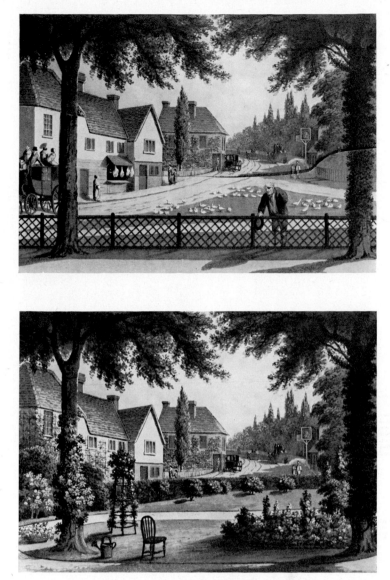

'View from my own cottage in Essex' from Repton's *Fragments on the Theory and Practice of Landscape Gardening*, 1810 (not exhibited).

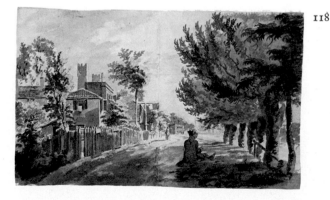

118

119

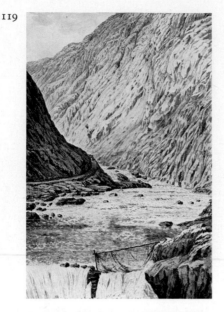

Born in Switzerland, Grimm worked there and in France before coming to England in 1768. Among his patrons in England was Gilbert White, who commissioned him to illustrate *The Natural History and Antiquities of Selborne* (see No.165). Grimm made 12 watercolours of Selborne in 1776, charging 2½ guineas a week for his labours: 'Mr. Grimm was with me just 28 days;' White carefully noted, '24 of which he worked very hard'.[1] In the following year Grimm was engaged by Henry Penruddocke Wyndham for a tour of Wales, to make drawings for the second edition of his book, No.112 above. No.119 was used for the frontispiece. A smaller version, signed and dated 1777, is included in Wyndham's extra-illustrated copy in the National Library of Wales. For Francis Towne's drawing of almost the same view, and made in the same year, see No.103.

THOMAS HEARNE (1744–1817)

120

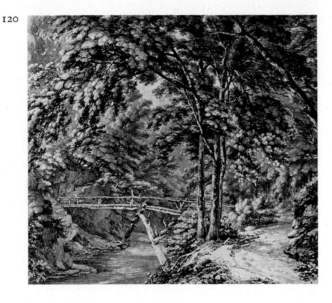

120. **Wooded Glen at Downton, Herefordshire**
 Pen and wash, $12\frac{5}{8} \times 13\frac{3}{4}$ in.
 The Victoria and Albert Museum
Hearne served an apprenticeship as an engraver under Woollett and then spent three-and-a-half years in the West Indies as draughtsman to the Governor of the Leeward Islands. In the late 1770s he turned to British topography, his largest undertaking being the *Antiquities of Great Britain*, No.109 above. He was a great favourite of Sir George Beaumont and also worked for Richard Payne Knight. Downton Castle was Knight's seat.

MICHAEL 'ANGELO' ROOKER (1743–1801)

121

121. **Caerphilly Castle**
 Inscribed on verso 'Caerphilly Castle, &c. Drawn from a window at the Boar's Head Inn, Glamorganshire, by M. A. Rooker.'
 Pen and watercolour, $8\frac{7}{8} \times 14\frac{3}{16}$ in.
 The City Museum and Art Gallery, Birmingham
Rooker worked as an engraver for such publications as *The Copper Plate Magazine* and *The Virtuosi's Museum* and later as a scene painter at the Haymarket Theatre. He had studied painting under Paul Sandby and from the late 1780s made sketching tours of Britain, but apparently found little market for his watercolour views. Broken by 'the neglect of an undiscerning public', said Dayes, Rooker 'drooped into eternity'.[2] Edward Edwards, however, attributed his decline to the loss of the Haymarket job.

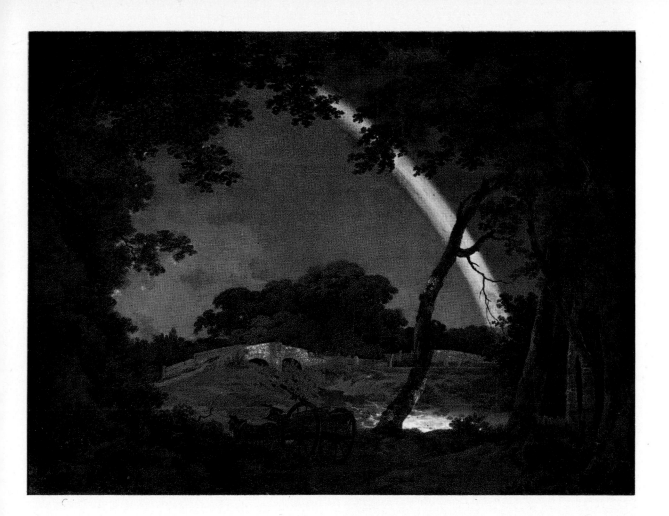

127. Joseph Wright
Landscape with a Rainbow *c.*1794–5

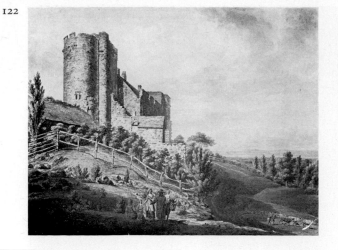

EDWARD DAYES (1763–1804)

122. Lympne Castle *c.*1790
Watercolour, $17\frac{1}{2} \times 21\frac{1}{2}$ in.
The Laing Art Gallery and Museum, Newcastle upon Tyne

Dayes was a topographical watercolourist, teacher, mezzotint engraver, miniaturist and author. He committed suicide, leaving behind some bitter *Professional Sketches of Modern Artists*, among them an account, largely inspired by jealousy, of his pupil Girtin.

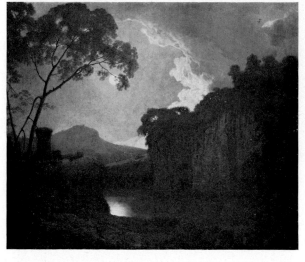

JOSEPH WRIGHT (1734–97)

Lit: Benedict Nicolson, *Joseph Wright of Derby*, 1968.

123. Landscape with Ruins, by Moonlight
?1780–2
Oil on canvas, 25 × 30 in.
Lit: Nicolson No.305
Private Collection

124. Landscape with Dale Abbey *c.*1785
Oil on canvas, $28\frac{1}{2} \times 39$ in., repr. on p.66
Lit: Nicolson No.331
The Sheffield City Art Galleries

Already a successful painter of portraits, subject pictures and genre, Wright went to Italy at the end of 1773 and it was there that he first became seriously interested in landscape. The volcanic eruptions, firework displays and watery caverns which he studied in Italy provided material for the rest of his life, but on his return in 1775 he turned also to the scenery of his native Derbyshire. In the two sorts of landscape, local and Italian, he continued to pursue a life-long passion for the more unusual effects of light. His patrons among the Derbyshire gentry appear to have been equally at home with either kind of subject, and in the case of No.123, which is painted over a portrait, Italian and local features are actually combined in one picture. The Derbyshire crags at the right of this work reappear in No.124, a painting which used to be attributed to Richard Wilson.

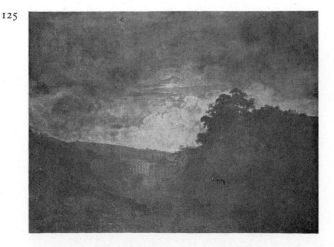

125. Arkwright's Cotton Mills, by Night *c.*1782–3
Oil on canvas, 34 × 45 in.
Lit: Nicolson No.311
I. M. Booth, Esq.

Richard Arkwright set up the first water-powered cotton mill at Cromford, near Matlock, in 1771. Although Wright was in touch with him by 1783 and later painted three portraits for him, this picture and a companion view of the mills by day were bought not by Arkwright, but by the M.P. for Nottingham and Fellow of All Souls, Daniel Parker Coke, who paid £52.10s. for the two. As Benedict Nicolson shows, the first generation industrialists commissioned portraits but were indifferent to landscape.

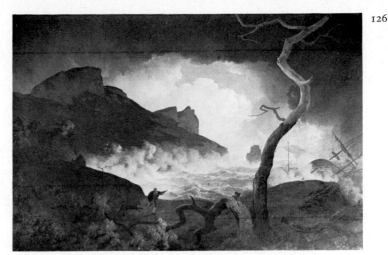

126

126. Antigonus in the Storm 1790

 Inscribed 'I.W.Pinx^t 1790'

 Oil on canvas, 61 × 85 in.

 Exh: R.A.1790(221) and, after reworking,

 Society of Artists 1791(219)

 Lit: Nicolson No.231

 The Viscount Scarsdale

The Shakespeare Gallery, designed to promote English history painting and the arts of engraving and printing, was the last and by far the most ambitious scheme of John Boydell's long career as a print-publisher, which had effectively begun with his publication of Woollett's 'Niobe' (No.31). Wright was invited to contribute at the outset of the project in 1786, but did not see eye to eye with Boydell on the question of money or his status in relation to the other contributors. His 'Romeo and Juliet' appears to have been rejected, but two other pictures were included in the opening exhibition of the Gallery in 1789–90: 'Ferdinand and Miranda in Prospero's Cell' from *The Tempest* and 'Antigonus in the Storm' from *The Winter's Tale*, for which he received £315 and £136 respectively. No.126 is a smaller, variant version of the Boydell picture, which is now lost, and was painted for Henry Philips for £105. Badly hung at the Academy in 1790, this 'Antigonus' was the occasion of one of Wright's many quarrels with that body. Nicolson points out that Wright introduced some of his favourite Derbyshire hills in the background, creating a sort of 'phantom resort. . . Matlock-on-Sea'.

127. Landscape with a Rainbow *c.*1794–5

 Oil on canvas, 32 × 42 in., repr. on p.63

 Lit: Nicolson No.298

 Derby Museums and Art Gallery

One of two versions of a 'picture of a bridge w^th the effect of a rainbow', as Wright called it; the other, now lost, was bought by Nathaniel Philips in 1795 for £52.10s. No.127 was with Wright at his death and appeared in his sale at Christie's in 1801 as 'A Landscape with a Rainbow, View near Chesterfield in Derbyshire'. It was bought in at £59.17s.

128. Blot drawing in the manner of Alexander Cozens

 Ink, 10¼ × 15¼ in.

 Derby Museums and Art Gallery

128

For a note on Cozens' 'blot' drawings see No.78. Nicolson finds the influence of Cozens in some of the drawings Wright made in France and Italy, and especially in one made at Nice on 19 December 1773. Oddly, his brother appears to have sold two Cozens drawings on his behalf in Derby only a fortnight earlier, on the day before Wright reached Nice (see Nicolson p.75, n.2). Among Wright's later paintings several after Cozens are recorded, including 'The close scene from Cozens blot', which seems to have been made around 1786–8, i.e. soon after the publication of Cozens' *A New Method*.

129. Study for 'Dovedale' *c.*1786

 Wash, 14¼ × 21 in.

 Derby Museums and Art Gallery

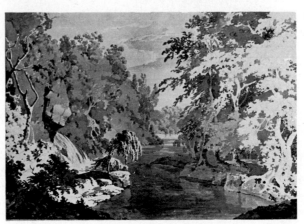

129

A study for a painting dated 1786 in the collection of Mrs George Anson.

124

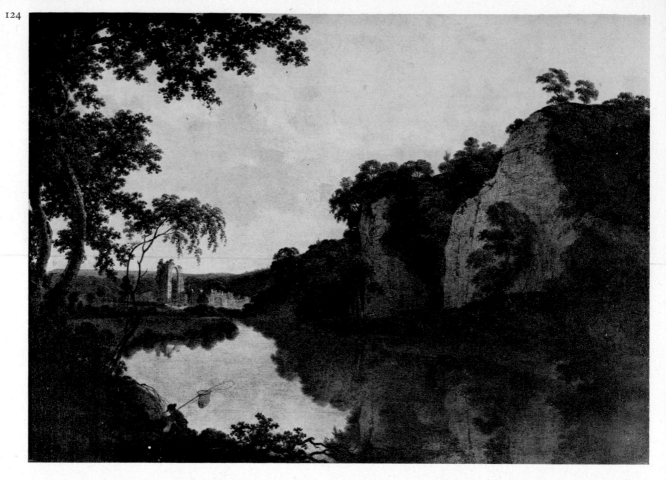

131

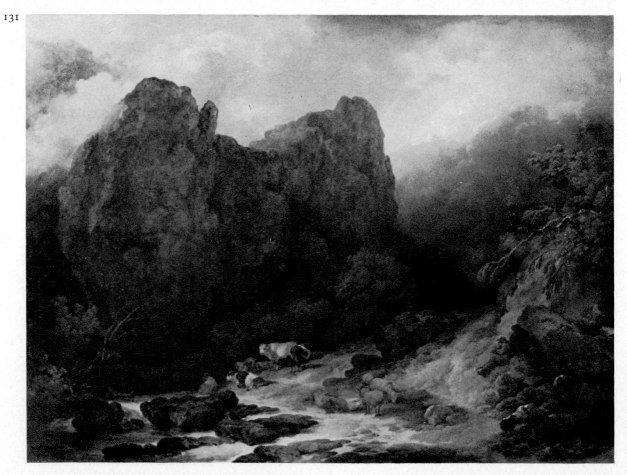

PHILIP JAMES DE LOUTHERBOURG
(1740–1812)

130. **Maquette for 'The Wonders of Derbyshire'**
1778
Pen, bodycolour and oil, 12¾ × 16 in.
Lit: Rüdiger Joppien, catalogue of the exhibition
Philippe Jacques de Loutherbourg, RA, Kenwood
1973, No.83.
The Victoria and Albert Museum

131. **Dovedale in Derbyshire** 1784
Inscribed 'P.I.de Loutherbourg 1784'
Oil on canvas, 38½ × 51 in.
Exhib: R.A.1784(25)
The City of York Art Gallery

When he came to London from Paris in 1771 de Lou-
therbourg was already an established artist with a large
repertoire of pastorals, shipwrecks, biblical subjects and
so on. In England landscape continued to be one of his
principal interests, but at first his efforts in this direction
were mainly in the field of theatre design. Between 1773
and 1781 he was employed as stage designer to Drury
Lane at £500 a year, first under Garrick's direction and
then Sheridan's. He made many technical innovations
aimed at increasing the range and credibility of natural
effects created on the stage and these were concentrated
in his own miniature theatre, the Eidophusikon, which
he opened in 1781 on leaving Drury Lane (see also
under No.62–3).

De Loutherbourg first visited Derbyshire in 1778 to
make studies for the Drury Lane pantomime 'The
Wonders of Derbyshire', which was staged the follow-
ing January. The site depicted in No.130 is the Cavern
of Castleton or Peak's Hole; the other wonders were
Chatsworth House, Mam Tor, Eden Hole, Buxton
Wells, Tideswell and Poole's Hole. Rüdiger Joppien
describes the novelty of this pantomime: 'Never before
had there been a production on the British stage which
concentrated exclusively on landscape as a form of
theatrical representation, and the plot was simply de-
veloped as a pretext for a number of changes in scenery
. . . . The construction of the scenery of the model is
particularly interesting in that it no longer follows the
tradition of separating wings from borders, but unifies
these two elements in a sweeping, oval, coherent curve.'

No.131 was painted after a second visit to Derbyshire
and the Lake District in 1783. De Loutherbourg's
friend Gainsborough was also in the Lake District that
year, though it is not known whether they met there.
Gainsborough had probably already exhibited his own
version of 'sublime' mountain scenery, 'Rocky Land-
scape' (No.59) at the Royal Academy earlier in the year.

132. **Lake Scene in Cumberland** 1792
Inscribed 'P I de Loutherbourg 1792'
Oil on canvas, 16¾ × 23¾ in.
The Tate Gallery (316)

133. **Coalbrookdale by Night** 1801
Inscribed 'R.A.1801 P.I.de Loutherbourg'
Oil on canvas, 26¾ × 42 in., repr. on p.73
Exh: R.A.1801(54)
The Science Museum

130

132

To Arthur Young, touring Shropshire in 1776, Coalbrookdale appeared 'a very romantic spot, it is a winding glen between two immense hills which break into various forms, and all thickly covered with wood, forming the most beautiful sheets of hanging wood. Indeed too beautiful to be much in unison with that variety of horrors art has spread at the bottom: the noise of the forges, mills, &c. with all their vast machinery, the flames bursting from the furnaces with the burning of the coal and the smoak of the lime kilns, are altogether sublime, and would unite well with craggy and bare rocks, like St. Vincent's at Bristol.'[1] During the last quarter of the eighteenth century industrial sites of all kinds—furnaces, factories, mills, mines, quarries, etc—were added to the tourist's itinerary, as places where agreeable sensations of terror could be had and ingenious technologies marvelled at. But it soon became less easy to see such places as pleasing: early euphoria about Britain's industrial supremacy was accompanied by, and eventually gave way to, a worrying awareness of the commercial and social problems which followed industrial expansion. In painting, industrial landscape was very nearly a stillborn genre. A number of artists, Wright and Loutherbourg chief among them, painted occasional subjects of this kind, but it never became a widely marketable commodity.

134

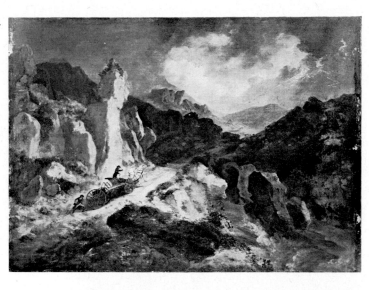

JULIUS CAESAR IBBETSON (1759–1817)

134. **A Phaeton in a Thunderstorm** 1798
Inscribed 'Julius Ibbetson pinx 1798'
Oil on canvas, $26\frac{1}{2} \times 36\frac{1}{2}$ in.
Leeds City Art Galleries

A label on the back reads 'An Actual Scene The Honable Robt Greville Phaeton Between Pont Aberglaslyn & Tan y Bleh in Crossing the Mountain Rhge in a Thunder Storm Painted by Julius Ibbertson who was passer [i.e. passenger]'. Ibbetson shows himself about to place a rock behind the carriage wheel to act as a brake. The incident presumably occurred on the tour of Wales which Ibbetson and John 'Warwick' Smith made with the Hon. Robert Fulke Greville in 1792, during which they 'visited many of the principal families', including Thomas Johnes at Hafod. For a different image of the travelling artist contending with the elements see Rowlandson's anti-hero in the next item.

135

THOMAS ROWLANDSON (1756–1827)

H. MERKE after THOMAS ROWLANDSON
135. **An Artist Travelling in Wales** 1799
Hand-coloured aquatint, $13 \times 15\frac{1}{4}$ in.
The Trustees of the British Museum (1938–6–13–11)

HAFOD, Cardiganshire

After the death of his first wife in 1782 the Cardiganshire landowner Thomas Johnes (1748–1816) moved to an estate previously neglected by his family, Hafod, in the mountains to the east of Aberystwyth. He began a remarkable transformation of the wilderness he found there, planting trees at a vast rate (over two million between 1795 and 1801), introducing modern agricultural methods, attempting to educate his tenants and improve the lot of his labourers. For his new wife, Jane, and himself he commissioned a 'gothic' house from Thomas Baldwin of Bath and, in the valley of the Ystwyth in which it was sited, laid out romantic walks leading to the waterfalls and a cave on the estate. An Alpine Bridge and a Druid Temple were built and a miniature Garden of Eden created for their daughter Mariamne. Johnes' 'paradise', as he called it, was rather different from Henry Hoare's at Stourhead: at Hafod the visitor was as likely to be reminded of Salvator and Milton as of Claude and Virgil. In developing the naturally wilder character of Hafod Johnes was no doubt encouraged by his friend Uvedale Price and his cousin Payne Knight. After a disastrous fire in 1807 Johnes rebuilt the house, but another tragedy followed—the death of Mariamne in 1811 at the age of 27. The house was altered again at a later date and, left unoccupied in the late 1930s, what remained of it was dynamited in 1958. Its grounds survive in a derelict state.

Lit: Elisabeth Inglis-Jones, *Peacocks in Paradise*, 1950.

JOHN 'WARWICK' SMITH (1749–1831)
136. **Hafod House** 1793
Inscribed on verso 'General View of Hafod.
J. Smith. 1793'
Watercolour, $13\frac{5}{8} \times 22\frac{1}{8}$ in.
Private Collection

Smith and Ibbetson stayed at Hafod in 1792 during their tour with the Hon. Robert Greville (see No.134). Smith's watercolours of the place were later aquatinted for his namesake's book, No.137 below, this view being used for plate 1. The foundation stone of Baldwin's house was laid in 1786 and the building finished two years later. The young John Nash also seems to have been involved in the early design of the house and was probably responsible for the octagonal library added about 1793. A celebrated bibliophile, Johnes was the translator of Froissart and other French chroniclers and set up the Hafod Press to publish his translations.

JAMES EDWARD SMITH (1759–1828)
137. **A Tour to Hafod** 1810
The National Library of Wales, Aberystwyth
Illustrated with 15 aquatints by J. C. Stadler after John 'Warwick' Smith and published by White & Co. at 12 guineas. The plate shown is No.5, 'Cavern Cascade'. Smith does not give the most dramatic view of the cascade, which the visitor, approaching through a dark cave, came on suddenly after a turn in the passage. Possibly he agreed with Benjamin Heath Malkin that 'The circumstances are eccentric and wonderful, but not picturesque. There is neither foliage nor herbage; nothing but rock and water, confined as it were in one

136

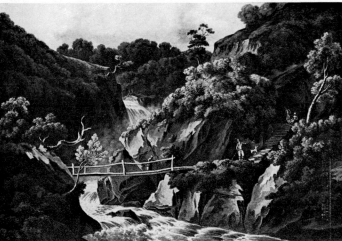

137

139

of nature's cabins. The most striking feature, is the luminous appearance of the foaming element, seen from so dark a station, glittering as if with gems. This could scarcely be represented on paper. I have therefore chosen the open view of the upper falls from the bottom. . . '.[1] The text of *A Tour to Hafod* is by the eminent botanist and the founder of the Linnean Society, Sir James Edward Smith, a friend of Johnes and an admirer of his daughter's precocious botanical and entomological studies.

GEORGE CUMBERLAND (1754–1848)

138. An Attempt to Describe Hafod 1796
The National Library of Wales, Aberystwyth
Cumberland visited Hafod in 1794 following an appreciative letter from Johnes on his *Poems on Landscapes*.[2] The folding map of Hafod shown here was engraved for Cumberland's book by William Blake, whose *Songs of Innocence* and 'Blair's Grave' Johnes was later to acquire.[3]

THOMAS STOTHARD (1755–1834)

139. Hafod
Pencil, $8\frac{1}{4} \times 6\frac{1}{2}$ in.
Denys Oppé, Esq.

140

THOMAS STOTHARD (1755–1834)

140. View near Hafod
Pencil, $8\frac{1}{4} \times 9\frac{5}{8}$ in.
The Trustees of the British Museum (1919–11–15–29)
Stothard was engaged to teach drawing to Mariamne Johnes and seems to have first visited Hafod for this purpose in 1803. In 1810 he painted grisaille scenes from Monstrelet for Johnes' library. Primarily a figure painter, and a prolific book illustrator, Stothard's occasional landscapes have received less than their due.

JOSEPH MALLORD WILLIAM TURNER (1775–1851)

141. 'Hafod'
Watercolour, 24 × 36 in.
The Trustees of the Lady Lever Art Gallery, Port Sunlight
Turner is thought to have visited Hafod during his Welsh tour of 1798. In 1847 he wrote to Hawkesworth Fawkes, who was planning a visit to Aberystwyth: 'You are in the neighbourhood of Havord or Hawvaford, know[n] I dare say yet known by being the Seat of Esquire Johns a fine place well wooded and he employ'd Stothard to paint the same so think you will find some Pictures by him there. I do not think that [?] you [could] have hit upon a more desirable spot for your pencil and hope you may feel—just what I felt in the days of my youth when I was in search of Richard Wilson's birthplace'.[4] This watercolour, however, presents problems. Known for a long time as Hafod, it bears only a very general resemblance to the house and its setting, but is too precise in architectural detail to be regarded as a fantasy. If connected with Hafod at all, it may perhaps incorporate an unexecuted design for the remodelling of the house.

141

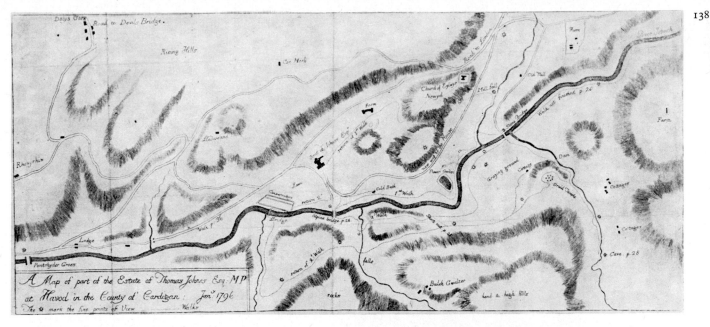

HENEAGE FINCH, 4th EARL OF AYLESFORD (1751–1812)

142. **A Barn**
Wash and watercolour, $9\frac{1}{2} \times 13\frac{1}{8}$ in.
The Rt. Hon. the Earl of Aylesford

143. **A Barn** 1794
Etching, $4\frac{1}{8} \times 6\frac{15}{16}$ in.
Lit: A. P. Oppé, 'The Fourth Earl of Aylesford',
The Print Collector's Quarterly, Vol.11, p.288,
No.39.
Private Collection

142

143

Aylesford and Beaumont are included here as leading representatives of the vast army of amateurs at work in this period. The amateur can be of interest for his own productions, usually a shadow of his teacher's, but occasionally striking out in directions unexplored by the professional, and in his rôle of patron, financing the professional and influencing what he did in any number of ways.

Aylesford studied under Malchair at Oxford in the years 1767–71 and his early work is the sort of tonal sketching from nature which Malchair encouraged. Later he discovered Piranesi and finally Rembrandt, of whose etchings he is said to have formed an unequalled collection. Aylesford's passion for Rembrandt, which was a fairly novel one, was commented on by Sir George Beaumont in a conversation with Farington in 1809. Beaumont's report also reveals some of the short-comings of contemporary connoisseurship: 'Sir George spoke of Mr. Long's taste for pictures being of a limited kind. He is gratified by the works of Claude, but dis-liked the landscapes of Rubens; & he has no real relish for those of Wilson.—He spoke of some drawings which He had seen which were made last year by Lord Aylesford; studies from nature but executed in the stile of *Rembrant*. He said they were extremely well done. But His Lordship's taste is also limited. He has no great liking for pictures unless those by Rembrant;

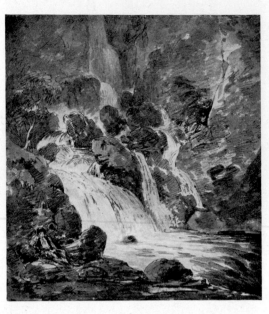

144

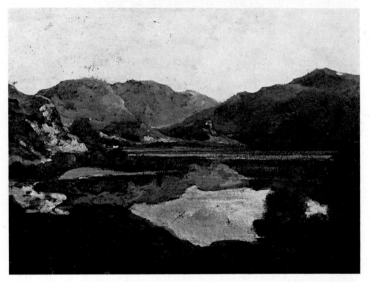

145

146a

and he has quite an abhorence of the pictures by Wilson. —In this respect Sir George remarked How enlarged was the mind of Sir Joshua Reynolds, who felt the merits of every kind of practise of the art if excellent in its kind'.[1]

SIR GEORGE BEAUMONT (1753–1827)

144. **Waterfall at Keswick** 1803
 Chalk and wash, $12\frac{5}{16} \times 10\frac{15}{16}$ in.
 The Tate Gallery (T.1221)

The original backing board is inscribed 'G H Beaumont Keswick August 11 1803—'. This and a companion drawing, now in the Leicester Museum and Art Gallery, were given by Beaumont to William Wordsworth at the outset of their long friendship. On behalf of the Wordsworths, Coleridge wrote to thank Beaumont: 'it would be no easy matter to say, how much they were delighted with the two Drawings, as two poems, how affected by them, as marks of your kindness & attention'[2]. Ill and dejected, Coleridge recognised that for himself the drawings would carry other associations: 'It will give a lasting Interest to the Drawing of the Waterfall, that I first saw it through tears'.[3]

Beaumont was a pupil both of Alexander Cozens and of Malchair. In Italy in 1783 he worked alongside J. R. Cozens. As a patron of Hearne, Girtin, Constable and many more, he came under an enormous variety of influences, a good number of them reflected at different times in his own work. Despite his patronage of the newest poets, Wordsworth and Coleridge, his attitudes to art remained those of the older generation, and of Reynolds in particular. Though one of Constable's most loyal supporters he never bought a picture by him, and there were distinct limits to his appreciation of Turner (see No.208). Like Farington, he had fingers in many pies and many of the younger artists resented this.

145. **Keswick Lake**
 Inscribed on verso 'Keswick Lake. GHB'
 Oil on millboard, $9\frac{1}{2} \times 12$ in.
 Leicester Museum and Art Gallery

In recent years this sort of oil sketch by Beaumont has been ascribed to 1807 and seen as an early reflection of Constable's Lake District oils of the previous year. However, the authors of the new catalogue of the Beaumont collection at Leicester incline to date it to 1818, when Beaumont was in the Lakes with William Collins.[4]

 THOMAS HEARNE (1744–1817)
146. **Sir George Beaumont and Joseph Farington painting a Waterfall**
 a. Pen and wash, $17\frac{1}{2} \times 11\frac{1}{2}$ in.
 b. Pencil, $7 \times 7\frac{1}{2}$ in.
 Sir George Beaumont, Bt.

As their materials indicate, the two artists are painting in oil and on fairly large canvases: it would be intriguing to see what they produced on this occasion. Oil painting outdoors on any scale was, to say the least, a

133. P. J. de Loutherbourg
Coalbrookdale by Night 1801

Photo, Science Museum, London

146b

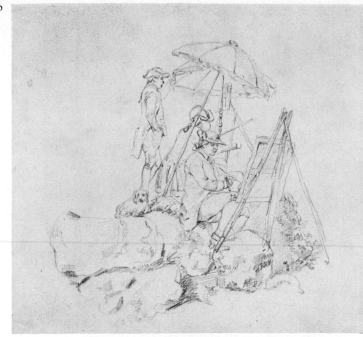

147

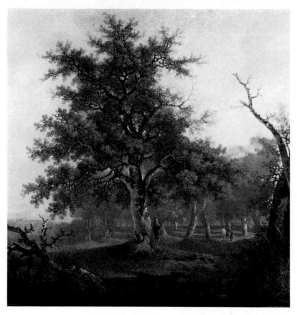

very unusual activity in the late eighteenth century and these drawings may be as early as 1777 or 1778, two years in which Beaumont is known to have been in the Lake District with Hearne and Farington. The latter's first exhibit at the Royal Academy, in 1778, was 'A Waterfall', sent in from Keswick.

JOSEPH FARINGTON (1747–1821)

147. **The Oak Tree**
Oil on canvas, 25 × 24 in.
The Tate Gallery (T.786)

As a diarist—and he is immensely valuable as such—Farington, says Lawrence Gowing, 'wrote down everyone's opinion in the hope of developing his own'.[5] As a painter he was rather less ambitious and one would hardly guess from his surviving works that he had been one of Wilson's favourite pupils.

After 1800 he more or less gave up exhibiting at the Royal Academy, but he continued to fill sketchbooks on his travels, sometimes producing drawings of considerable charm. His real *métier* was as an art-politician. 'How Farington used to rule the Academy!', said Northcote, 'He was the great man to be looked up to on all occasions; all applicants must gain their point through him. But he was no painter; he cared nothing at all about pictures; his great passion was the love of power—he loved to rule. He did it, of course, with considerable dignity; but he had an untamable spirit, which, I suppose, was due to the fact that he had lost the game as a painter, and that it was too late to mend the matter.'[6]

WILLIAM COMBE (1741–1823)
148. **An History of the River Thames**, Vol.II 1796
The Trustees of the British Museum (1871-8-12-179 . . . 208)

Published by Boydell in two volumes in 1794–6, the work contains 76 hand-coloured aquatints by J. C. Stadler after Farington and is one of the most lavish topographical productions of the period.

149. **Thames and Hastings sketchbook** 1792–7
The Victoria and Albert Museum (P.84–1921)

150. **West of England and Derbyshire sketchbook**
1810–12
The Victoria and Albert Museum (P.71–1921)

The Literature of Landscape

The patrons and artists of British landscape were, not always deeply, but certainly much of the time, concerned with poetry and prose; there is a deal of truth in the notion that our art was verbally framed before becoming visually real. The character of the British countryside has of course altered continuously and, taken as a whole, massively, and writers have shown a host of different faces to the change. There have been expressions of pleasure and expressions of fear: pleasure at the thought of 'progress' and fear induced by the blankness of a future without identifiable precedent. But, it must be emphasised, the give and take between 'fact' (invariably open to dispute) and imaginative actuality is a tale the telling of which has hardly begun: what did contemporaries think was happening to the rural way of life and what did they feel about it? The lineaments of it are, broadly, apparent; the inner truth evasive. Those who viewed and/or bought pictures naturally gave them a literary setting, but this setting awaits analysis.

Milton may be taken, near enough, as the literary counterpart to Titian. He was not, of course, a pastoralist proper, but natural description, while never at the centre of his stage, was a vital part of the scenery and momentarily (in 'L'Allegro' and 'Il Penseroso', in sections of 'Comus', too, and elsewhere) bore the burden of his meaning, emotionally resonant to an extraordinary degree. It was Milton's Eden that John Constable held at the back of his mind's paradisal Suffolk. James Thomson reversed the order of things. He, emphatically, set out from natural scenes and states to a consideration of man's place in the great scheme. What looks like cataloguing today was once an exciting redirecting of attention, and he brought to an established tradition of pseudo-Virgilian pastoral a new concern for the *detail* of nature. From here on, what has for convenience been called the landscape of feeling and the landscape of fact (the boundaries between the two are impossible to settle) developed in verse and prose along many a devious route.

Enormous difficulties were put in the way of those who would see the countryside simply, by the development of industry and agriculture and by the refinement of the natural sciences. With the improvement of agricultural techniques and methods, the balance of rural life was drastically affected. The myth of rural *stasis* was, no doubt, a device to meet fear of change, but it was a myth constantly open to challenge, constantly needing re-iteration. And a close understanding of natural phenomena, which would, supposedly, lead to the discovery of pattern, of order, briefly promised peace. But the process of investigation turned up a mass of disturbing new ideas. Orthodox theories of Creation were eroded by geological evidence of an earth infinitely older than the six millennia calculated by Bishop Ussher, and not just older but in a condition of constant flux. 'If only the Geologists would leave me alone,' complained Ruskin in 1851, 'I could do very well, but those dreadful Hammers! I hear the clink of them at the end of every cadence of the Bible verses.'[1] To Tennyson, greatest of the natural philosophers in Victorian poetry, nature, when kind to man, was but temporarily and accidentally so.

JOHN MILTON (1608–74)

151. **Paradise Regained. . . . to which is added Samson Agonistes and Poems on Several Occasions**, ed. Thomas Newton 1752
Illustrated by Francis Hayman
The Trustees of the British Museum

152. **The Paradise Lost of Milton** 1827
Illustrated by John Martin
The Tate Gallery
'Straight toward Heaven my wondering eyes I turned,
And gazed a while the ample sky, till, raised
By quick instinctive motion, up I sprung,
As thitherward endeavouring, and upright
Stood on my feet. About me round I saw
Hill, dale, and shady woods, and sunny plains,
And liquid lapse of murmuring streams; by these,
Creatures that lived and moved, and walked or flew,
Birds on the branches warbling: all things smiled;
With fragrance and with joy my heart o'erflowed. . . .
"Thou Sun," said I, "fair light,
And thou enlightened Earth, so fresh and gay,
Ye hills and dales, ye rivers, woods, and plains,
And ye that live and move, fair creatures, tell,
Tell, if ye saw, how came I thus, how here?
Not of myself; by some great Maker then,
In goodness and in power pre-eminent." '
Paradise Lost, Book VIII, ll.257–79

JAMES THOMSON (1700–48)

153. **The Seasons** 1730
Illustrated by N. Tardieu after William Kent
The Trustees of the British Museum

154. **The Seasons** 1797
Illustrated by Bartolozzi and Tomkins after William Hamilton
The Trustees of the British Museum
'I know no subject more elevating, more amusing; more ready to awake the poetical enthusiasm, the philosophical reflection, and the moral sentiment, than the works of Nature. Where can we meet with such variety, such beauty, such magnificence? All that enlarges and transports the soul! For this reason the best, both ancient, and modern, Poets have been passionately fond of retirement, and solitude. The wild romantic country was their delight. And they seem never to have been more happy, than when, lost in unfrequented fields, far from the little busy world, they were at leisure, to meditate, and sing the Works of Nature.'
Preface to *Winter*, 2nd ed., 1726

'Confessed from yonder slow-extinguished clouds,
All ether softening, sober Evening takes
Her wonted station in the middle air,
A thousand shadows at her beck. First this
She sends on earth; then that of deeper dye
Steals soft behind; and then a deeper still,
In circle following circle, gathers round
To close the face of things. A fresher gale
Begins to wave the wood and stir the stream,
Sweeping with shadowy gust the fields of corn,
While the quail clamours for his running mate.
Wide o'er the thistly lawn, as swells the breeze,
A whitening shower of vegetable down
Amusive floats. The kind impartial care
Of Nature naught disdains: thoughtful to feed
Her lowest sons, and clothe the coming year,
From field to field the feathered seeds she wings.'

Summer, ll.1647–63

Thomas Gray (1716–71)

155. **Designs by Mr R. Bentley for Six Poems by
Mr T. Gray** 1753
Illustrated by C. Grignion and J. S. Muller after
Richard Bentley
Private Collection
'Beneath those rugged elms, that yew-tree's shade,
Where heaves the turf in many a mould'ring heap,
Each in his narrow cell for ever laid,
The rude Forefathers of the hamlet sleep.

The breezy call of incense-breathing Morn,
The swallow twitt'ring from the straw-built shed,
The cock's shrill clarion, or the ecchoing horn,
No more shall rouse them from their lowly bed.

For them no more the blazing hearth shall burn,
Or busy housewife ply her evening care:
No children run to lisp their sire's return,
Or climb his knees the envied kiss to share.

Oft did the harvest to their sickle yield,
Their furrow oft the stubborn glebe has broke;
How jocund did they drive their team afield!
How bow'd the woods beneath their sturdy stroke!

Let not Ambition mock their useful toil,
Their homely joys, and destiny obscure;
Nor Grandeur hear with a disdainful smile,
The short and simple annals of the poor.'

Elegy Written in a Country Churchyard, ll.13–32

156. **Pocket-diary for 1755**
*The Master and Fellows of Pembroke College,
Cambridge*

157. **Notebook** containing part of the Journal of his
visit to the Lake District and Yorkshire in 1769
Private Collection
Gordale Scar, 13 October 1769: 'the rock on the left
rises perpendicular with stubbed yew-trees & shrubs,
staring from its side to the height of at least 300 feet.
but these are not the thing! it is that to the right, under
w^ch you stand to see the fall, that forms the principal
horror of the place. from its very base it begins to slope
forwards over you in one black & solid mass without

[76]

any crevice in its surface. . . . & in one part of the top
more exposed to the weather there are loose stones that
hang in air, & threaten visibly some idle Spectator with
instant destruction. it is safer to shelter yourself close
to its bottom, & trust the mercy of that enormous mass,
w^ch nothing but an earthquake can stir. . . . I stay'd
there (not without shuddering) a quarter of an hour, &
thought my trouble richly paid, for the impression will
last for life. at the alehouse where I dined, in Malham,
Vivares, the landscape-painter, had lodged for a week or
more. Smith & Bellers had also been there, & two prints
of Gordale have been engraved by them.'

(Ed. Paget Toynbee and Leonard Whibley,
Correspondence of Thomas Gray, 1935, III, p.1107)

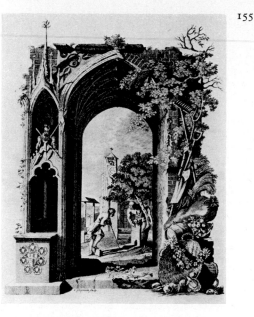

155

Oliver Goldsmith (?1730–74)

158. **The Deserted Village** 1770
The Trustees of the British Museum
'A time there was, ere England's griefs began,
When every rood of ground maintained its man;
For him light labour spread her wholesome store,
Just gave what life required, but gave no more:
His best companions, innocence and health;
And his best riches, ignorance of wealth.

But times are altered; trade's unfeeling train
Usurp the land and dispossess the swain;
Along the lawn, where scattered hamlets rose,
Unwieldy wealth and cumbrous pomp repose. . . .

The man of wealth and pride
Takes up a space that many poor supplied;
Space for his lake, his park's extended bounds,
Space for his horses, equipage and hounds;
The robe that wraps his limbs in silken sloth
Has robbed the neighbouring field of half their growth;
His seat, where solitary sports are seen,
Indignant spurns the cottage from the green;
Around the world each needful product flies,
For all the luxuries the world supplies:
While thus the land, adorned for pleasure all,
In barren splendour feebly waits the fall.'

ll.57–66, 275–86

WILLIAM COWPER (1731–1800)

159. The Task 1785
The Trustees of the British Museum
'Nature, enchanting Nature, in whose form
And lineaments divine I trace a hand
That errs not, and find raptures still renew'd,
Is free to all men—universal prize.
Strange that so fair a creature should yet want
Admirers, and be destin'd to divide
With meaner objects ev'n the few she finds!
Stripp'd of her ornaments, her leaves and flow'rs,
She loses all her influence. Cities then
Attract us, and neglected Nature pines
Abandon'd, as unworthy of our love.
But are not wholesome airs, though unperfum'd
By roses; and clear suns, though scarcely felt;
And groves, if unharmonious, yet secure
From clamour, and whose very silence charms;
To be preferr'd to smoke, to the eclipse,
That Metropolitan volcanos make,
Whose Stygian throats breathe darkness all day long;
And to the stir of commerce, driving slow,
And thund'ring loud, with his ten thousand wheels?'
 Book III, 'The Garden', ll.721–40

GEORGE CRABBE (1754–1832)

160. The Village 1783
The Trustees of the British Museum
'I grant indeed that fields and flocks have charms
For him that grazes or for him that farms;
But when amid such pleasing scenes I trace
The poor laborious natives of the place,
And see the mid-day sun, with fervid ray,
On their bare heads and dewy temples play;
While some, with feebler heads and fainter hearts,
Deplore their fortune, yet sustain their parts—
Then shall I dare these real ills to hide
In tinsel trappings of poetic pride?....

 Lo! where the heath, with withering brake grown o'er
Lends the light turf that warms the neighbouring poor;
From thence a length of burning sand appears,
Where the thin harvest waves its wither'd ears;
Rank weeds, that every art and care defy,
Reign o'er the land, and rob the blighted rye:
There thistles stretch their prickly arms afar,
And to the ragged infant threaten war;
There poppies nodding, mock the hope of toil;
There the blue bugloss paints the sterile soil;
Hardy and high, above the slender sheaf,
The slimy mallow waves her silky leaf;
O'er the young shoot the charlock throws a shade,
And clasping tares cling round the sickly blade;
With mingled tints the rocky coasts abound,
And a sad splendour vainly shines around.'
 Book I, ll.39–48, 63–78

161. Tales in Verse 1812
The Trustees of the British Museum
'It is the Soul that sees; the outward eyes
Present the object, but the Mind descries;
And thence delight, disgust, or cool indiff'rence rise:
When minds are joyful, then we look around,
And what is seen is all on fairy ground;
Again they sicken, and on every view
Cast their own dull and melancholy hue;
Or, if absorb'd by their peculiar cares,
The vacant eye on viewless matter glares;
Our feelings still upon our views attend,
And their own natures to the objects lend;'
 'The Lover's Journey', ll.1–11

ROBERT BLOOMFIELD (1766–1823)

162. The Farmer's Boy 1800
Illustrated by John Anderson
The Trustees of the British Museum
'THEN welcome, COLD; welcome, ye *snowy* nights!
Heaven midst your rage shall mingle pure delights,
And confidence of hope the soul sustain,
While devastation sweeps long the plain:
Nor shall the child of poverty despair,
But bless THE POWER that rules the *changing year*;
Assur'd, ... tho' horrors round his cottage reign, ...
That *Spring* will come, and Nature smile again.'
 'Autumn', ll.353–60

ANN RADCLIFFE (1764–1823)

163. The Romance of the Forest 1791
The Trustees of the British Museum
'He approached, and perceived the Gothic remains of
an abbey: it stood on a kind of rude lawn, overshadowed
by high and spreading trees, which seemed coeval with
the building, and diffused a romantic gloom around.
The greater part of the pile appeared to be sinking into
ruins, and that which had withstood the ravages of time
showed the remaining features of the fabric more awful
in decay. The lofty battlements, thickly enwreathed
with ivy, were half demolished, and become the
residence of birds of prey. Huge fragments of the eastern
tower, which was almost demolished, lay scattered amid
the high grass, that waved slowly to the breeze. "The
thistle shook its lonely head, the moss whistled to the
wind." A Gothic gate, richly ornamented with fretwork,
which opened into the main body of the edifice, but
which was now obstructed with brushwood, remained
entire. Above the vast and magnificent portal of this
gate arose a window of the same order, whose pointed
arches still exhibited fragments of stained glass, once
the pride of monkish devotion. La Motte, thinking it
possible it might yet shelter some human being,
advanced to the gate and lifted a massy knocker....'

GILBERT WHITE (1720–93)

164. Daines Barrington, **The Naturalist's Journal**,
with White's manuscript entries for 1776
The Trustees of the British Museum
8 July 1776: 'sun. clouds. sprinkling. sun. distant
showers. fine. M^r Grimm, my artist, came from London
to take some of our finest views. Second swarm of bees
on the same bough of the balm of Gilead fir. Turned
the hay-cocks which are in a bad state. Cherries
delicate.'

165. **The Natural History and Antiquities of
Selborne** 1789
Illustrated by D. Lerpinière and P. Mazell after
S. H. Grimm
The Trustees of the British Museum
'A circumstance that I must not omit, because it was
new to us, is, that on *Friday, December* the 10th [1784],
being bright sun-shine, the air was full of icy *spiculae*,
floating in all directions, like atoms in a sun-beam let
into a dark room. We thought them at first particles of
the rime falling from my tall hedges; but were soon
convinced to the contrary, by making our observations
in open places where no rime could reach us. Were they
watery particles of the air frozen as they floated; or
were they evaporations from the snow frozen as they
mounted ? I forgot to mention before, that, during
the two severe days, two men, who were tracing hares
in the snow, had their feet frozen; and two men, who
were much better employed, had their fingers so
affected by the frost, while they were thrashing in a
barn, that a mortification followed, from which they
did not recover for many weeks.'

JAMES SOWERBY (1757–1822)

166. **English Botany**, Vol.I, 1790
The Linnean Society of London
English Botany was published between 1790 and 1814 in
37 volumes, containing over 2,500 illustrations, with
texts by Sir James Edward Smith (see No.137).

WILLIAM CURTIS (1746–99)

167. **The Botanical Magazine**, Vol.I, 1787
The Linnean Society of London
Through his *Botanical Magazine*, which was 'Intended
for the Use of such LADIES, GENTLEMEN, and
GARDENERS, as wish to become scientifically ac-
quainted with the Plants they cultivate', Curtis aimed
'to render Botany a lasting source of rational amuse-
ment, and public utility'. Rival journals sprang up but
Curtis', selling originally at 1s. per part, flourished and
is still published today. The early volumes were illus-
trated by William Kilburn, James Sowerby and Syden-
ham Edwards.

WILLIAM WORDSWORTH (1770–1850) and SAMUEL TAYLOR COLERIDGE

168. **Lyrical Ballads, with A Few Other Poems**
1798
The Trustees of the British Museum
'I cannot paint
What then I was. The sounding cataract
Haunted me like a passion: the tall rock,
The mountain, and the deep and gloomy wood,
Their colours and their forms, were then to me
An appetite: a feeling and a love,
That had no need of a remoter charm,
By thought supplied, or any interest
Unborrowed from the eye.—That time is
past. . . .
For I have learned
To look on nature, not as in the hour
Of thoughtless youth, but hearing oftentimes
The still, sad music of humanity,
Not harsh nor grating, though of ample power
To chasten and subdue. And I have felt
A presence that disturbs me with the joy
Of elevated thoughts; a sense sublime
Of something far more deeply interfused. . . .'
WILLIAM WORDSWORTH, 'Lines written a few miles
above Tintern Abbey, on revisiting the banks of the
Wye during a tour, July 13, 1798', ll. 75–83, 88–96

WILLIAM WORDSWORTH AND JOSEPH WILKINSON

169. **Select Views in Cumberland, Westmorland
and Lancashire** 1810
The Trustees of the British Museum
Wordsworth's text, published anonymously in this port-
folio of Wilkinson's plates, was first issued separately in
1822 as *A Description of the Lakes in the North of Eng-
land*, and went through many later editions.

DOROTHY WORDSWORTH (1771–1855)

170. **Grasmere Journal No.II (MS.)** October 1801–
February 1802
The Trustees of Dove Cottage (not exhibited)
31 January 1802: 'Grasmere was very soft and Rydale
was extremely beautiful from the pasture side. Nab
Scar was just topped by a cloud which cutting it off as
high as it could be cut off made the mountain look
uncommonly lofty. We sate down a long time in
different places. I always love to walk that way because
it is the way I first came to Rydale and Grasmere, and
because our dear Coleridge did also. When I came with
Wm 6½ years ago it was just at sunset. There was a rich
yellow light on the waters and the Islands were
reflected there. Today it was grave and soft but not
perfectly calm. William says it was much such a day as
when Coleridge came with him. The sun shone out

before we reached Grasmere. We sate by the roadside at the foot of the Lake close to Mary's dear name which she had cut herself upon the stone. William. . . . cut at it with his knife to make it plainer. We amused ourselves for a long time in watching the Breezes some as if they came from the bottom of the lake spread in a circle, brushing along the surface of the water, and growing more delicate, as it were thinner and of a *paler* colour till they died away. Others spread out like a peacock's tail, and some went right forward this way and that in all directions. The lake was still where these breezes were not, but they made it all alive.'

(Ed. Mary Moorman, *Journals of Dorothy Wordsworth*, 1971, pp.82–3)

164

SAMUEL TAYLOR COLERIDGE (1772–1834)

171. Notebook No.21 (MS.) 1797–1805
The Trustees of the British Museum
October 1803: 'The *white rose* of Eddy-foam, where the stream ran into a scooped or scolloped hollow of the Rock in its channel— this shape, an exact white rose, was for ever overpowered by the Stream rushing down in upon it, and still obstinate in resurrection it spread up into the Scollop, by fits and starts, *blossoming* in a moment into a full Flower.—Hung over the Bridge, & musing considering how much of this Scene of endless variety in Identity was Nature's—how much the living organ's!—What would it be if I had the eyes of a fly!— what if the blunt eye of a Brobdignag!—'

(Ed. Kathleen Coburn, *The Notebooks of Samuel Coleridge*, I, 1957, Serial No.1589

171

173

LUKE HOWARD (1772–1864)

172. Essay on the Modification of Clouds
Philosophical Magazine, XVI 1803
The Chemical Society, London
The first publication of Howard's paper on the classification and nomenclature (Cirrus, Cumulus, Stratus, etc) of cloud forms, read to the Askesian Society earlier in 1803.

THOMAS FORSTER (1789–1860)

173. Researches about Atmospheric Phænomena
2nd ed. 1815. Illustrated by F. C. Lewis after the author. John Constable's annotated copy.
Colonel J. H. Constable
'Meteorology considered as a subject of amusement seems to have some advantages over many other pursuits; inasmuch as it may be studied and will afford interest in places unfavourable to the cultivation of other sciences. The botanist, who delights in the diversification of nature exhibited in the endless variety of the forms and colour of flowers; or the naturalist, who finds amusement in contemplating the habits of animals, and the adaptation of the structure of each to its mode of life, cannot indulge their inclination except in habitable countries, or where vegetation and life abound. But on the barren mountain's rugged vertex, in the uniform gloom of the desert, or on the trackless surface of the ocean, we may view the interesting electrical operations which are going on above,

manifested in the formation and changes of the clouds, which bear water in huge masses from place to place, or throw it down in torrents on the earth and waters; occasionally creating whirlwinds and waterspouts; or producing the brilliant phaenomena of meteors and of lightning; and constantly ornamenting the sky with the picturesque imagery of coloured clouds and golden haze. The atmosphere and its phaenomena are every-where, and thunder rolls, and rainbows glitter in all conceivable situations, and we may view them whether it may be our lot to dwell in the frozen countries of polar ice, in the mild climates of the temperate zone, or in the parched regions which lay more immediately under the path of the sun.'

REV. ARTHUR YOUNG

174. **General View of the Agriculture of the County of Sussex.** Drawn up for the Consideration of the Board of Agriculture and Internal Improvement 1808
The Trustees of the British Museum

JOHN CLARE (1793–1864)

175. **Natural History Letter (MS.)** 7 February 1825
In a quarto exercise-book containing various prose writings by Clare.
Peterborough City Museum and Art Gallery
'The instinct of the snail is very remarkable & worthy notice tho such things are looked over with a carless eye—it has such a knowledge of its own speed that it can get home to a moment to be safe from the sun as a moment too late woud be its death—as soon as the sun has lost its power to hurt in the evening it leaves its hiding place in search of food which it is generally aware were to find if it is a good way off it makes no stoppages in the road but appears to be in great haste & when it has divided its time to the utmost by travelling to such a length as will occupy all the rest of its spare time to return its instinct will suddenly stop & feed on what it finds there & if it finds nothing it will go no further but return homewards & feed on what it chances to meet with & if after it gets home the sun shoud chance to under a cloud it will potter about its door way to seek food but it goes no further & is ready to hide when the sun looks out'
(Ed. J. W. and Anne Tibble, *The Prose of John Clare*, 1951, p.184)

176. **Essay on Landscape (MS.)** 1820s
In a foolscap volume of prose, poems, memoranda and accounts.
Peterborough City Museum and Art Gallery
'There are other ridiculous situations oft to be found in modern fancy Landscapes where we often meet a group of cattle indiscrimatly intermixed just as they fancied not as they found them thus cows horses &

sheep were never seen in that situation since Noahs flood. . . . so much for fancy pictures & their unnatural extras—yet when nature dreams herself into extravagant vagaries & fancy pictures they are always beautiful fancys & who hath not seen some of these vagaries on beholding a Forrest cloaked in the magic foliage of a snowstorm—while walking in the fields in winter when the snow hung in light fairey shadows upon every tree & bush & tiny stalk of witherd herbage'
(*Ibid.*, p.214)

177. **The Mores.** First published 1966

'Now this sweet vision of my boyish hours
Free as spring clouds and wild as summer flowers
Is faded all—a hope that blossomed free
And hath been once no more shall ever be
Inclosure came and trampled on the grave
Of labours rights and left the poor a slave
And memorys pride ere want to wealth did bow
Is both the shadow and the substance now. . . .
Fence now meets fence in owners little bounds
Of field and meadow large as garden grounds
In little parcels little minds to please
With men and flocks imprisoned ill at ease. . . .
Each little tyrant with his little sign
Shows where man claims earth glows no more divine
But paths to freedom and to childhood dear
A board sticks up to notice 'no road here'
And on the tree with ivy overhung
The hated sign by vulgar taste is hung
As tho the very birds should learn to know
When they go there they must no further go'
ll.15–22, 47–50, 67–74
(Eric Robinson and Geoffrey Summerfield,
Clare, Selected Poems and Prose, 1966, pp.188–90)

WILLIAM SMITH (1769–1839)

178. **A Delineation of the Strata of England and Wales, with part of Scotland;** exhibiting The Collieries and Mines, the Marshes and Fen Lands originally overflowed by the sea, and the Varieties of Soil According to the Variations in the Substrata 1815
The Institute of Geological Sciences
The earliest large-scale (5 miles to 1 inch) geological map of any extensive area. Smith later published geological maps of individual English counties.

179. **A Geological Section from London to Snowdon;** showing the Varieties of the Strata, and the correct Altitude of the Hills 1817
The Institute of Geological Sciences

THE ORDNANCE SURVEY

180. **One-inch Old Series Sheet 7: London** 1822
The Royal Geographical Society

181. **One-inch Old Series Sheet 7: London** 1862
The Royal Geographical Society

CHARLES LYELL (1797–1875)

182. **Principles of Geology**, Vol.I 1830
The Institute of Geological Sciences

'We often discover with surprise, on looking back into the chronicles of nations, how the fortune of some battle has influenced the fate of millions of our contemporaries, when it has been long forgotten by the mass of the population. With this remote event we find inseparably connected the geographical boundaries of a great state, the language now spoken by the inhabitants, their peculiar manners, laws, and religious opinions. But far more astonishing and unexpected are the connexions brought to light when we carry back our researches into the history of nature. The form of a coast, the configuration of the interior of a country, the existence and extent of lakes, valleys and mountains, can often be traced to the former prevalence of earthquakes and volcanoes in regions which have long been undisturbed.'

JOHN RUSKIN (1819–1900)

183. **Modern Painters**, Vol.I 1843
The Trustees of the British Museum

'The teaching of nature is as varied and infinite as it is constant; and the duty of the painter is to watch for every one of her lessons, and to give (for human life will admit of nothing more) those in which she has manifested each of her principles in the most peculiar and striking way. The deeper his research and the rarer the phenomena he has noted, the more valuable will his works be; to repeat himself, even in a single instance, is treachery to nature, for a thousand human lives would not be enough to give one instance of the perfect manifestation of each of her powers; and as for combining or classifying them, as well might a preacher expect in one sermon to express and explain every divine truth which can be gathered out of God's revelation, as a painter expect in one composition to express and illustrate every lesson which can be received from God's creation. Both are commentators on infinity, and the duty of both is to take for each discourse one essential truth, seeking particularly and insisting especially on those which are less palpable to ordinary observation and more likely to escape an indolent research; and to impress that, and that alone, upon those whom they address, with every illustration that can be furnished by their knowledge, and every adornment attainable by their power. And the real truthfullness of the painter is in proportion to the number and variety of the facts he has so illustrated; those facts being always, as above observed, the realization, not the violation of a general principle. The quantity of truth is in proportion to the number of such facts, and its value and instructiveness in proportion to their rarity. All really great pictures, therefore, exhibit the general habits of nature, manifested in some peculiar, rare, and beautiful way. . . .

'It ought farther to be observed respecting truths in general, that those are always most valuable which are most historical, that is, which tell us most about the past and future states of the object to which they belong. In a tree for instance, it is more important to give the appearance of energy and elasticity in the limbs which is indicative of growth and life, than any particular character of leaf, or texture of bough. It is more important that we should feel that the uppermost sprays are creeping higher and higher into the sky, and be impressed with the current of life and motion which is animating every fibre, than that we should know the exact pitch of relief with which those fibres are thrown out against the sky. For the first truths tell us tales about the tree, about what it has been, and will be, while the last are characteristic of it only in its present state, and are in no way more interesting and more important than silent ones. So again the lines in a crag which mark its stratification, and how it has been washed and rounded by water, or twisted and drawn out in fire, are more important, because they tell more than the stains of the lichens which change year by year, and the accidental fissures of frost or decomposition; nor but that both of these are historical, but historical in a less distinct manner, and for shorter periods.'

<div align="right">Pt.II, Chapters V, §4, VI, §1</div>

ALFRED TENNYSON (1809–92)

184. **In Memoriam** 1850
The Trustees of the British Museum

'Are God and Nature then at strife,
 That Nature lends such evil dreams?
 So careful of the type she seems,
So careless of the single life;

That I, considering everywhere
 Her secret meaning in her deeds,
 And finding that of fifty seeds,
She often brings but one to bear. . . .

"So careful of the type"? but no.
 From scarped cliff and quarried stone
 She cries, "A thousand types are gone:
I care for nothing, all shall go.

"Thou makest thine appeal to me:
 I bring to life, I bring to death:
 The spirit does but mean the breath:
I know no more." And he, shall he,

Man, her last work, who seem'd so fair,
 Such splendid purpose in his eyes,
 Who roll'd the psalm to wintry skies,
Who built him fanes of fruitless prayer,

Who trusted God was love indeed
 And love Creation's final law—
 Tho' Nature, red in tooth and claw
With ravine, shriek'd against his creed—

Who loved, who suffer'd countless ills,
 Who battled for the True, the Just,
 Be blown about the desert dust,
Or seal'd within the iron hills?'

<div align="right">Sections LV–LVI</div>

<div align="right">[81]</div>

THOMAS GIRTIN (1775–1802)

'If Tom Girtin had lived I should have starved'.[1] Turner's much-quoted remark is slightly mysterious. Does it mean that he thought Girtin a better artist than himself? We know, indeed, that his admiration for Girtin was great. Or does Turner mean that competition was so fierce that there was hardly room for two distinctive artists? Girtin certainly made a name for himself, and some patrons preferred him to Turner. Hoppner told Farington in 1799 that 'Mr. Lascelles as well as Lady Sutherland are disposed to set up Girtin against Turner,—who they say effects his purpose by industry—the former more genius—Turner finishes too much'.[2] Inscriptions in Girtin's only surviving sketchbook show, rather surprisingly, that he could sell small drawings coloured on the spot for eight guineas each; larger works fetched up to twenty guineas. He had a variety of patrons, aristocratic and otherwise. Girtin never established himself in Academic circles, failing to gain any support for his A.R.A. candidacy in 1801, two years after Turner had been elected by a large majority, but clearly he did well enough for Turner to feel apprehensive.

Lit: Thomas Girtin and David Loshak, *The Art of Thomas Girtin*, 1954.

185

185. **Cloud Study** 1794
Inscribed 'T.Girtin 1794'
Wash, $4\frac{1}{2} \times 7\frac{1}{4}$ in.
W. A. Brandt, Esq.

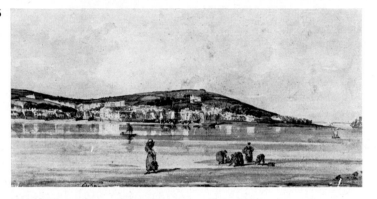

186

186. **Exmouth** *c.*1797–8
Inscribed 'Girtin'
Watercolour, $9\frac{1}{2} \times 18\frac{1}{2}$ in.
Lit: Girtin and Loshak No.254
The Courtauld Institute of Art (Witt Collection)

187. **The White House, Chelsea** 1800
Inscribed 'Girtin 1800'
Watercolour, $11\frac{3}{4} \times 20\frac{1}{4}$ in.
Lit: Girtin and Loshak No.337ii
The Tate Gallery (4728)

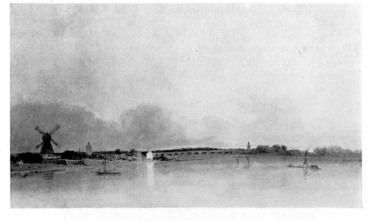

187

Another version is in the collection of Sir Edmund Bacon, Bt. One or other is the subject of the following anecdote: 'A dealer went one day to Turner, and after looking round at all his drawings in the room, had the audacity to say, "I have a drawing out there in my hackney coach, finer than any of yours." Turner bit his lip, looked first angry, then meditative. At length he broke silence: "Then I tell you what it is. You have got Tom Girtin's *White House at Chelsea*!" '.[3] Turner's admiration is also suggested by his inscription of Girtin's name and the title of this work on two of his own Swiss sketches of *c.*1840 (British Museum, Turner Bequest CCCXLII–66,–70).

188. **Gordale Scar** ?1801
Inscribed 'Gordale Scarr'
Watercolour, $5\frac{3}{8} \times 7\frac{3}{4}$ in.
Lit: Girtin and Loshak No.445
The Trustees of the British Museum (1855–2–14–19)

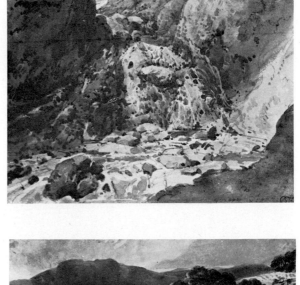
188

189. **Above Bolton** ?1801
Inscribed 'above Bolton'
Watercolour, 5⅝ × 8 in.
Lit: Girtin and Loshak No.441i
The Trustees of the British Museum (1855–2–14–10)
No.189 served as the basis for the large watercolour
known as 'Stepping Stones on the Wharfe' (Coll. Mr &
Mrs Tom Girtin).

190. **Albion Mills** *c.*1797–8
Watercolour, 12½ × 20 in.
Lit: Girtin and Loshak No.225ii
The Trustees of the British Museum (1855–2–14–24)
A study for part of Girtin's 'Eidometropolis', a circular
panorama of London painted in oil or tempera on can-
vas and perhaps measuring about 9 × 216 feet.[4] The
panorama is thought to have been executed around
1797–8 but was not exhibited, at Spring Gardens, until
shortly before Girtin's death. Girtin and Loshak specu-
late that the project was originally backed by J. S. Hay-
ward, 'floor-cloth manufacturer' and amateur artist, on
whose premises it could have been painted, but that the
two fell out and Girtin was left without the means to
exhibit his panorama.[5] He apparently tried to show it in
Paris but was refused permission by the French au-
thorities.[6] When eventually exhibited in Spring Gar-
dens in 1802 the 'Eidometropolis' was 'not much
noticed by the public', according to Edward Edwards,[7]
while *The New Monthly Magazine* described it as 'the
connoisseur's panorama'.[8] Its lack of popular success
has been attributed to the fact that Robert Barker had
already displayed a London panorama taken from al-
most the same spot, i.e. from near the southern end of
Blackfriars Bridge.
Albion Flour Mills were opened in 1784, but des-
troyed by fire in 1791.

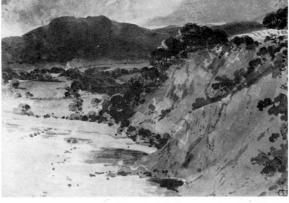
189

JOSEPH MALLORD WILLIAM TURNER (1775–1851)

Turner is the great virtuoso of English landscape art,
the man who took on everything and everybody, ex-
ploiting all available media and genres and overriding
established conventions when the spirit, or commercial
necessity, dictated: he drew in pen, pencil, chalk; paint-
ed in watercolour, oil, and, if legend is to be believed,
watercolour and oil together—much of his work is of
the utmost technical refinement, dexterous to the point
of magic. He ranged from antiquarian draughtsmanship
through topography and architecture (not for long),
Picturesquerie, magazine and book illustration, mar-
ines, to grandiose historical landscape. There was a
sizable Turner print industry. He found patrons at
nearly every level of picture-buying society, from the
semi-literate fan of the Keepsakes to the Milord. He
was A.R.A. 1799, a full Academician 1802, Professor of
Perspective 1806–38 (though an occasional lecturer
only), and Deputy President—his election to the Presi-
dency was announced, credibly though wrongly, at one
stage. But his art was hardly ever without enemies as

190

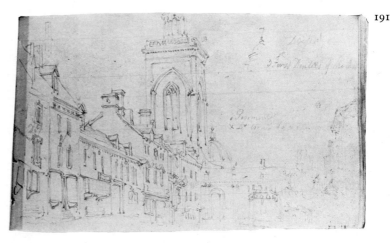
191

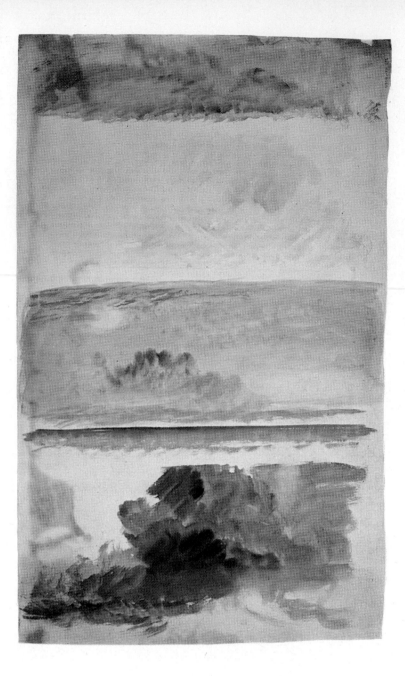

217. J. M. W. Turner
Studies of Skies

well as encomiasts and much of his *oeuvre* baffled (and continues to baffle) his audience.

Lit: Walter Thornbury, *The Life of J. M. W. Turner, R.A.*, 1862.

A. J. & H. F. Finberg, *The Life of J. M. W. Turner, R.A.*, 1961.

A. J. Finberg, *The History of Turner's Liber Studiorum*, 1924.

W. G. Rawlinson, *The Engraved Work of J. M. W. Turner, R.A.*, 1908–13.

191. **Northampton** 1794
Pencil, $4\frac{1}{4} \times 7\frac{1}{4}$ in.
The Trustees of the British Museum (Turner Bequest XIX, p.12)

In the 'Matlock' sketchbook used by Turner in the Midlands in 1794. On his early tours of Britain, Turner, like any other topographical artist of the period, collected material to be worked up into watercolours for exhibition or to be engraved for publication. Orders for watercolours might also be placed on the spot by patrons who saw his sketchbook studies. These comparatively humble occupations were the basis of his reputation and his fortune, but neither was easily won, as his sardonic remark to Farington in 1798 suggests—he had 'more commissions at present than He could execute & got more money than He expended'.[1] The work sold to publishers must have been the least satisfactory part of all this because the engravers working for such publications as *The Copper Plate Magazine* and *The Pocket Magazine* were hardly able to do Turner justice.

T. TAGG after J. M. W. TURNER

192. **Northampton** 1795
Line engraving, $2\frac{3}{4} \times 4\frac{1}{2}$ in.
Lit: Rawlinson No.31
The Trustees of the British Museum (1893–6–12–138)

Published in 1795 in three of Harrison & Co.'s serials, *The Pocket Magazine*, *The Ladies Pocket Magazine* and *The Pocket Print Magazine*. Fifteen other small engravings after Turner appeared in the same magazines during 1795–6. The plates were reprinted in 1804 for Lackington & Allen's *England Delineated*. Tagg presumably worked from a watercolour (now lost) made by Turner from the pencil sketch, No.191.

Fonthill 1799
193. Pencil, $18\frac{5}{8} \times 13$ in.
The Trustees of the British Museum (Turner Bequest XLVII–1)

194. Watercolour, $13 \times 18\frac{5}{8}$ in. 1799
The Trustees of the British Museum (Turner Bequest XLVII–11)

95. Pencil, $18\frac{5}{8} \times 13$ in. 1799
The Trustees of the British Museum (Turner Bequest XLVII–4)

196. Watercolour, $18\frac{5}{8} \times 13$ in. 1799
The Trustees of the British Museum (Turner Bequest XLVII–10)

193

195

194

196

197

197. Watercolour, 41½ × 28 in. ?1799
The Trustees of the British Museum (Turner
Bequest LXX–P)

198. Watercolour, 27 × 40½ in. ?exhibited 1800
*The National Trust for Scotland (Brodick Castle,
Isle of Arran)*

In 1799 Turner was commissioned by William Beck-
ford, the millionaire eccentric and author of *Vathek*, to
make drawings of the 'gothic' abbey which he was
building at Fonthill in Wiltshire. He spent three weeks
making a variety of studies of the place, from meticu-
lous architectural drawings of the unfinished building
(No.193) to distant views in which the abbey seems the
least of his interests (Nos.194, 196). From such studies
Turner prepared several large watercolours, five of
which, probably including No.198, he exhibited at the
Royal Academy in 1800. In that year he told Farington
that he was thinking of charging Beckford 40 guineas
each for seven watercolours, but in the event he seems
to have settled for 35 guineas each. About the same time
Beckford bought Turner's first history painting, 'The
Fifth Plague of Egypt', for 150 guineas. One of the
attractions of Fonthill for Turner was that it housed the
two 'Altieri' Claudes which Beckford had recently pur-
chased.

199–203. Liber Studiorum
Turner was, apparently, indebted to his friend the
watercolourist W. F. Wells for the idea of producing a
series of prints which would epitomise his achievement
in landscape. Wells, said his daughter Mrs Wheeler,
was 'constantly urging Turner to undertake a work on
the plan of Liber Veritatis [see No.5]. I remember over
and over again hearing him say—"For your own
credit's sake Turner you ought to give a work to the
public which will do you justice—if after your death any
work injurious to your fame should be executed, it then
could be compared with the one you yourself gave to
the public." '[2] Turner is reported to have sat down
there and then, in October 1806, to plan the work, make
drawings for the first plates and arrange for publication.
The designs were etched on the plates by Turner and
completed in mezzotint by engravers employed by him
or, in a few cases, by Turner himself. The first number,
comprising five subjects, appeared in June 1807, Turner
having previously exhibited the corresponding drawings
in his Harley Street gallery. A manuscript prospectus
displayed in the gallery announced: 'It is intended in
this publication to attempt a classification of the various
styles of landscape, viz., the historic, mountainous,
pastoral, marine, and architectural.'[3] Despite Mrs
Wheeler's allusion, Turner's aim was very different
from Claude's in the 'Liber Veritatis'. The *Liber Studio-
rum* was to be not simply a private record, nor even, as
Wells suggested it should be, a public one, but was in-
tended, in Thornbury's words, 'to show his command
of the whole compass of landscape art, and the bound-
less and matchless richness of his stores both of fact and
invention'.[4] But an exchange between the engraver John
Pye and Turner suggests that this was not all. Roget
retails one of Pye's memoranda: ' "When," Pye writes,
"I told him I desired to have a copy of the *Liber*, for
that I liked it, he said, 'What is there in it that you like?'

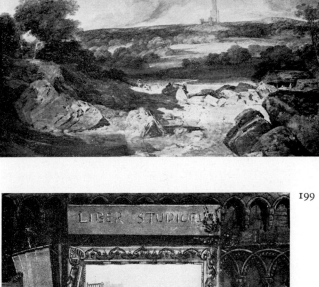

'The variety of effects,' was my reply. 'There's nothing else. I want something more than that,' said he." [5] Did he want the sort of appreciation that Ruskin gave in *Modern Painters*, a sense of the philosophy underlying the work? The theme of the *Liber Studiorum*, Ruskin believed, was decay and ruin. 'Turner only momentarily dwells on anything else than ruin. Take up the Liber Studiorum, and observe how this feeling of decay and humiliation gives solemnity to all its simplest subjects. . . . The meaning of the entire book was symbolised in the frontispiece, which he engraved with his own hand: Tyre at sunset, with the Rape of Europa, indicating the symbolism of the decay of Europe by that of Tyre, its beauty passing away into terror and judgment (Europa being the mother of Minos and Rhadamanthus).' [6]

199

The project was beset with difficulties. Turner was unwilling to pay his engravers adequately and the first two he employed, F. C. Lewis and Charles Turner, resigned from the work for that reason. The *Liber* was insufficiently advertised, irregularly published and finally abandoned in 1819 when 71 of the intended 101 plates had appeared. Only towards the end of his life was there much of a market for the prints, but Turner himself never undervalued them. By 1816 he had raised the price per number, i.e. five prints, from 15s. to £1.1s. and from £1.5s. to £2.2s. for proofs. When interest picked up in the 1840s he adopted a hard line towards the print-dealers, who until then had not handled the work. Dominic Colnaghi, for example, found his discount cut from 20 per cent to 10 per cent in two or three years, and finally to nothing: ' "But," said I, "in that case how are we to live?" "That's no affair of mine," said he.' [7]

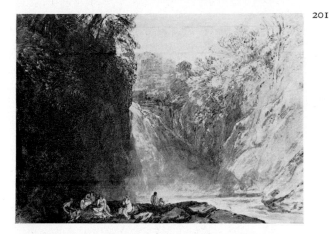

201

199. **Frontispiece**

Proof of the etching, extensively worked over by Turner in pen and wash, $7\frac{3}{8} \times 10\frac{7}{16}$ in.
Lit: Finberg 1924, No.1
The Trustees of the British Museum (Turner Bequest CXVII–V)

The plate was mezzotinted by I. C. Easling, except the central part, which Turner himself engraved. It was published in 1812.

200. **The Fifth Plague of Egypt**

Etching (by Turner) and mezzotint (by Charles Turner), $7\frac{1}{16} \times 10\frac{1}{4}$ in.
Lit: Finberg 1924, No.16
The Tate Gallery (4049)

Published 1808. Based on the painting bought by William Beckford in 1800: an 'Historic' landscape in Turner's classification.

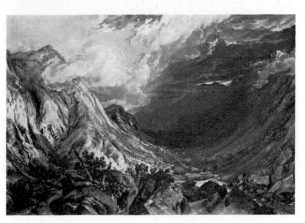

202

201. **The Fall of the Clyde**

Pen and sepia, $7\frac{1}{4} \times 10\frac{1}{4}$ in.
The Trustees of the British Museum (Turner Bequest CXVI–U)

Original drawing for the *Liber Studiorum*. The plate, published in 1809, was etched by Turner and mezzotinted by Charles Turner: an 'E.P.' subject in Turner's classification, variously interpreted as Elevated Pastoral, Epic Pastoral and Elegant Pastoral—this is one category Turner did not explain.

203a

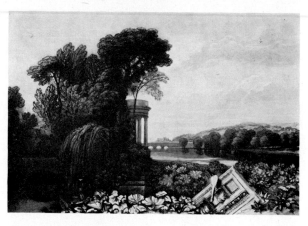

203b

204

205

[88]

202. **Ben Arthur**

Etching (by Turner) and mezzotint (by Thomas Lupton), $7\frac{3}{16} \times 10\frac{9}{16}$ in.
Lit: Finberg 1924, No.69
The Tate Gallery (4049)

Published 1819: a 'Mountainous' subject.

203. **Isis**

a. Etching (by Turner), $7\frac{1}{16} \times 10\frac{1}{4}$ in.
b. Etching (by Turner) and mezzotint (by William Say), $7\frac{1}{16} \times 10\frac{1}{4}$ in.
Lit: Finberg 1924, No.68
The Tate Gallery (4049)

Published 1819: an 'E.P.' subject (see No.201).

204. **Walton Reach**

Oil on panel, $14\frac{1}{2} \times 29$ in.
The Tate Gallery (2681)

This is one of a small group of studies which is unique in Turner's *oeuvre* and has never been satisfactorily dated. Finberg, for no very good reason, ascribed them all to *c*.1807, John Gage, for this particular study and a similar one (Tate Gallery 2680), inclines to *c*.1810–12[8]. Conal Shields tentatively suggests that the peculiar character of No.204 and its companion derives from the use of a mechanical aid, the camera lucida patented by W. H. Wollaston in 1807 (see No.304): Turner has none of his usual difficulty with the proportions of things, with perspective, but goes directly to the notation of colour and tonal relationships. These studies seem to come midway between Turner's two principal methods of working, both of which can be seen in the Fonthill series: one is to painstakingly move from point to point around the outline of his subject, as in No.193, the other to refine at length upon the most generalised of statements, as he does in No.196. Mr Shields' speculation has the virtue of resolving a seeming contradiction between accounts of the artist on the job: at some moments almost comically secretive and at others extravagantly exhibitionistic. Turner, who was prone to sneer at mere 'Map making' as no business of the genuine landscapist, might well have wished to conceal the use of a machine.

205. **Sketch of a Bank with Gipsies** Exhibited 1809

Oil on canvas, 24×33 in.
Exh: Turner's Gallery 1809(1)
The Tate Gallery (467)

As Dr Gage says, this is one of Turner's last essays in the Picturesque.[9] The artist runs through the stock motifs: broken ground, gipsies, cattle, a cart. It is also one of Turner's acts of homage to Rembrandt. The nearest model seems to be 'The Rest on the Flight to Egypt' (The National Gallery of Ireland), which Turner may have come across at Stourhead as early as 1796 and which, unlike its owner, he had examined closely enough to recognise for what it was: Richard Colt Hoare called it 'A Moonlight, in which some gypsies are reposing by a fire-side'.[10] The forced contrast of light and dark in Turner's 'Sketch' is the Rembrandtian chiaroscuro, those 'bursts of light and darkness', which he analysed in his 'Backgrounds' lecture in 1811 (see p.21).

No.205 is one of the works exhibited by Turner in his own gallery in Harley Street, which he opened in

1804. This gallery functioned until 1816 and was replaced by a new one in 1822. Although he continued to send things to the Academy and elsewhere, possession of his own gallery gave Turner much greater control over the conditions in which his work was shown and also allowed him to show more of it. A similar dissatisfaction with the manner in which pictures were hung at the Royal Academy had led Gainsborough to the same expedient in the 1780s (see No.60).

**206. Tabley: The Seat of Sir J. F. Leicester, Bart.
—Windy Day** 1808–9
Oil on canvas, 36 × 47½ in.
Exh: R.A.1809(105)
Lt. Col. J. L. B. Leicester-Warren

206

One of two paintings of Tabley in Cheshire commissioned from Turner by Sir John Leicester in 1808, probably at 250 guineas each. The other is now at Petworth. They were well received at the Academy: 'the views of Sir John Leicester's seat, which in any other hands would be mere topography, touched by his magic pencil have assumed a highly poetical character', wrote the critic of *The Repository of Arts*: 'It is on occasions like this that the superiority of this man's mind displays itself; and in comparison with the production of his hands, not only all the painters of the present day but all the boasted names to which the collectors bow— sink into nothing'.[11] For James Ward's different view of the matter see No.219.

Sir John Leicester was an important patron not only of Turner, from whom at various dates he purchased eleven works, but of British artists in general. By 1818 he was able to open to the public, in his gallery in Hill Street, London, a collection of nearly 70 British paintings, most of them acquired since 1805 and about a third of them landscapes or seascapes. In 1823 his offer to sell this collection (by that time amounting to about 100 items) to the nation as the basis of a National Gallery was rejected by the Prime Minister on grounds of cost, but the respectable prices subsequently fetched by the pictures at auction gave a different sort of encouragement to native artists.

**207. Snow Storm: Hannibal and his Army
Crossing the Alps** Exhibited 1812
Oil on canvas, 57 × 93 in.
Exh: R.A.1812(258)
The Tate Gallery (490)

When he exhibited 'Hannibal' at the Academy Turner published in the catalogue the first of several quotations he was to make from his manuscript poem 'Fallacies of Hope':
"Craft, treachery, and fraud—Salassian force,
Hung on the fainting rear! then Plunder seiz'd
The victor and the captive,—Saguntum's spoil,
Alike became their prey; still the chief advanc'd,
Look'd on the sun with hope;—low, broad, and wan;
While the fierce archer of the downward year
Stains Italy's blanch'd barrier with storms.
In vain each pass, ensanguin'd deep with dead,
Or rocky fragments, wide destruction roll'd.
Still on Campania's fertile plains—he thought,
But the loud breeze sob'd, 'Capua's joys beware!' "

208

207

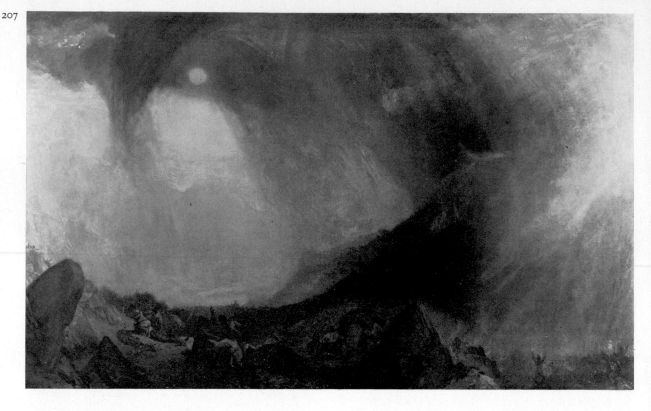

Although widely regarded as the best picture of the year, its anti-heroics were not altogether approved or even understood. The critic of the *St. James's Chronicle*, entirely missing the point, thought the subject 'badly considered. The soldiers of Hannibal in the act of crossing the Alps during a storm might have been represented in a manner more becoming hardy warriors than crouching under projections of rocks for shelter from the snow'.[12] 'Hannibal', expressing the futility of man's efforts in the face not only of nature but of history, marks the beginning of Turner's involvement with Carthage. The fate of Carthage, corrupted by the luxury of 'Capua's joys', and by inference the possible fate of Britain, became an obsession, brought to a head in 'Dido building Carthage' (1815) and 'The decline of the Carthaginian Empire' (1817).

The storm effects in 'Hannibal' are said to have been studied in Yorkshire during a visit to his friends the Fawkes:

> "One stormy day at Farnley," says Mr. [Hawkesworth] Fawkes, Turner called to me loudly from the doorway, "Hawkey—Hawkey!—come here —come here! Look at this thunderstorm! Isn't it grand?—isn't it wonderful?—isn't it sublime?
>
> "All this time he was making notes of its form and colour on the back of a letter. I proposed some better drawing-block, but he said it did very well. He was absorbed—he was entranced. There was the storm rolling and sweeping and shafting out its lightning over the Yorkshire hills. Presently the storm passed, and he finished. 'There,' said he, 'Hawkey; in two years you will see this again, and call it Hannibal Crossing the Alps.' "[13]

This sort of anecdote generally suggests a specious connection between Turner's nominal subject matter and his interest in the effects of nature. It was not like this

to Turner. He looked at nature with a mind already charged with certain themes and didactic intentions, and in this case already deeply impressed with another 'Hannibal', that of J. R. Cozens, which, C. R. Leslie heard, 'Turner spoke of. . . . as a work from which he learned more than from anything he had then seen'.[14]

208. **Crossing the Brook** Exhibited 1815
 Oil on canvas, 76 × 65 in.
 Exh: R.A.1815(94)
 The Tate Gallery (497)

'Crossing the Brook' was based in part on sketches made by Turner in Devon in 1813. One of his companions on that tour, Cyrus Redding, identified the bridge in the picture as New Bridge over the Tamar at Gunnislake.[15] He described Turner's delight with the scenery of the Tamar Valley and said he 'was struck with admiration at the bridge above the Wear, which he declared altogether Italian'.[16] One morning they rose before six 'and went down towards the bridge. The air was balmy; the strong light between the hills, the dark umbrage, and the flashing water presented a beautiful early scene. Turner sketched the bridge, but appeared, from changing his position several times, as if he had tried more than one sketch, or could not please himself as to the best point. I saw that bridge and part of the scene afterwards in a painting in his gallery. He had made several additions to the scenery near the bridge from his own imagination.'[17] Charles Lock Eastlake, apparently also with Turner on this occasion, identified the bridge as that at Calstock.[18]

The composition is more or less 'Claudian' and has been compared to the 'Hagar and the Angel' which Sir George Beaumont owned (see No.1). In the foreground, however, Turner modifies the traditional formula by introducing not a biblical or mythological episode, but

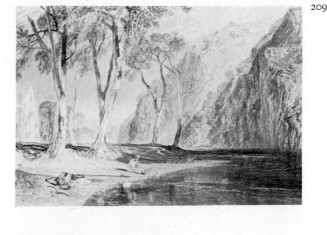

209

an unportentous genre scene which only serves to emphasise the landscape behind. In handling and colour too the work is un-Claudian: the trees are rather Rubensian. Beaumont himself could not stand the picture. For several years a severe critic of Turner's eccentricities, he found 'Crossing the Brook' *weak and like the work of an Old man, one who no longer saw or felt colour properly; it was all of pea-green insipidity*.[19] Although this seems to have been a minority opinion, Turner did not find a buyer for the painting, though Cotman's patron Dawson Turner enquired about it in 1818, when the price was 550 guineas.

209–13. Picturesque Views in England and Wales

Begun in 1827, *Picturesque View in England and Wales* was the most ambitious of the many publishing schemes Turner was involved in. 120 subjects were to be engraved, Turner receiving 60–70 guineas for each of his watercolours, the engravers £80–£100 for each plate. Most of the engravers had worked for Turner before and, following the detailed instructions indicated on his proofs, were able to match the brilliance of his watercolours. But the work found little response in the public. After various changes of publisher, the proprietor Charles Heath went bankrupt in 1838, when 96 of the subjects had been published, and the copperplates and remaining stock were auctioned by his trustees. Turner bought the lot at the reserve price of £3,000 and kept them until his death, refusing at least one offer from a publisher for them.

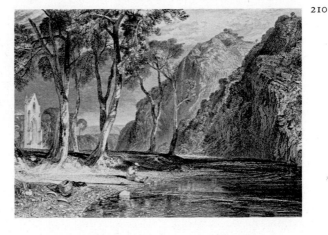

210

209. Bolton Abbey
Watercolour, 11 × 15½ in.
The Trustees of the Lady Lever Art Gallery, Port Sunlight

ROBERT WALLIS after J. M. W. TURNER
210. Bolton Abbey Published 1827
Line engraving, 6 7/16 × 9 in.
Lit: Rawlinson No.212
The Trustees of the British Museum (1850–1–12–2)

211. Richmond, Yorkshire
Watercolour, 10¾ × 15½ in.
The Fitzwilliam Museum, Cambridge

J. T. WILLMORE after J. M. W. TURNER
212. Richmond, Yorkshire Published 1828
Line engraving, 6 9/16 × 9 3/16 in.
Lit: Rawlinson No.232
The Trustees of the British Museum (1851–3–8–769)

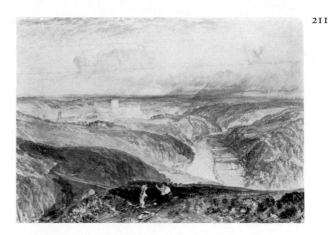

211

213a–d. Lancaster from the Aqueduct Bridge
Line engravings by Robert Wallis, each
6½ × 9⅛ in.: 3 working proofs (one heavily scratched, touched and annotated by Turner) and an impression of the plate as published in 1827.
Lit: Rawlinson No.210
The Trustees of the British Museum (1889–7–24–169; 1894–2–26–10; 1894–2–26–11; 1849–5–12 682)

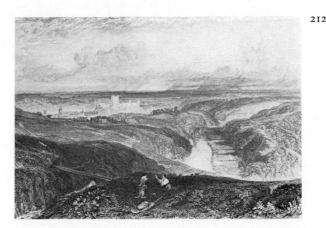

212

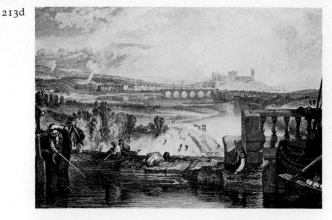

213d

214

215

214–217. **'Colour Beginnings'**

214. **On the Coast**
 Watercolour, 13¾ × 20 in.
 The Trustees of the British Museum (Turner Bequest CCLXIII–7)

215. **Rolling Clouds**
 Watercolour, 12 × 19 in.
 The Trustees of the British Museum (Turner Bequest CCLXIII–80)

216. **Studies of Clouds**
 Watercolour, 22 × 12½ in.
 The Trustees of the British Museum (Turner Bequest CCLXIII–122)

217. **Studies of Skies**
 Watercolour, 21½ × 15 in., repr. on p.84
 The Trustees of the British Museum (Turner Bequest CCLXIII–119)

In the main, English artists set about picture-making with a primarily linear pattern in mind. In the so-called 'Colour Beginnings' Turner seems to be adapting in terms of colour the 'blottism' of Cozens. He employed such methods as early as 1799, when Farington reported: 'Turner has no settled process but drives the colours abt. till He has expressed the Idea in his mind.'[20]

218. **The Fall of the Clyde** *c.*1835
 Oil on canvas, 35 × 47 in.
 The Trustees of the Lady Lever Art Gallery, Port Sunlight

At the Royal Academy in 1802 Turner exhibited a watercolour (now Walker Art Gallery, Liverpool) with the caption 'The fall of the Clyde, Lanarkshire: Noon. —Vide Akenside's Hymn to the Naiads'. The subject reappeared in the *Liber Studiorum* (see No.201). Akenside sees 'The Nymphs who preside over springs and rivulets' as 'giving motion to the air, and exciting summer breezes; as nourishing and beautifying the vegetable creation'. As Dr Gage says, Turner's 1802 watercolour 'was scarcely able to show that it was about the elemental forces of nature, the effect of sun on water, without a reference to Akenside's *Hymn to the Naiads*; in the prismatic colour of the later oil versions. . . . this content is immediately clear'.[21] It is, indeed, reasonable to see the later work as in some sense a critique of the 1802 piece, but what precisely is the character of that critique, one can hardly say. Critics (then as now) have hidden behind such words as 'abstract'. Ruskin, himself a fanatical cataloguer of natural phenomena, whose involvement with Turner's work was of unparalleled intensity, believed that Turner knew more about the look of nature than anybody ever, that his late pictures were full of 'information', but that particulars had been somehow conflated, built into generalisations of entirely novel power.

JAMES WARD (1769–1859)

219. Tabley Lake and Tower 1814
Inscribed 'J. Ward [cipher], R.A. 1814'
Oil on canvas, 37 × 53½ in.
The Tate Gallery (385)

When Sir John Leicester commissioned Ward to paint this view of Tabley he already had two paintings of the place by Turner (see No.206) and one by Henry Thomson, as well as the Richard Wilson which his father had commissioned (No.40). Ward tried to justify his own contribution in a letter to Sir John in 1814:

'I have had to tell a story that has been told before so beautifully as to make me tremble—yet I must consider them as told with great Poetic liberties as to the Picturesque. . . . I see Tabley Tower as anything but a Picturesque or Rustic object. . . . if I take the liberties that others have done, I am only repeating the ground that has been already three times passed over, the only road left me is to produce something new by a more rigid attention to truth. The effect is such as I have often seen on the spot, It is a close sultry day, what is vulgarly called a Muggy or a murky day—when the air is charged or charging with Electric fluid—preparitory to a Thunder storm. A gentle breeze is slowly running [?] over the surface of the Lake. . . . The Foliage near the Tower you call stiff and formal, I would term classically simple

uniting with—the Tower running on but increasing in variety as it approaches the Shepherd, etc—to the distant Cattle, and led on by the sail etc to the climax of light colour and interest in the foreground group the focus of which is the Young White Bull, the Adonis of my picture. . . .'[22]

After further explanation he concluded: 'Thus Sir John I have endeavoured to prove to you that what I have done is not the effect of chance and that if I have erred it was in consideration that I was painting a portrait that had been three times painted before'. Ward was paid £100 but asked, and apparently received, a further £50 for additional work on the picture.

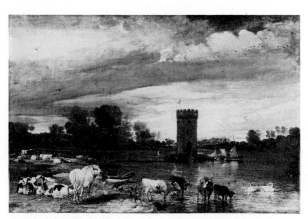

219

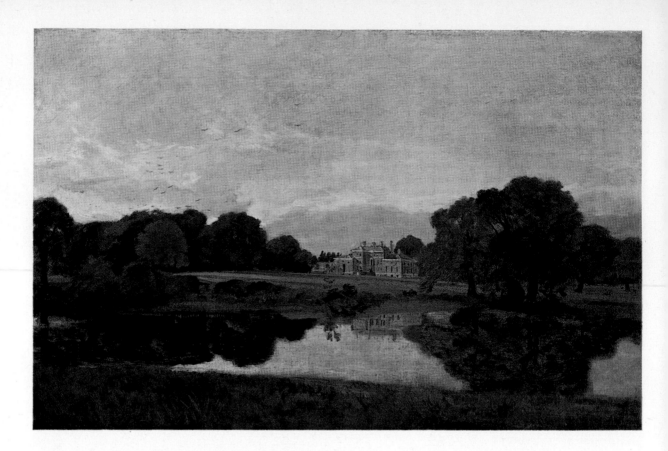

223. John Constable
Malvern Hall 1809

[94]

JOHN CONSTABLE (1776–1837)

Our image of the English countryside derives so much from Constable that he is usually seen as the archetypal English landscape painter. He was, in fact, quite atypical. Although one of the most dedicated, industrious and intelligent of artists, he never found a tolerable place in his profession. He was 53 when finally he gained full membership of the Royal Academy—Turner had been 27—and even then was only grudgingly admitted. In terms of ambition he was second only to Turner, but he was pitifully unsuccessful by comparison, his audience consisting mainly of family friends and kindly neighbours. Reduced much of the time to accepting commissions for portraits, house pictures and the like, he could be regarded, as late as 1829, as a suitable artist to paint an inn sign—'This is encouraging —and offers no small solace to my previous labours at landscape for the last twenty years'.[1] The most he ever got for a landscape appears to be the £300 Vernon paid for 'The Valley Farm'; his annual income from picture sales at the end of his life, R. B. Beckett calculates, was £700 or £800. Constable, wrote Henry Trimmer, 'was always making some great preparation to render himself worthy of notice: a point from which in his own eyes he seemed always receding. He seemed to think his works would never live: and very few of his brother artists either'.[2]

Lit: C. R. Leslie, *Memoirs of the Life of John Constable, Esq. R.A.*, 1843, revised edition 1845.
R. B. Beckett, *John Constable's Correspondence*, 6 vols., 1962–8.
Graham Reynolds, *Victoria and Albert Museum, Catalogue of the Constable Collection*, 1960.

220. **A Dell** 1796
 Inscribed 'J. Constable 1796'
 Wash, 16 × 18 in.
 The Forty Hall Museum, London Borough of Enfield

221. **Dedham Vale** 1802
 Oil on canvas, $17\frac{1}{8} \times 13\frac{1}{2}$ in.
 Lit: Reynolds No.37
 The Victoria and Albert Museum

An inscription on the stretcher of No.221 gives the date 'Sep 1802': this is presumed to copy an inscription by Constable on the back of the original canvas, which has been relined.

From London in May 1802 Constable made his famous progress report to John Dunthorne, his first mentor (see No.232a.): 'For these two years past I have been running after pictures and seeking the truth at second hand. . . . I am come to a determination to make no idle visits this summer or to give up my time to common place people. I shall shortly return to Bergholt where I shall make some laborious studies from nature—and I shall endeavour to get a pure and unaffected representation of the scenes that may employ me. . . . there is room enough for a natural painture'.[3] No.221 and two or three other paintings in the Victoria and Albert Museum are the result of this determination and they do indeed look radically different to such earlier works as the

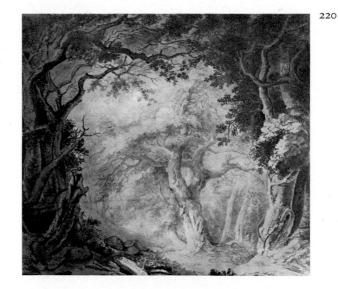

220

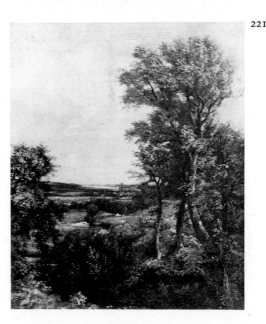

221

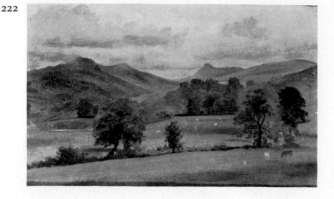

drawing of 1796 (which is virtually a Loutherbourgian stage-set) shown here. But, to be properly understood, Constable's resolve to be 'a natural painture' must be read in the context he himself provides in this letter. He has, he says, 'just returned from a visit to Sir G. Beaumont's pictures.—I am returned with a deep conviction of the truth of Sir Joshua Reynolds' observation that "there is no *easy* way of becoming a good painter." ' Constable paraphrases Reynolds when he goes on to say that 'Nature is the fountain's head, the source from whence all originality must spring'. Seeking truth at first hand did not mean rejecting previous example. Constable formulated what has been called his '*credo* as a naturalist' after studying Beaumont's old masters and introduced it by appeal to authority. In 'Dedham Vale' Claude, and in particular the Beaumont 'Hagar and the Angel' (No.1), is his guide.

222. Lake District Landscape 1806
 Oil on paper, $9\frac{3}{4} \times 15\frac{1}{2}$ in.
 Dr. Matilda Winternitz

Painted on Constable's only visit to the Lakes in 1806. The sketches made on this tour, said C. R. Leslie, 'abound in grand and solemn effects of light, shade, and colour, but his mind was preoccupied with the love of a different class of scenery, and from these sketches he never painted any considerable picture'[4]: 'I have heard him say the solitude of mountains oppressed his spirits. His nature was peculiarly social and could not feel satisfied with scenery, however grand in itself, that did not abound in human associations. He required villages, churches, farm-houses, and cottages; and I believe it was as much from natural temperament as from early impressions that his first love, in landscape, was also his latest love.'[5] Nevertheless, Constable exhibited six paintings of Lakeland subjects at the Royal Academy over the following two years, and it was in such oil sketches as No.222 that he first began to develop a personal idiom.

223. Malvern Hall 1809
 Oil on canvas, $20\frac{1}{4} \times 30\frac{1}{4}$ in., repr. on p.94
 The Tate Gallery (2653)

'I do not regret not seeing Fonthill', Constable declared in 1822, 'I never had a desire to see sights—and a gentleman's park—is my aversion. It is not beauty because it is not nature'.[6] Constable seldom painted country houses and when he did he needed some larger idea to interest him. When Richard Benyon-De Beauvoir commissioned him to paint Englefield House in 1832 Constable produced, as he put it, 'a picture of a summer morning, *including a house*'.[7] His patron rejected it for being too little a portrait of his house, the Royal Academy condemned it for being little more than that. Constable was delighted to hear a more disinterested observer exclaim '*how fresh—how dewy—how exhilarating*'.[8]

The origin of Constable's picture of Malvern Hall, near Solihull, the seat of Henry Greswolde Lewis, has been the subject of some debate. An inscription on the stretcher by J. H. Anderdon, who owned the work in 1840, records that it was relined that year and that 'on the original stretcher was written in red chalk Malvern Hall Warwickshire Augt 1. 1809 x apparently in the autograph of the painter'. Constable paid his first visit

to Malvern Hall in July 1809, setting out from London on the 15th.[9] He painted two portraits there and this was probably the reason for his visit, but a later letter[10] from Lewis suggests that he also painted the house on this occasion. The reliability of the date on the back of No.223 has, however, been questioned because the last two digits, though perfectly clear, are, Martin Davies says, 'on top of a mess, which seems rather dubiously to cover a different and illegible date'.[11] Following his last visit to Malvern Hall in September 1820 Constable painted another version of No.223 and a companion view of the house from the front. Discrediting the 1809 date on the back of No.223, recent commentators have preferred to associate the picture with this 1820 visit and to see it as a 'sketch' for the other version. But there is no evidence that the date on the back has been altered, only that it covers an inky mess, and no motive for the supposed alteration has been adduced. Moreover, the day and the month in the inscription are accepted by those who question the year and 1809 is the only year to which 'Augt 1.' can refer, assuming the picture to have been painted on the spot: Constable's only other known visit, in 1820, did not begin until September—for almost the whole of July and August he was with the Fishers and on 31 July, for example, is known to have been with them at Gillingham in Dorset.[12]

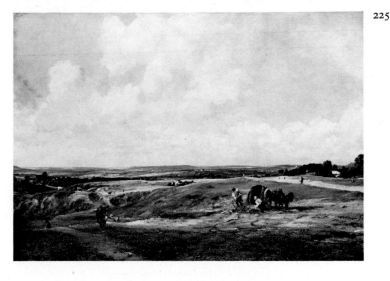

224. Sketchbook 1815–1819
28 leaves (others removed), $2\frac{5}{8} \times 3\frac{5}{8}$ in.
The Trustees of the British Museum (1972–6–17–15)
Begun at East Bergholt in 1815 and taken up again when the artist moved to Hampstead in the late summer of 1819. At a later date the sketchbook was, mysteriously, attributed to Bonington.

225. Hampstead Heath *c.*1820
Oil on canvas, $21\frac{3}{4} \times 30\frac{1}{4}$ in.
The Fitzwilliam Museum, Cambridge

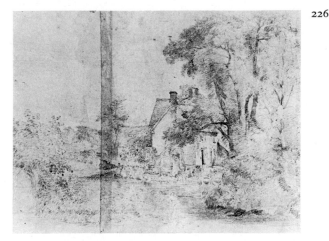

226–231. The Valley Farm

226. Willy Lott's House
Pencil, $7\frac{7}{8} \times 11\frac{3}{16}$ in, watermarked 1807
The Courtauld Institute of Art (Witt Collection)

227. Sketch for 'The Valley Farm'
Oil on canvas, $13\frac{3}{8} \times 11$ in.
Lit: Reynolds No.373
The Victoria and Albert Museum

228. Sketch for 'The Valley Farm'
Oil on canvas, $10 \times 8\frac{1}{4}$ in.
Lit: Reynolds No.374
The Victoria and Albert Museum

229. Study of Ash Trees
Pencil, $13 \times 9\frac{3}{8}$ in.
Lit: Reynolds No.163
The Victoria and Albert Museum

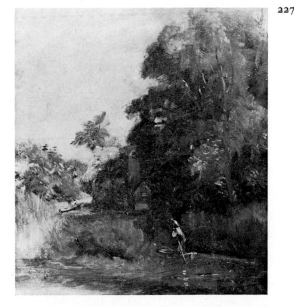

228

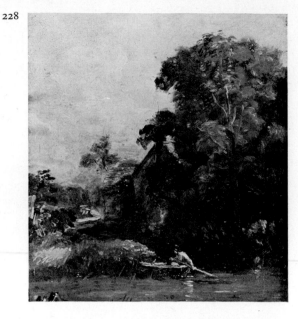

229

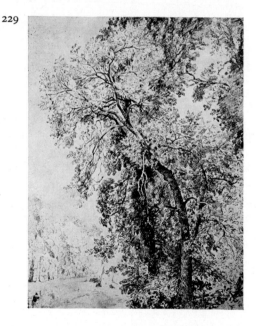

230

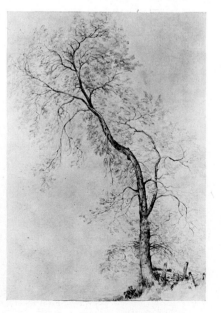

230. **An Ash Tree**
Pencil and watercolour, 39 × 26¾ in.,
watermarked 1833
Lit: Reynolds No.375
The Victoria and Albert Museum

231. **The Valley Farm** 1835
Inscribed 'John Constable R.A. [. . . .] 1835'
Oil on canvas, 58 × 49¼ in.
Exh: R.A. 1835(145), B.I. 1836(43)
The Tate Gallery (327)

To this collection of 'Valley Farm' material could be
added an early oil study in the collection of the Earl of
Haddington, two sketchbook drawings of 1813 (Victoria
and Albert Museum, Reynolds No.121, pp.31, 70),
canvases in the collections of Lord Forteviot and Mr
R. A. Vestey and a study for the girl in the boat (Vic-
toria and Albert Museum, Reynolds No.377). These
items span almost the whole of Constable's career and
illustrate not only the complexities of his procedure, but
the obsessive character of much of his subject matter.
The building upon which they all centre, the 'Valley
Farm' opposite Flatford Mill, was the house of Willy
Lott, who, wrote C. R. Leslie in 1843, 'was born in it,
and it is said, has passed more than eighty years without
having spent four whole days away from it'.[13] Lott must
have seemed very much part of the landscape: in Con-
stable's work his house becomes the nostalgic image of a
'natural' way of life which has become increasingly
foreign to Constable himself.

A good deal of the material shown or listed here was
used in the preparation of the final painting, but the
exact sequence of events is not very clear. No.226, on
paper watermarked 1807, shows the house and the tree
which partly obscures it much as they appear in the
painting of 1835. The foremost tree on the right of the
painting, however, is derived from a separate study,
No.229, from which a full-scale drawing, No.230, was
made. Graham Reynolds presents alternative arguments
for the dating of these tree studies and for the where-
abouts of the ash tree in question. Firstly, in the Victoria
and Albert Museum there is another tree drawing, of
identical size and on the same sort of paper, which can
be regarded as a companion to No.230; this companion
drawing (Reynolds No.376) can be associated with
observations in Constable's Hampstead lecture of 1836
about a tree at Hampstead which had been disfigured
and finally killed by having a notice board ('All vagrants
and beggars will be dealt with according to law') nailed
to it—Reynolds' No.376, shows a tree with a similar
notice and what may be a vagrant seated at its base; as
this drawing was apparently made at Hampstead, its
companion, No.230 here, is presumed also to show a
Hampstead tree and No.229, upon which it is based,
would therefore date from 1819 at the earliest, the year
in which Constable first took a house at Hampstead.
The second argument is that, stylistically, No.229 re-
sembles two tree drawings made at East Bergholt in 1817
(Reynolds Nos.161–2) sufficiently closely for it to be
attributed to the same year and locality. Reynolds pre-
fers the latter idea, though the fact that No.229 also in-
cludes a tree with a notice board (and the word
'vagrants'?) would seem to support his other argument.
Similar uncertainties surround the two oil studies,
Nos.227–8, thought by some to have been made about

the time of the final painting, but lacking the 'Hampstead' tree and apparently closer in other ways to the 1813 sketchbook drawings.

Having dwelt on the subject for most of his life, Constable was reluctant to let go of the painting he at last made. Robert Vernon saw it in his studio in March 1835 and immediately bought it, leaving the price, eventually fixed at £300, to the artist. It went to Royal Academy that year and then Constable resumed work on it. In October 1835 he was 'Oiling out, making out, polishing, scraping, &c. . . . The "sleet" and "snow" have disappeared, leaving in their places, silver, ivory, and a little gold.'[14] By December Vernon, Constable said, was 'fidgetting about it—but it never was half so good before, and I will do as I like with it, for I have a greater interest in it than anybody else'.[15] The 'sleet' and 'snow'—Constable's flickering touches of white—had come in for criticism when the painting was shown at the Academy. John Eagles, writing for *Blackwood's Magazine*, suggested the picture had been 'powdered over with the dredging box, or to have been under an accidental shower of white lead—which I find on enquiry is meant to represent the sparkling of dew. The sparkling of dew! . . . Such conceited imbecility is distressing, and being so large, it is but magnified folly'.[16] *The Observer* went for the sky: 'what a sky!—the "tossing about of the stuffings of pack-saddles among remnants of blue taffeta," with a witness to it—if he had made a present of it to little Martin for a "*Chaos is come again*," it might have served him, and left Mr. C.'s picture with one blot less. . . . He ought to be whipped for thus maiming a real genius for Landscape.'[17]

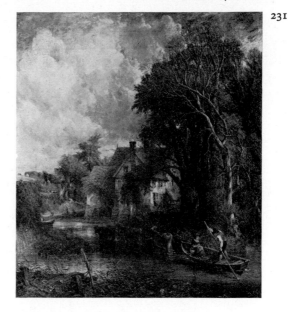

231

DAVID LUCAS (1802–1881) and JOHN CONSTABLE
232. Salisbury Cathedral
Wash and white over mezzotint, $5\frac{1}{2} \times 8\frac{3}{8}$ in.
Lit: Andrew Shirley, *The Published Mezzotints of David Lucas after John Constable, R.A.*, 1930, No.30.
Colonel J. H. Constable

An impression of Lucas' mezzotint extensively worked over in wash and heightened with white by Constable. The plate was to have been included in the *English Landscape* series published by Constable from 1830 onwards, but there were difficulties with it and it ended up in an appendix to the work published by Moon after the artist's death.

English Landscape, a collection of mezzotints after his compositions with an explanatory text, was intended by Constable as an epitome of his lifetime's work, but it attracted even less notice than his paintings had. Leslie was able to use the unsold stock to illustrate his own *apologia* for the painter, the biography which he published in 1843.

JOHN DUNTHORNE Senior (1770–1844)

232a. Flatford Lock 1814
Inscribed 'Oct[t] 1814 John Dunthorn' on verso
Oil on panel, $9\frac{1}{4} \times 14\frac{1}{8}$ in.
The Colchester and Essex Museum, Colchester

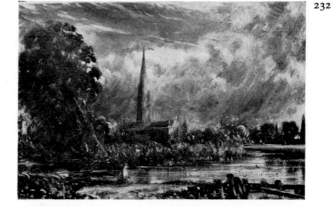

232

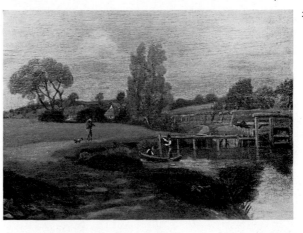

232a

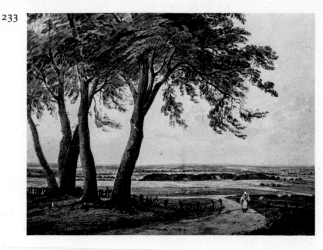

Dunthorne, plumber, glazier and amateur artist of East Bergholt, was Constable's first tutor in art, their association dating from the 1790s. Dunthorne's son, also John (1798–1832), later became Constable's studio assistant in London, but No.232a seems, from its date, more likely to be the work of the father than of the son. Constable was at Bergholt in October 1814 and possibly beside Dunthorne when he painted this picture. The two figures in the boat resemble those in Constable's 'Valley Farm' (No.231). The boatman, in his black hat and red jerkin, was, no doubt, a familiar local figure. The connection between the two paintings suggests that this is another instance (comparable with his copying Sir George Beaumont's drawings of Dedham) of Constable turning to humble examples in the making of his own art, and of his lifelong devotion to early scenes and events.[18]

JOHN VARLEY (1778–1842)

233. **View from Polsden, Surrey** 1800
Inscribed 'View from Polsden near Bookham in Surrey Made in company with Dr Monro by J. Varley Oct.1800 Study from Nature'.
Watercolour, $15\frac{3}{4} \times 20$ in.
The Laing Art Gallery and Museum, Newcastle upon Tyne

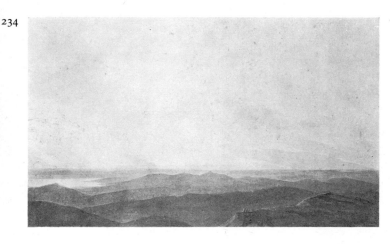

234. **Sunrise from Cader Idris** 1804
Inscribed 'J. VARLEY 1804' and on verso: 'View of Sunrise from the top of Cader Idris N. Wales with Bala Lake in the distance, at Half Past 3 in the morning by J.Varley 1804.'
Watercolour, $11\frac{1}{4} \times 19\frac{1}{4}$ in.
Miss Scott-Elliot, C.V.O.

F. C. LEWIS (1779–1856) after JOHN VARLEY
235. **Precepts for Designs in Landscape**, 1818, Plate II
Aquatint, $11\frac{3}{16} \times 15\frac{1}{2}$ in.
Private Collection

Varley was a central figure for the generation of water-colourists born in the 1780s and 1790s. A founder member in 1804 of the Society of Painters in Water Colours, he was its most prolific exhibitor, showing an average of 41 works each year up to 1812. His pupils during the same period included Turner of Oxford, William Henry Hunt, Linnell and Cox. Although he seems to have encouraged Hunt and Linnell to adopt a 'naturalistic' approach to landscape (see under No.245), his own work tended towards the sort of ideal composition he set out in his instruction manuals. These treatises extended an already vast private teaching practice. In 1812 he was charging amateurs a guinea a lesson and a few years later his income is supposed to have been an incredible £3,000 per annum.

CORNELIUS VARLEY (1781–1873)

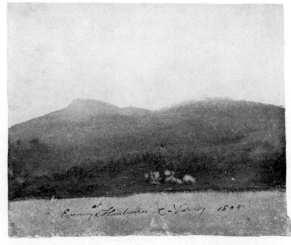

236. **Evening at Llanberis** 1805
Inscribed 'Evening at Llanberris C. Varley 1805'
Watercolour, $7\frac{7}{8} \times 9\frac{3}{8}$ in.
The Tate Gallery (T.1710)

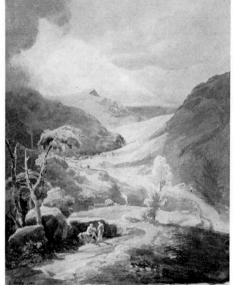
237b

237. **Landscape, North Wales** 1805
 a. Pencil, 12¼ × 9⅝ in.
 b. Inscribed 'C Varley 1805'. Wash, 12⅝ × 9⅝ in.
 c. Watercolour, 12½ × 9⅝ in.
 d. Watercolour, 12⅜ × 9⅝ in.
 The Marchioness of Dufferin and Ava

Cornelius Varley, John Varley's younger brother, was not really a professional artist at all. Brought up by his uncle Samuel, a watch and instrument maker, most of his own career was devoted to scientific instrument making. But in the first decade of the century, at least, he was equally active as an artist and the rediscovery of large numbers of his early watercolours has shown him to be a figure of considerable interest.

No.236 was made on Varley's third visit to Wales in 1805, and Nos.237a–d presumably on his return. As on a previous visit in 1803, when he was accompanied by Cristall and Havell, Varley wrote detailed descriptions of atmospheric phenomena which he later incorporated in an autobiographical document. His purpose was 'to observe and understand what I saw'.[1] In 1805, for example, he made a long note on 'the gradual progress from a cloudless morning to universal rain' in the region of Snowdon. These interests are reflected in a number of 'informal' cloud and mountain studies, such as No.236, and carry over into more deliberate compositions: the four drawings in No.237 seem intended to demonstrate different sky effects as much as the gradual construction of a watercolour.

238a

238. **John Heathcoat's Lace Factory at Tiverton, Devon** 1824
 a. Inscribed 'J.Heathcoate Esqʳ Lace Factory Tiverton Nᵗʰ Devon Cornelius Varley 1824 July in P.G.T. Power 2'
 Watercolour and pencil, 15 × 21¾ in.
 b. Inscribed 'Part of the sketch of the Factory Tiverton Pᵗ 2. C Varley July 1824'
 Pencil, 12¼ × 10½ in.
 Mr and Mrs Ian Heathcoat Amory

Drawings made with the Patent Graphic Telescope (see No.305). Varley was employed by Heathcoat in 1824 to advise on improvements in lace machinery but declined a permanent post as consulting engineer.

JOHN JAMES CHALON (1778–1854)

239. **Landscape with Cattle and Cowherds** 1808
 Oil on canvas, 36 × 47 in.
 The Duke of Westminster

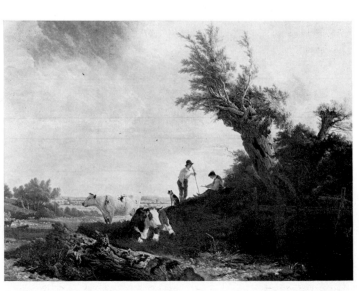
239

WILLIAM MULREADY (1786–1863)

240. **The Mall, Kensington Gravel Pits** 1811
 Oil on canvas, 14 × 19¼ in.
 The Victoria and Albert Museum

At the beginning of his career Mulready made a living of sorts as a book-illustrator, panorama painter and teacher. After unsuccessful attempts at history painting around 1804, he turned to landscape, no doubt encouraged by his brother-in-law John Varley. His first

240

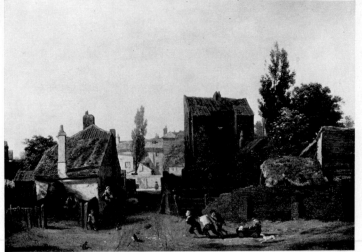

241a

241b

242

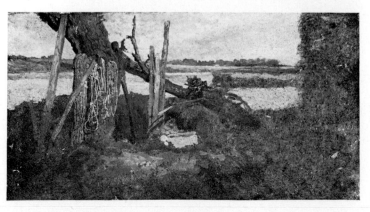

exhibits at the Royal Academy were small scenes of cottages and churches, but even in these there was some element of genre and from 1808 Mulready began exhibiting anecdotal figure interiors of the kind his friend Wilkie was making popular. His decision to concentrate on figure rather than landscape painting may also have been influenced by the outcome of a commission for two landscapes he received from the painter Augustus Callcott, acting on behalf of a Mr Horley. The pictures, No.240 and its companion, 'Near the Mall' (1812, Victoria and Albert Museum), were completed but proved unacceptable. 'His patrons were not "educated" enough to admit, still less to admire, anything so literal,' wrote F. G. Stephens in 1867: 'the gentleman for whom they were produced, and the artist who brought Mulready to that patron, declined to receive them, the one refusing to recognise them as pictures, the other as not fulfilling the commissions he had given'.[2] Stephens says that the two works were also rejected by the Royal Academy.

Kensington Gravel Pits were near the junction of the Bayswater Road and Kensington Church Street, i.e. what is now Notting Hill. Mulready moved his family there in 1809 while continuing to lodge in London with Linnell.

241. Studies of Tree Trunks 1845–6
 a. Inscribed '29 Dec.1845' and 'Jan.3 1846'
 Pen and wash, $3\frac{1}{2} \times 4\frac{1}{2}$ in.
 b. Inscribed '28 29 Dec.1845'
 Pen and wash, $2\frac{7}{8} \times 4\frac{3}{4}$ in.
 The Victoria and Albert Museum

Mulready produced only one landscape proper after 1812, 'Blackheath Park' in 1852, but, especially during the last twenty years of his life, he made detailed pen studies of trees, plants, birds and so on, many of which were used in the landscape backgrounds of his figure paintings.

JOHN LINNELL (1792–1882)

242. Twickenham 1806
 Inscribed on verso 'J. Linnell 1806' and 'Twickenham'
 Oil on board, $6\frac{1}{8} \times 11\frac{3}{4}$ in.
 Private Collection

243. Primrose Hill 1811
 Inscribed 'Primrose Hill. J Linnell 1811.' and 'part of primrose hill'.
 Pen, wash and chalk, $15\frac{5}{8} \times 26\frac{1}{4}$ in.
 The Fitzwilliam Museum, Cambridge

244. Five Studies at Kensington 1812–14
 a. Alpha Cottage
 b. Brick Kiln
 c. Kensington Gardens
 d. Brick Kiln
 e. Brick Kiln
 Each signed and dated: a. 1814, b.–e. 1812
 Watercolour, approximately $4 \times 5\frac{5}{8}$ in. each
 Private Collection

245. Kensington Gravel Pits Exhibited 1813
Inscribed 'J. Linnell'
Oil on canvas, 28 × 42 in., repr. on p.105
Exh: B.I. 1813(99), Liverpool Academy 1813(75)
The Tate Gallery (5776)

'Twickenham' is one of a number of small oil studies
Linnell made at the age of fourteen during his year's
apprenticeship to John Varley.[3] Other examples are in
the Tate Gallery (T.933–5, T.1490), as is a similar
study by his fellow pupil William Henry Hunt (T.1154).
'Varley's motto was "Go to Nature for everything," '
wrote his biographer A. T. Story, 'and henceforth
Linnell adopted it as his own. In order the better to
enable his pupils to carry out his advice, Varley in the
summer took a house at Twickenham near to the river,
and sent them out into the highways and byways to make
such transcripts as they could'.[4] Whether there was any
practical instruction in making 'transcripts', or indeed
in oil painting (Varley being, after all, a watercolourist),
is not stated. Nor is Mulready's part in all this clear.
Linnell originally wished to study under Mulready, but
was advised by him to go to Varley. Probably it amounted
to the same thing because, after marrying Varley's sister
in 1803, Mulready helped with Varley's teaching and
kept in close touch with his pupils after he left the Var-
ley establishment about 1806. 'Linnell himself acknow-
ledged', says Story, 'that he received more valuable in-
struction from Mulready than from anyone else'.[5] Be-
tween 1808 and 1811 the two shared lodgings in Lon-
don and Linnell seems to have moved to Kensington
with Mulready when he rejoined his family there in
1811. Roget quotes an account of Linnell, Hunt and,
apparently, Mulready working at Kensington Gravel
Pits, where 'sitting down before any common object,
the paling of a cottage garden, a mossy wall, or an old
post, [they would] try to imitate it minutely'.[6] Nos.244
a–e are examples of these deliberately casual studies.

Linnell's large painting of the Gravel Pits, No.245,
met with little more success than Mulready's pair of the
Mall. It failed to find a private buyer at the British In-
stitution in 1813 and the Institution itself did not buy
it: 'This the painter always considered a proof of the
apathy and neglect which characterized the doings of
the Institution, which was supported by wealthy
patrons whose object was the encouragement of this
description of art'.[7] At the Liverpool Academy later
that year the painting was bought for 45 guineas by
Thomas Bewick's pupil Henry Hole, whose training may
be supposed to have given him a more than usual feeling
for the sort of detailed observation, and even the sort
of subject matter, of Linnell's picture.

246. Harvest Home, Sunset (The Last Load)
1853
Inscribed 'J Linnell 1853'
Oil on canvas, 35¾ × 58 in., repr. on p.104
Exh: B.I. 1854 (50)
The Tate Gallery (2060)

Linnell's early work and his involvement with Blake
and Palmer (see Nos.287ff.) seem today his strongest
claims to attention, but his contemporary reputation
was made by his portraits and by later landscapes of the
kind shown here.

244a

244b

244d

246

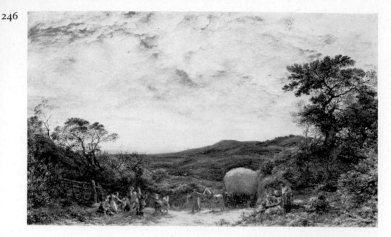

248

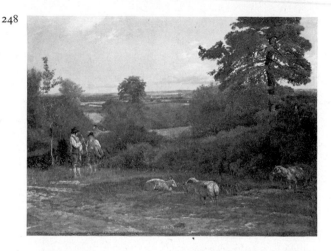

249

250

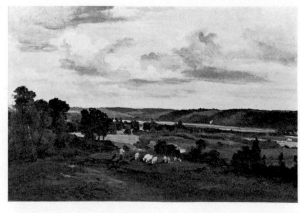

GEORGE ROBERT LEWIS (1782–1871)

247. **Hereford, Dynedor, and Malvern Hills, from the Haywood Lodge, Harvest Scene, Afternoon** 1815
Inscribed on a label removed from verso:
'[?No 1 . . .] Hereford, Dynedor and Malvern Hills from the Haywood Lodge Geo.Lewis. 9. Southampton Row New Road Paddington'
Oil on canvas, 16⅜ × 23½ in., repr. on p.105
Exh: Society of Painters in Oil & Water Colours 1816 (139)
The Tate Gallery (2961)

248. **Hereford, from the Haywood, Noon** 1815
Oil on canvas, 16⅜ × 23½ in.
Exh: ?Society of Painters in Oil & Water Colours 1816 (12); ? B.I.1817 (225)
The Tate Gallery (2960)

Lewis, a brother of the engraver F. C. Lewis, painted landscape at the beginning of his career, but then turned to other things—from about 1820 he was primarily a portrait painter. Very little is known of his early life or of his work in landscape, but he was a friend of Linnell, who accompanied him on a tour of Wales in 1813. The catalogue of the 1816 exhibition referred to above adds 'Painted on the Spot' after the title of No.247. As the exhibition opened in April and the picture is a harvest scene, it was therefore most likely painted in 1815. In the same exhibition Lewis showed groups of smaller studies of the area and a work entitled 'Hereford, from the Haywood, Noon, painted on the Spot'. This is very probably the same picture as the 'View of Hereford, from the Haywood' shown at the British Institution the following year, where its size, including frame, was given as 29 × 35 in. It seems reasonable to identify this with No.248 and the early title has been accordingly adopted for it. Both paintings have previously been dated *c*.1817.

JOSHUA CRISTALL (?1767–1847)

249. **Falls at Pont y Pair, Betws-y-Coed** 1803
Inscribed on old mount 'Falls at Pont y pair—Betwys y Coed. Carnarvonshire' and 'J.Cristall—1803' (the '3' apparently altered from '2')
Oil on paper, 7 9/16 × 13⅝ in.
The National Library of Wales, Aberystwyth

WILLIAM DELAMOTTE (1775–1863)

250. **The Thames Valley between Marlow and Bisham** 1806
Inscribed on verso 'Willm Dela Motte—R. M College Marlow. 1806.' and 'Marlow & Bisham churches.'
Oil on board, 13¼ × 20⅛ in.
Peter D. Jolly, Esq.

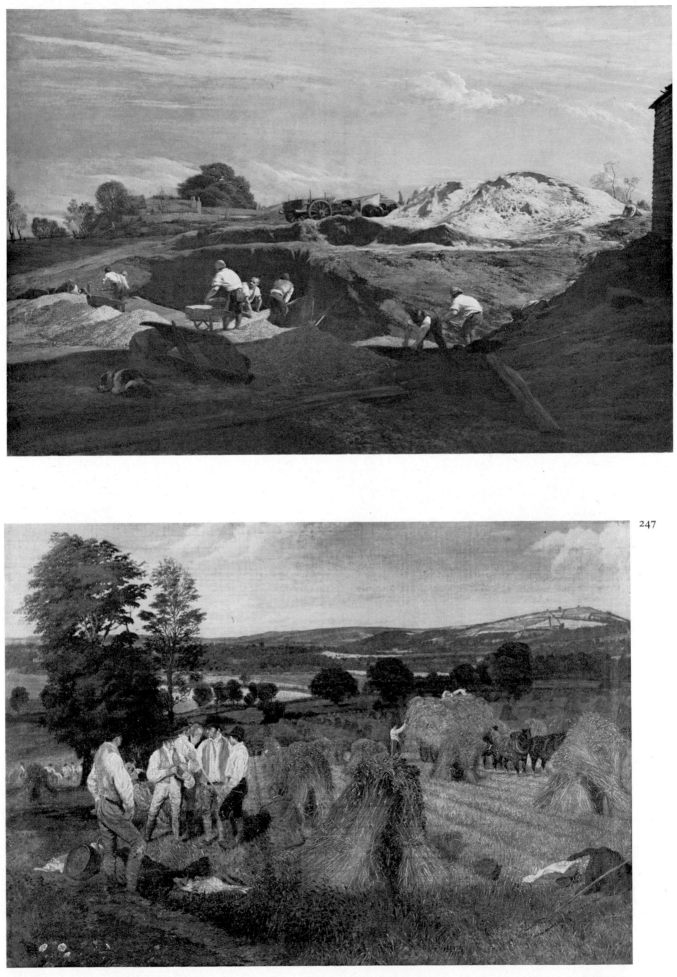

247

251

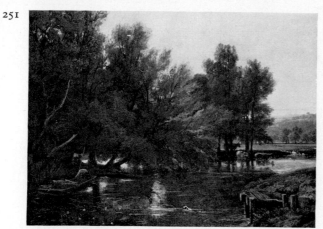

WILLIAM HAVELL (1782–1857)

251. **Thames Valley Landscape** 1807
Inscribed 'WHAVELL 1807'
Oil on panel, 19¼ × 25⅛ in.
Mrs Felicity Owen

THOMAS CHRISTOPHER HOFLAND (1777–1843)

252. **A Lady reading by the drive at White Knights** *c.*1816
Oil on canvas, 17 × 23 in.
Private Collection

Hofland and his wife Barbara, the novelist, were commissioned in 1816 to produce an illustrated account of the Duke of Marlborough's house, White Knights, near Reading. The book appeared in 1819 but the Hoflands, apparently, received nothing for their work and even had to pay the cost of producing the volume. In 1827 Mrs Hofland caught sight of the Duke 'in excellent *health* and high *spirits* saying however not a word of paying my husband a shilling of all that he owes him and which is unquestionably gone for ever'.[8]

252

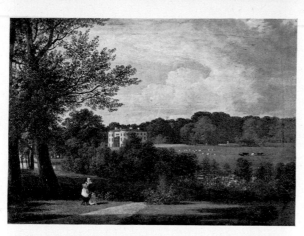

253

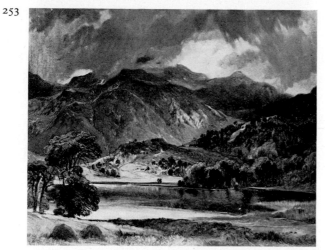

SIR EDWIN LANDSEER (1802–73)

253. **Landscape in the Lake District** Before 1830
Oil on panel, 9½ × 11 in.
Mrs Gilbert Russell

WILLIAM ETTY (1787–1849)

254. **Landscape** *c.*1840
Oil on board, 18½ × 24 in.
The City of York Art Gallery

254

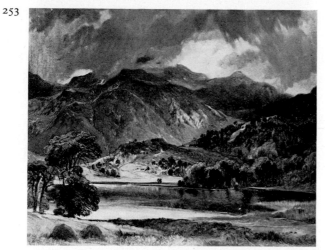

DAVID COX (1783–1859)

255. **On the Road from Pont Aberglaslyn to Maentwrog** 1805 or 1806
Inscribed with title and 'Moel Hebog', 'Snowden'
Pencil and watercolour, 5¾ × 36⅞ in.
The City Museum and Art Gallery, Birmingham

One of Cox's early employments, around 1800–4, was at the Birmingham theatre as a scene-painter under James de Maria, whose landscape effects Cox still spoke of with admiration forty years later. De Maria was the artist of a panorama of Paris shown in London

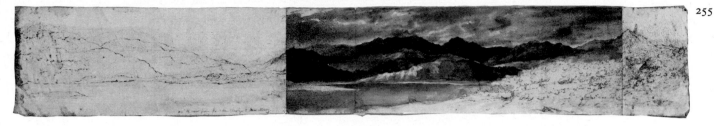

in 1802 and it would be interesting to know whether this miniature Welsh panorama by Cox was conceived with any theatrical end in mind or as a self-sufficient piece of documentation.

Cox came to London in 1804 and continued to paint scenery for London and provincial theatres, the last recorded occasion being in 1808, when he was paid at the rate of 4s. a square yard by a Wolverhampton theatre. At the same time he sold drawings to dealers who supplied country drawing masters with material for their pupils to copy and for this kind of work he seems to have received two guineas per dozen drawings. For his own education he bought Pond's engravings of old master landscapes, subscribed to Turner's *Liber Studiorum* and took lessons from John Varley.

256. A Treatise on Landscape Painting and Effect in Water Colours: from the first rudiments, to the finished picture, with examples in outline, effect, and colouring 1814
Iain Bain, Esq.

257. The Young Artist's Companion; or, Drawing-Book of Studies and Landscape Embellishments: comprising a great variety of the most picturesque objects required in the various compositions of landscape scenery, arranged as progressive lessons 1825

257

The Trustees of the British Museum (1897–5–12–54)
Up to about 1840 Cox made a steady, if unspectacular, income from teaching. He took private pupils during his first years in London, was drawing master at the Military College, Farnham for a few weeks in 1815 and then received a post at Miss Croucher's seminary for young ladies in Hereford, where he taught twice a week for a salary of £100. He held other posts in Hereford and also taught privately at 7s.6d.–10s.6d. an hour. When he returned to London in 1827 he raised his fee to a guinea.

Through his manuals Cox may have reached a wider audience of amateurs. 'The urgent and repeated solicitations of many of his Pupils', he says in the *Treatise*, 'have induced the author of this Work to submit to the Public those remarks which . . . may guide the Student in the selection of appropriate effects of Nature, adapted to the different characters of Landscape composition' and 'The principal art of Landscape Painting consists in conveying to the mind the most forcible 'effect which can be produced from the various classe of scenery'. Varley's treatises are also concerned with effects', but his are very definitely effects of art, aps plicable to a variety of subject matter. Cox talks much more of 'effects of nature', accidents of time, weather

258a

258b

259

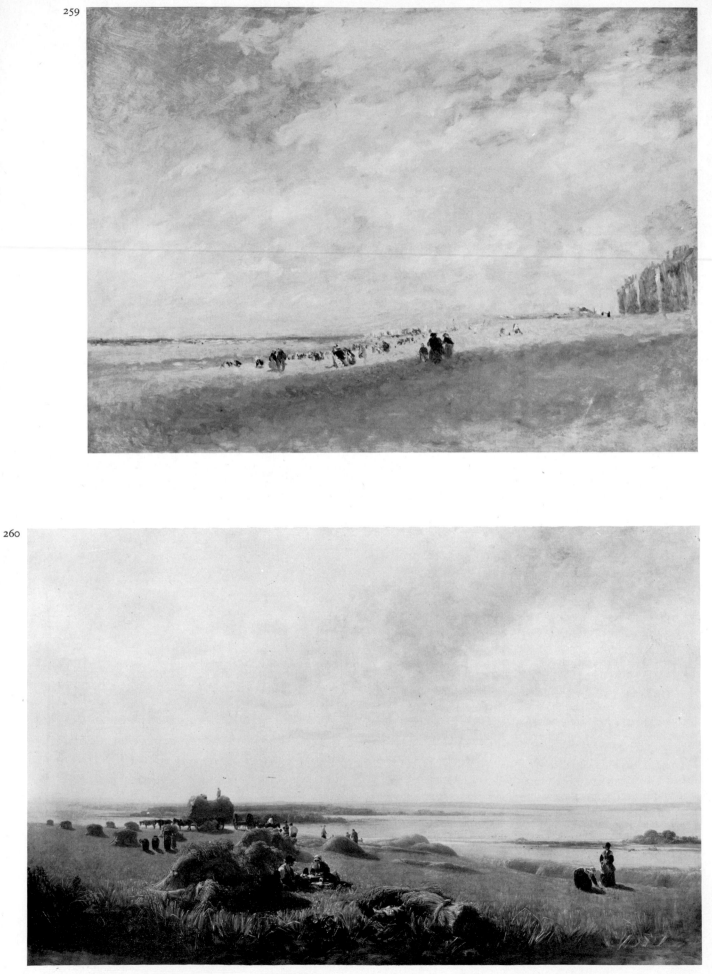

260

and season. And unlike Varley he provides 'progressive lessons' which take the student from the drawing of simple objects to the use of chiaroscuro and finally to colouring. In his manuals different processes reproduce the relevant examples, soft-ground etching giving way to plain aquatint, followed by spendid hand-coloured aquatints.

258a. Carting Hay
Pencil and chalk, $4\frac{7}{8} \times 15\frac{1}{2}$ in., repr. on p.107
b. A Harvest Field
Pencil and chalk, $4\frac{3}{4} \times 15\frac{5}{8}$ in., repr. on p.107
The Trustees of the British Museum (1889-5-26-1. . .5)

These two drawings were etched in soft-ground by Cox for plate 16 of his *Treatise*, the publication date of the plate being 1 May 1813. Elements from both are combined in a watercolour dated 1814 in the British Museum (1915-3-13-76, repr. F. Gordon Roe, *David Cox*, 1924, frontispiece).

259. Rhyl Sands *c.*1854
Oil on canvas, 19 × 25 in.
Private Collection

Although he seems to have made isolated attempts at earlier dates, Cox only seriously took up oil-painting around 1840, when he had lessons from W. J. Müller. Very few of his oils were exhibited and the highest price he ever received for one—or for a work in any medium—was £100, for a larger, more finished version of 'Rhyl Sands' (dated 1854-5, Birmingham City Art Gallery). Another version, closer to No.259, is in the Manchester City Art Galleries.

Adopting oil-painting so late in life (and he was about 70 when he painted No.259), Cox felt reticent about his work in the medium. His friend and biographer William Hall records that he 'frequently had misgivings that his method of working was not in accordance with the accepted practice—he cherished the notion that there were secrets which "the oil men" would not tell him— and he was invariably nervous and fidgety when any of the painters in oil approached his pictures to examine them closely'.[1] A painting such as No.259 is indeed something of a sport in English landscape of the period and most subsequent observers have felt compelled to look to France for analogies.

PETER DE WINT (1784-1849)

260. A Cornfield Exhibited 1815
Oil on canvas, $41\frac{1}{4} \times 64\frac{1}{2}$ in.
Exh: R.A.1815(290)
The Victoria and Albert Museum

Unlike Cox, de Wint was a professional oil-painter as well as watercolourist from the beginning of his career, giving up, it seems, because his paintings never sold. After his death the dealer who had handled his water-colours for a number of years, Vokins, was surprised to find the attic of de Wint's Gower Street house fitted up as a private gallery of his unsold oils. Among them was No.260, which has since come to be regarded as one of the great monuments of early nineteenth-century 'naturalism'. If there really was no market for this sort of picture, it is difficult to see why de Wint painted 'A Cornfield' in two versions: the other, in the Usher Art Gallery, Lincoln, appears to be almost identical to this one and is on the same scale.

261. Lincoln from Sincil Dyke
Watercolour, $6\frac{1}{4} \times 18\frac{1}{4}$ in.
The Usher Art Gallery, Lincoln

A sketchbook study used as the basis of a watercolour which in 1947 belonged to A. H. Gregson (repr. on cover of the *Catalogue of the Peter de Wint Collection*, Usher Art Gallery, Lincoln, 1947).

While oil paintings remained on his hands, there was a fairly ready market for de Wint's watercolours. In 1827 he was selling works at between 5 and 50 guineas and apparently doing better than Cox, who ten years later received what for him was an exceptional sum of 35 guineas for an exhibition piece. In 1831 de Wint's things were 'so congenial indeed to the general feeling of the collectors of water-colour painting, that not only his larger works, but every scrap from his ingenious pencil is sought with avidity'.[2] Poor John Clare stood little chance of getting the 'bit of your genius to hang up in a frame in my Cottage' that he asked for in 1829: 'what I mean is one of those scraps which you consider nothing after having used them & that lye littering about your study for nothing would appear so valuable to me as one of those rough sketches taken in the fields that breathes with the living freshness of open air &

261]

262

sunshine where the blending & harmony of earth air & sky are in such a happy unison of greens & greys that a flat bit of scenery on a few inches of paper appear so many miles'.[3] So far as is known, the poet never got his scrap.

262. **Studies of Plants: Monkey flower, Globe flower, Soapwort and Stocks**
Watercolour, $10\frac{3}{4} \times 7\frac{1}{2}$ in.
The Usher Art Gallery, Lincoln
Two pages from a sketchbook of botanical and other studies.

JOHN SELL COTMAN (1782–1842)

263. **Bedlam Furnace** 1802
Watercolour, $10\frac{1}{4} \times 18\frac{3}{4}$ in.
From the Sir Hickman Bacon collection, lent by Sir Edmund Bacon, Bart.

Cotman and Paul Sandby Munn visited Coalbrookdale on their way to Wales in 1802. For Munn's view of the scene see No.270. Unlike de Loutherbourg, whose melodramatic 'Coalbrookdale by Night' (No.133) he would have seen at the Academy the previous year, Cotman underplays the subject and makes the industry seem almost a natural part of the landscape.

Cotman came to London from Norwich in 1798 and earned a living by making drawings and watercolours for printsellers. For a time he worked alongside Munn, who was in the same business, his brothers selling his and Cotman's drawings in their stationery and print shop. The two artists' tour of Wales in 1802 was one of several expeditions in search of suitable material for sale in this way and for working up into larger watercolours to be exhibited at the Royal Academy.

263

264

264. **Greta Woods from Brignall Banks** *c.*1805
Inscribed on verso 'On the Greta Yorkshire'
Watercolour, $7\frac{3}{8} \times 11\frac{1}{8}$ in.
Leeds City Art Galleries

On a sketching tour of Yorkshire in 1803 Cotman and Munn were taken up by the Cholmeleys of Brandsby, apparently after a chance meeting. Cotman was retained for the rest of the summer to teach drawing to the daughters of the family and returned in the following two years. On his 1805 visit he also stayed with his patrons' friends the Morritts at Rokeby, and there, on the banks of the River Greta, produced the most original works of his whole career. But the emphatic pattern-making and lack of incident which recommended these Greta watercolours so highly to later generations was not at all in their favour at the time. Morritt, it seems, did not acquire any, nor did Cotman's new patron the Norfolk banker and antiquarian Dawson Turner. In 1811 Francis Cholmeley passed on to Cotman a bookseller's remarks on one of his etchings—an opinion that may also help to explain the contemporary indifference to his best watercolours—'He said his subscribers did not like the view in Duncombe Park, because it might have been *anywhere*. Two-thirds of mankind, you know, mind more *what* is represented than *how* it is done'.[1]

276. John Martin
**Joshua Commanding the Sun to Stand Still upon
Gibeon** 1816

265

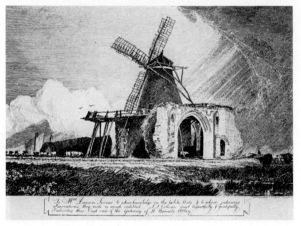

266

269

265. Old Houses at Gorleston
 Oil on canvas, 18 × 14 in.
 City of Norwich Museums

Having failed to make a mark in London, Cotman returned to Norwich in 1806 and tried, without any success, to establish himself as a portrait painter. He also began painting landscape in oils and in 1809, attempting to find a market in a city already well stocked with drawing masters, introduced a 'Circulating Library' of 600 drawings for hire as drawing models at a quarterly subscription of a guinea. As a further expedient he took up etching and began the first of several series of prints aimed at exploiting local antiquarian interests.

266. East View of the Gateway of St. Benet's
 Abbey Published 1813
 Etching, 11 × 15 1/16 in.
 Lit: A. E. Popham, 'The Etchings of John Sell
 Cotman', *The Print Collector's Quarterly*, IX, 1922,
 No.154
 City of Norwich Museums

One of the 60 prints comprising *A Series of Etchings illustrative of the Architectural Antiquities of Norfolk*, published in parts between 1812 and 1818. Cotman undertook the series on his own initiative but managed it badly, finishing the work two or three years behind schedule and probably losing subscribers along the way. There was, however, one patron whose interest could be relied on—Dawson Turner, whose appetite for such things was insatiable. Perhaps already sensing that the series would not bring him the independence he hoped for, Cotman reluctantly accepted an invitation in 1812 to move to Yarmouth and become drawing master to the Turner family and, as it happened, draughtsman for Turner's own antiquarian projects. *Architectural Antiquities of Normandy* was the most extensive of these and involved Cotman in three visits to France. He left Turner in 1823 and tried again to establish himself as a drawing master in Norwich.

267. Devil's Bridge, Cardiganshire
 Soft-ground etching, 7 3/8 × 5 in.
 Lit: Popham, *op. cit.*, No.305
 Alec Cotman, Esq.

268. Parson's Bridge, Cardiganshire
 Soft-ground etching, 6 7/8 × 5 in.
 Lit: Popham, *op. cit.*, No.306
 Alec Cotman, Esq.

Four drawings exhibited by Cotman at the Norwich Society of Artists in 1824 were described in the catalogue as 'part of a Series intended to Illustrate a book now publishing on Landscape Composition'. The book never materialised, but the four subjects were included in a collection of etchings entitled *Liber Studiorum* published in 1838 by Henry Bohn, who had purchased the copper-plates from the artist. Cotman's original plan may have been closer to Turner's *Liber Studiorum*, which he was certainly familiar with, than was Bohn's publication of 1838—a miscellaneous collection of etchings of different dates, done, Bohn said, 'more for practice and amusement than with any view to publication'. Nos.267–8 are some of the best plates of the 1838 volume. Their date is unknown but Cotman presumably

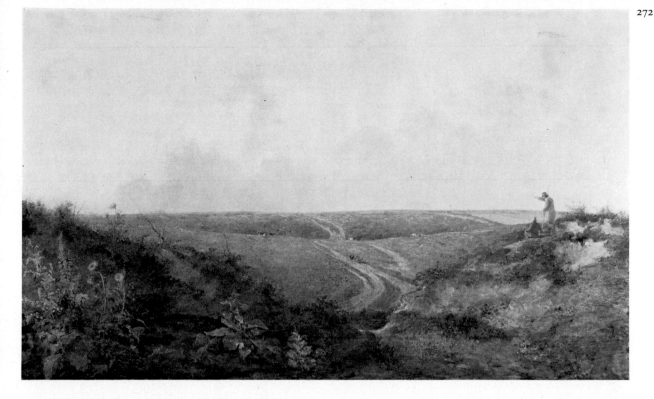

based them on drawings made on his visit to Cardigan-shire in 1800.

269. **The Lake**
Watercolour, $7\frac{1}{8} \times 10\frac{1}{2}$ in.
The Victoria and Albert Museum
A late work, executed in the watercolour and paste medium which Cotman adopted around 1830. It was probably made after he returned to London in 1834 to take up the last of his teaching appointments, as Professor of Drawing at King's College.

PAUL SANDBY MUNN (1773–1845)

270. **Bedlam Furnace, Madeley Dale, Shropshire** 1803
Inscribed 'P.S.Munn 1803'
Watercolour, $12\frac{3}{4} \times 21\frac{5}{8}$ in.
Exh: R.A. 1803 (625)
Mrs Judy Egerton
Cf. Cotman No. 263 and de Loutherbourg No. 133.

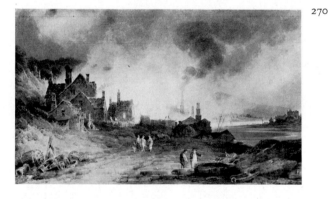

270

JOHN CROME (1768–1821)

271. **Back of the New Mills, Norwich** c. 1814–17
Oil on canvas, $16\frac{1}{4} \times 21\frac{1}{4}$ in.
City of Norwich Museums

272. **Mousehold Heath, Norwich** ?c. 1818–20
Oil on canvas, $43\frac{1}{4} \times 71\frac{1}{4}$ in.
The Tate Gallery (689)

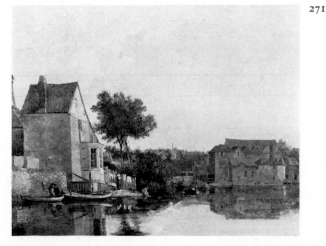

271

It is not at all clear why Norwich should have become an art centre with its own exhibiting body—The Norwich Society, founded in 1803—when comparable cities did not. The character of the art is a little more comprehensible. Commercial and cultural links with the Netherlands may help to explain why Dutch pictures were available and acceptable to the merchants of Norwich and Yarmouth. The local artists whom they patronised depended very largely on the same pictorial sources, though Wilson and Gainsborough were also important models for Crome. The conservative character of the Norwich school is clearly shown by the difficulties its commentators have found in distinguishing one hand from another and in establishing an *oeuvre* for its leader, Crome. Norwich was not, however, an easy market for painters. Although he had a number of loyal patrons, Crome depended as much on teaching as on picture sales and even at the end of his life his prices for paintings were only in the £15–£50 range. Cotman found it hard enough to establish himself as a teacher, let alone a painter, and dreamt of 'the success of myself and my family and the downfall (in plain English) of the family of Crome'.[2]

Six paintings with the title of No.271 were in the Crome memorial exhibition in 1821. Five of them were dated in the catalogue 1814–17, which is the presumed date of the one shown here. 'Mousehold Heath' is usually thought to be later. Its early history is confused. It may have been bought (for £1) by the painter Joseph Stannard at the bankruptcy sale of Crome's son in 1834. One source has it that the painting fell apart while in Stannard's possession and that he used the halves as blinds, but there are other stories also purporting to explain the vertical join in the canvas. According to another account the work was sold by Crome's widow for £12 to pay her rent.

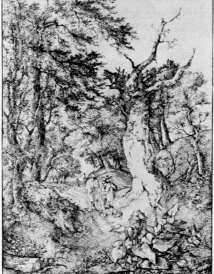

273

273. Sandy Road through Woodland 1813
Etching, 14⅗ × 10½ in.
Lit: H. S. Theobald, *Crome's Etchings*, 1906, No.21ii
The Trustees of the British Museum (1852–2–14–70)
Crome etched some 33 or 34 plates, including 9 in softground. One is dated 1809, others carry dates of 1812 or 1813. He issued a prospectus for an edition of his prints in 1812, but in fact none were published until his widow brought out 31 of them under the title *Norfolk Picturesque Scenery* in 1834.

John Martin (1789–1854)

274. Carisbrooke Castle 1815
Inscribed 'J.Martin. 1815'
Oil on canvas, 11¾ × 17¾ in.
Exh: B.I. 1816(178)
Private Collection

274

275. Edwin and Angelina (The Hermit) 1816
Inscribed 'J.Martin 1816'
Oil on canvas, 11½ × 17½ in.
Exh: B.I. 1817(200)
Private Collection

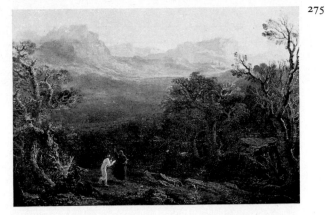

Goldsmith's ballad 'Edwin and Angelina' is included in *The Vicar of Wakefield*. Believing that Edwin, the suitor she has scorned, has died of a broken heart, Angelina goes in the garb of a male pilgrim to 'seek the solitude he sought'. She takes shelter with a hermit (Martin shows their meeting) who discovers that his guest is disappointed in love and advises 'him' to forsake women. At this she blushes, her true sex is discovered, and the hermit reveals himself to be Edwin.

276. Joshua Commanding the Sun to Stand Still upon Gibeon 1816
Inscribed 'J.Martin'
Oil on canvas, 59 × 91 in., repr. on p.111
Exh: R.A.1816(347), B.I.1817(152)
The United Grand Lodge of England

When he came to London from Newcastle in 1806 Martin supported himself and his family, he later recalled, 'by pursuing almost every branch of my profession, teaching, painting small oil pictures, glass enamel paintings, watercolour drawings: in fact, the usual tale of a struggling artist's life'.[1] Two early exhibits at the Royal Academy, 'Sadak in search of the Waters of Oblivion' (1812) and 'Clytie' (1814) reveal the simple pictorial idea which dominated most of his work: the contrast of tiny figures and vast landscape or architectural settings. 'Sadak' was purchased at half price after the close of the exhibition but 'Clytie', ruined, Martin claimed, because an R.A. or A.R.A. spilt varnish down it, remained unsold. It was with 'Joshua' (No.276) that he really began to make a mark. Unlike the paintings just mentioned, or the smaller 'Edwin and Angelina' (No.275), 'Joshua' is crowded with incident: within a framework borrowed more or less from Turner's 'Hannibal' (No.207), Martin presents myriads of figures in place of the solitary individuals of his earlier works and he introduces a greater variety of spectacular landscape forms and weather effects: here too appear the first of the fantastic cityscapes which were to take over completely from landscape in some of his later pictures. Charles Lamb found 'the marshalling and the landscape of the war is everything, the miracle sinks into an anecdote of the day; and the eye may "dart through rank and file traverse" for some minutes, before it shall discover, among his armed followers, *which is Joshua*'.[2] But the superabundant detail was a principal attraction for most spectators; for subsequent works Martin published explanatory pamphlets with engraved 'keys' so that the compositions could, literally, be read. Despite its popular success, Martin had difficulty in selling 'Joshua'. It was awarded a premium at the British Institution in 1817, but remained on his hands until about 1822. But he was sufficiently encouraged to go ahead with 'The Fall of Babylon', which not only drew crowds at the British Institution in 1819 but found a buyer at 400 guineas. 'Belshazzar's Feast' (1821) completed his triumph: an offer of 800 guineas for it from the Duke of Buckingham was refused, the Institution extended its exhibition by three weeks and a further 5,000 visitors paid to see the

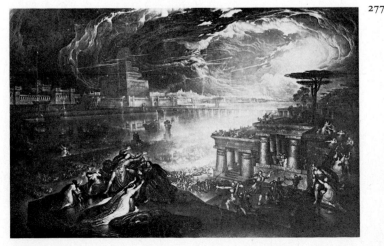

painting when it was privately exhibited immediately afterwards.

277. The Deluge 1828
Mezzotint, $18\frac{1}{2} \times 27$ in., repr. on p.115
The Victoria and Albert Museum

Martin followed up the success of his large compositions by publishing mezzotints of them, engraved by himself and printed in a printing-room set up for the purpose under his studio. At first the mezzotints sold extremely well. 'Belshazzar' appeared in 1826 and 'Joshua' in 1827: by the end of 1827 he had taken just under £3,000 from sales of the two prints, more than half this amount being net receipts from dealers who handled the prints for him, and during the same period he twice raised his prices. The painting of 'The Deluge' exhibited in 1826 remained unsold until about 1844, but the mezzotint brought in over £1,000 from 482 impressions retailing at between $2\frac{1}{2}$ and 10 guineas each. Later subjects did less well. The market became congested not only with his own prints, but with pastiches and copies. Martin told the Select Committee on Arts in 1836 that he had been 'driven from the market by inferior copies of my own work, to the manifest injury of my credit and pecuniary resources'.[3]

278. Martin's Album
The Victoria and Albert Museum

An album of cuttings from his prints put together by Martin. Some of the cuttings are presumably of details he was especially pleased with; others show him making new compositions by means of collage.

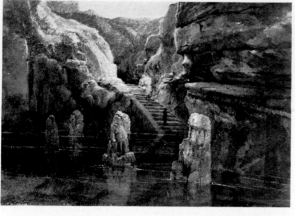

279

279. The Cave
Inscribed 'J.Martin.'
Pen and wash, $7\frac{7}{8} \times 11\frac{3}{4}$ in.
Private Collection

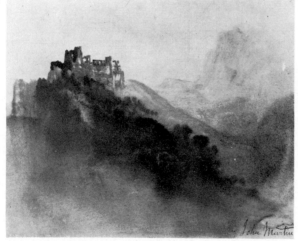

280

280. The Ruined Castle 1851
Inscribed 'John Martin 1851.'
Wash, $8\frac{1}{2} \times 10\frac{3}{4}$ in.
Private Collection

FRANCIS DANBY (1793–1861)

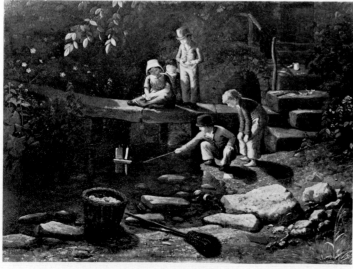

281

281. Boys Sailing a Little Boat *c.*1821
Inscribed 'F. DANBY' and on a label on verso:
'Boys sailing a little Boat F. Danby No.19
Stapleton near Bristol'
Oil on panel, $9\frac{3}{4} \times 13\frac{1}{4}$ in.
The City Art Gallery, Bristol

282. The Frome at Stapleton *c.*1821–3
Inscribed 'F. DANBY'
Pencil, watercolour and bodycolour, $7\frac{7}{8} \times 11\frac{7}{8}$ in.
The City Art Gallery, Bristol

283. The Avon at Clifton *c.*1821
Inscribed 'F. DANBY'
Watercolour and bodycolour, $5 \times 8\frac{3}{8}$ in.
The City Art Gallery, Bristol

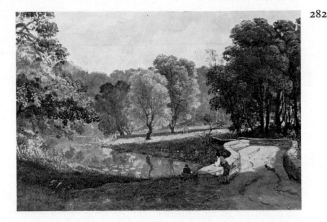
282

283

Born in Ireland, Danby visited London in 1813 and then settled in Bristol, where he set up as a drawing-master. A number of small landscapes on panel, intimate in character and full of naturalistic detail, were painted there for the Rev. George Weare Braikenridge, whose special interest was local topogrpahy. Nos.281–2 are from his collection. At the same time Danby began sending to London landscapes on a much larger scale and aimed at a different sort of audience. 'The Upas, or Poison-Tree of the Island of Java' (1820) was the first of these more spectacular works. His exhibit at the Royal Academy in 1824 was purchased by the President, Sir Thomas Lawrence, and Danby found himself being adopted as the Academy's answer to John Martin. Although continuing to exhibit there, Martin had never forgiven the Academy for its treatment of 'Clytie' and had become one of its fiercest critics.

284. **The Delivery of Israel out of Egypt** 1824–5
 Oil on canvas, $58\frac{3}{4} \times 94\frac{1}{2}$ in., repr. on p.118
 Exh: R.A.1825(287)
 The Harris Museum and Art Gallery, Preston
This, Danby's first major essay in the Martinesque, was the show-piece of the Academy exhibition of 1825. The Marquis of Stafford narrowly beat the Prime Minister, Lord Liverpool, in the race to buy it at £500 and Danby obtained a further £300 from Colnaghi's in 1827 for the copyright.[4] He was elected an A.R.A. in 1825 and went on to paint 'The Opening of the Sixth Seal', bought by William Beckford at the 1828 exhibition for 500 guineas. But Danby's career foundered soon afterwards. Heavily in debt and involved in a marital scandal, he left England in 1829 (returning briefly in 1830 for Lawrence's funeral) and lived on the Continent until 1838. The gigantic 'Deluge' (Tate Gallery) shown in 1840 was intended to re-establish his reputation as a painter of cataclysmic subjects but later work was mostly in a more lyrical vein.

SAMUEL COLMAN (Active 1816–40)

285. **The Coming of the Messiah and the**
 Destruction of Babylon
 Inscribed 'S. Colman'
 Oil on canvas, 54×75 in., repr. on p.118
 The City Art Gallery, Bristol
One of four Danby-esque biblical subjects, all about the same size, painted by Colman at Bristol probably in the 1820s.[5] The other three are 'The Delivery of Israel out of Egypt' (City Art Gallery, Birmingham), 'The Edge of Doom' (The Brooklyn Museum) and 'St. John Preaching in the Wilderness' (untraced). No.285, says Eric Adams, 'illustrates to the letter all the metaphors in at least nine verses of the prophecies of Isaiah, besides other texts'.[6]

286

284

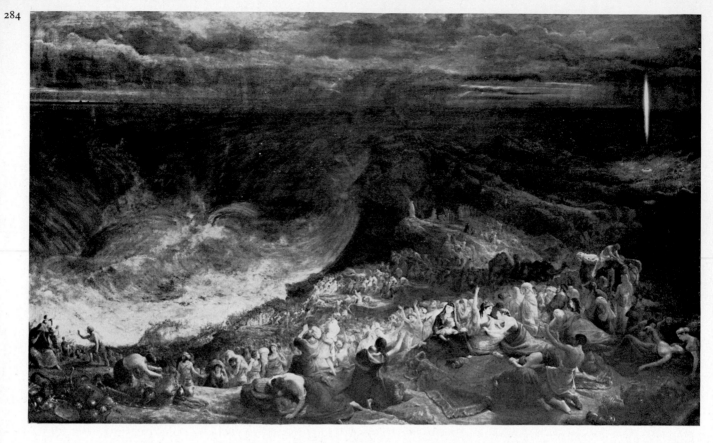

285

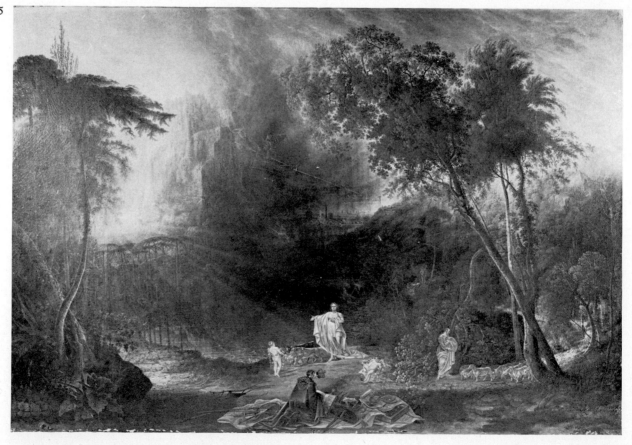

WILLIAM BLAKE (1757–1827)

287

286. Felpham *c.*1800–3

Pencil and watercolour, 9⅜ × 13½ in., repr. on p.117
The Tate Gallery (3694xii)

One of Blake's very few drawings of an actual landscape, made at Felpham, Sussex, during the three years he spent there under William Hayley's patronage. Landscape of a different sort is, however, an integral part of much of Blake's work and the symbolic pastoral settings found in *Songs of Innocence* (1789), the illustrations to Thornton's Virgil and *The Book of Job* were a revelation to Palmer and his circle.

287

287. Seventeen Illustrations to 'The Pastorals of Virgil' 1821

Wood-engravings, one 2⅜ × 3¼ in., the others approximately 1½ × 3 in. each.
The Tate Gallery (3866)

In 1819 Blake was commissioned by Dr Robert Thornton to help illustrate the third edition of his school version of Virgil's 'Pastorals'. The work appeared in 1821, 23 of its 232 illustrations being designed and engraved by Blake and another four engraved by others after him. Thornton was horrified when he saw Blake's contribution and was only persuaded to include it after representations from Lawrence, Ward, Linnell and others. It was Linnell who found Blake this and many other commissions. Introduced to him in 1818 by George Cumberland, Linnell was by far the most valuable of Blake's later friends and patrons. In 1824 he in turn introduced Palmer to Blake, and Palmer recorded his impressions of the Virgil engravings in a notebook the following year: 'They are visions of little dells, and nooks, and corners of Paradise; models of the exquisitest pitch of intense poetry. . . . There is in all such a mystic and dreamy glimmer as penetrates and kindles the inmost soul, and gives complete and unreserved delight, unlike the gaudy daylight of this world. They are like all that wonderful artist's works the drawing aside of the fleshy curtain, and the glimpse which all the most holy, studious saints and sages have enjoyed, of that rest which remaineth to the people of God'.[1]

287

288. Thus did Job continually *c.*1824–5

Line-engraving, 7¾ × 5⅞ in.
The Tate Gallery (3372i)

Plate 1 of *The Book of Job*, a set of engravings commissioned from Blake in 1823 by Linnell and based on reductions from a series of watercolours which Blake had made for him in 1821. The plates are dated 1825 but were not published until the following year. Palmer told Blake's biographer Gilchrist: 'At my never-to-be forgotten first interview' with Blake 'the copper of the first plate—"Thus did Job continually"—was lying on the table where he had been working at it. How lovely it looked by the lamplight, strained through the tissue paper!'[2] Here, as in the Virgil engravings, are the sheep, the shepherds and the moonlit hills which Palmer absorbed into his own art. In this case, however, they are not symbols of pastoral innocence, but of Job's spiritual complacency, a meaning which, if he was aware of it at all, Palmer presumably ignored.

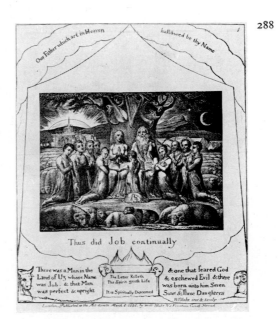

288

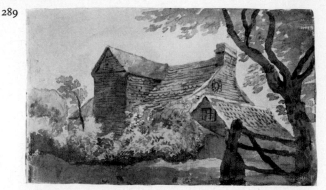

289

290

291

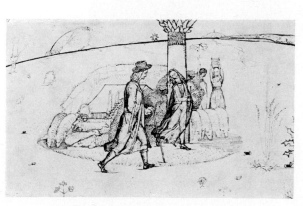

292

Samuel Palmer (1805–81)

289. Sketchbook 1819
 Inscribed inside front cover 'Samuel Palmer Jun^r
 Feb^y 1819' and 'Sketches from Nature—'
 28 leaves, 4 × 7¼ in.
 The Trustees of the British Museum (1966-2-12-11)
Palmer was fourteen when he filled this sketchbook
with Cox-like country lanes and cottages. A few years
later, after a visit to Dulwich with Linnell, he decided
that 'Cox is pretty—is sweet, but not grand, not pro-
found. . . . Nature has properties which lie still deeper'.[3]
Linnell, whom he first met in 1822, had a lot to do with
this change of heart. Palmer saw him as 'a good angel
from Heaven' sent 'to pluck me from the pit of modern
art'.[4] As with the Pre-Raphaelites a quarter of a century
later, redemption lay in the example of 'primitive' art.
Introduced by Linnell to the work of Dürer, Lucas
van Leyden and other early masters, and of course to
Blake, Palmer set to work 'with a child's simple feeling
and with the industry of humility'.[5]

290–2. Three Leaves from the 1824 Sketchbook
 Pen, 4 9/16 × 7 7/16 in. each
 Lit: Martin Butlin, *Samuel Palmer's Sketch-Book,
 1824,* 1962
 The Trustees of the British Museum (1964-11-4-1,
 fols.2, 7, 8)

290. Sketches of cornfields, moons, etc. with
 various annotations.
 Butlin pp.24–5, facsimile p.2.
A long note in the centre of the page develops an image
of a cornfield as a 'wavy sea of plenty' with small islands
of trees and cottages rising from it: 'over the distant
line that boards this golden sea might peep up elysian
hills, the little hills of David or the hills of Dulwich or
rather the visions of a better country which the Dulwich
fields [?well] shew to all true poets'. The small figure
sketch at the left may recall plate 1 of Blake's *Job*
(No.288).

291. Studies at Shoreham(?)
 Butlin p.28, facsimile p.24.
Palmer is not recorded at Shoreham before 1826, but
earlier visits are suggested by some of the sketches in
this book.

292. Old Testament subject(?)
 Butlin p.29, facsimile p.27
The sheep are reminiscent of Blake (cf. No.288), the
tree and figures of Dürer (cf. No.17).

293. A Hilly Scene *c.*1826–8
 Inscribed 'No.3 A Hilly Scene' on verso
 Watercolour, pen and tempera, varnished, on
 panel, 8⅛ × 5⅜ in.
 The Tate Gallery (5805)
Palmer appears to have found some buyers for his
earliest work. A 'Landscape Composition' shown at the
British Institution in 1819, for example, sold for seven
guineas. In 1825, however, he felt obliged to warn a
patron who had ordered eleven works, at just under
£32 the lot, 'that the pictures and drawings now de-

293. Samuel Palmer
A Hilly Scene c.1826–8

livered, being somewhat different in style from those he used to paint when Mr. Bennett gave the commission, he shall not feel the least reluctance to taking back any of this set that Mr. Bennett may disapprove'.[6] Shortly afterwards he reproved himself for 'seeking for Mr. Bennett's pictures, visions more consonant with common nature than those I received at my first regeneration, from the Lord. I will no more, by God's grace, seek to moderate for the sake of pleasing men'.[7] Two of Bennett's pictures may have been works which Palmer had exhibited at the Royal Academy in 1825, when the critic of the *European Magazine*, finding them 'so amazing that we feel the most intense curiosity to see what manner of man it was who produced such performances', suggested that Palmer should exhibit himself as well.[8] These works are untraced, or at least unidentified, but their style is probably reflected in the six sepia and gum drawings of 1825 in the Ashmolean Museum and in this 'Hilly Scene'. Geoffrey Grigson has suggested a source for Palmer's unbotanical combination of flowering horse-chestnut and ripened wheat in Spenser's *Faërie Queen*, Book iii, Canto VI, beginning 'There is continuall spring, and harvest there'.[9]

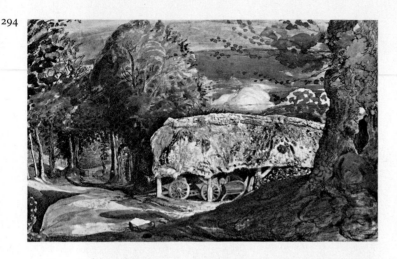

294. **Cart-Shed and Lane** 1828
Inscribed 'Saml Palmer fect'
Pen, watercolour and gouache, 10$\frac{15}{16}$ × 17$\frac{11}{16}$ in.
The Victoria and Albert Museum

Palmer visited Shoreham in Kent several times before actually moving there in 1827. He remained there on and off until 1834. A legacy of about £3,000 from his grandfather produced a small income, but it was insufficient. 'Mr. Linnell tells me', he wrote in 1828, 'that by making studies of the Shoreham scenery I could get a thousand a year directly. Tho' I am making studies for Mr. Linnell, I will, God help me, never be a naturalist by profession'.[10] No.294 is one of the drawings he made for Linnell and it reveals none of his professed reluctance for such work. But Palmer never got his thousand a year. Some of the more naturalistic drawings were sent to the Royal Academy in 1829 together with two less conventional works. 'The ways of the Royal Academy are to me unaccountable—', Palmer wrote to Linnell, 'not that it is unaccountable they should reject six of my drawings; but that they should hang those two which I thought far least likely. . . . As they condescended to receive any, I wonder they did not prefer the nature sketches'.[11]

WELBY SHERMAN after SAMUEL PALMER
295. **Evening** 1834
Mezzotint, 5$\frac{7}{8}$ × 7 in.
The Tate Gallery (3869)

An impression before letters. The lettered state, published by Palmer at 2s.6d. in 1834, has a quotation from Milton: 'EVENING LATE, BY THEN THE CHEWING FLOCKS HAD TA'EN THEIR SUPPERS OF THE SAVOURY HERB OF KNOT-GRASS DEW-BESPRENT'. Palmer asked George Richmond in October 1834 to 'let the little mezzotint flock hang up somewhere where it can be seen as it might be of some service to Sherman or myself who are both at present pinched by a most unpoetical & unpastoral kind of poverty'.[12] As only one or two impressions are known today, the print seems likely to have had no success at all.

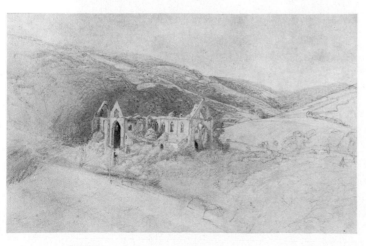

296. Tintern Abbey 1835
 Pencil and bodycolour, $11\frac{3}{4}$ × 18 in.
 Private Collection

Palmer first visited Wales in 1835. In a letter to George Richmond he described Tintern as 'such an Abbey! the lightest Gothic trellised with ivy & rising from a wilderness of orchards—& set like a gem amongst the folding of woody hills'.[13] He continued the letter next day in a different mood: 'Poetic vapours have subsided, and the sad realities of life blot the field of vision. . . I have not cash enough to carry me to London—O miserable poverty! how it wipes off the bloom from everything around me'. He moved to London in 1836 with a view to better organising himself to earn a living, married Linnell's daughter the following year and went on an extended working-honeymoon to Italy. But his financial troubles continued. Between 1843 and 1853 sales of paintings and drawings brought in an average of less than £72 a year and he was forced to work hard at teaching. Membership of the Etching Club from 1850 onwards to some extent compensated for his lack of official recognition and his etchings are among the best of his later works.

297. Christmas 1850
 Etching, $3\frac{15}{16}$ × $3\frac{3}{16}$ in.
 Lit: R. G. Alexander, *A Catalogue of the Etchings of Samuel Palmer*, 1937, No.4iii
 Private Collection
Illustrating a sonnet by J. C. Bampfylde.

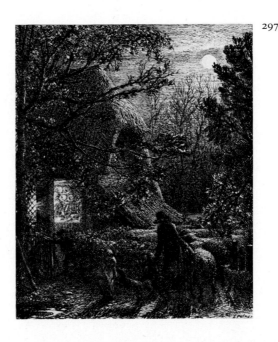

297

EDWARD CALVERT (1799–1883)

298. The Bride 1828
 Copper-plate, $4\frac{7}{16}$ × $6\frac{9}{16}$ in.
 The Trustees of the British Museum

299. The Sheep of His Pasture 1828
 Copper-plate, $1\frac{5}{8}$ × $3\frac{3}{16}$ in.
 The Trustees of the British Museum

300. Impressions from Nos. 298–9
 The Tate Gallery

As published in Samuel Calvert's *Memoir* of his father (1893).
'The Sheep of His Pasture' is based on one of Blake's Virgil wood-engravings (repr. on p.119), the original blocks of which Calvert himself printed from in 1828 after Linnell had acquired them from the publisher. Calvert was one of several young artists who, like Palmer, came under the spell of the aged Blake, drawing from the contact some sense of direction, however temporary: by the 1830s Calvert had lapsed into an effete classicism that was closer to Etty.

298

299

Optical Instruments

The rôle of mechanical aids in landscape art is an intriguing issue, but one which has hardly been investigated. Nevertheless, it does seem safe to say that, rightly or wrongly, mechanical aids were seen as setting new standards of 'objectivity', but that no landscape painter in this period looked on the images they produced as anything but a foundation to work upon.

301. **Camera Obscura**
The Science Museum

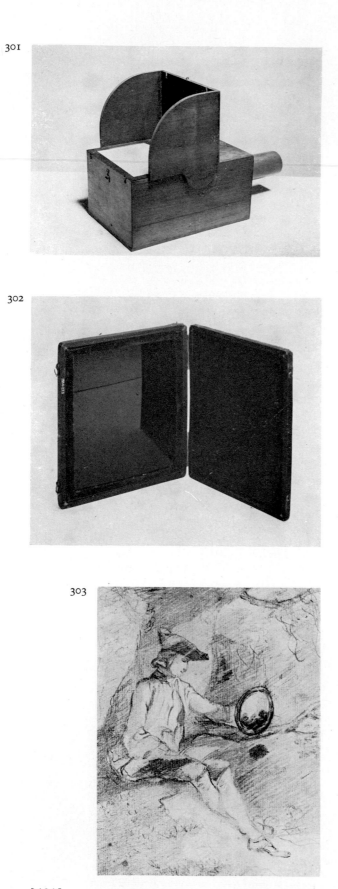

The lens at the front of the box produces an image which is reflected by an inclined mirror on to thin paper placed over a glass screen on top. Portable camera obscuras may have been available in England *c.*1700 and were widely used during the eighteenth and nineteenth centuries. A variety of types is known, some more portable than others. Canaletto (see No.21), the Sandbys, de Loutherbourg, Girtin and Crome are among artists known to have used the device. Sir Joshua Reynolds' camera (Science Museum) is, characteristically, disguised when closed as a leather-bound folio of 'Ancient History'. The example shown here belonged to W. H. Fox Talbot and probably dates from *c.*1820.

302. **Claude Glass**
The Science Museum

The Claude Glass, a slightly convex blackened mirror, was standard equipment for Picturesque tourists, producing instant low-key images of supposedly Claudian character. 'The person using it ought always to turn his back to the object that he views', Thomas West explained in his *Guide to the Lakes*, 'It should be suspended by the upper part of the case, holding it a little to the right or left (as the position of the parts to be viewed requires) and the face screened from the sun.' Thomas Gray, who had one bound like a pocket-book, used a glass constantly on his tour of the Lakes in 1769 and on one occasion, no doubt doing the required about-turn, 'fell down on my back across a dirty lane with my glass open in one hand, but broke only my knuckles: stay'd nevertheless, & saw the sun set in all its glory'.[1] Silvered mirrors were used on days too dark for the blackened kind. The landscape could also be viewed through coloured filters, used separately or in combination.

THOMAS GAINSBOROUGH (1727–1788)
303. **Study of a Man sketching, using a Claude Glass** *c.*1750–5
Pencil, 7¼ × 5 in.
Lit: John Hayes, *The Drawings of Thomas Gainsborough*, 1971, No.10
The Trustees of the British Museum (Oo.2–27)

304. **Wollaston's Camera Lucida**
The Science Museum

William Hyde Wollaston's camera lucida, patented in 1807, consists of a prism through which the user sees a virtual image of the object projected on to a surface placed beneath the prism. By careful adjustment of an eye hole over the prism both the object and the user's

hand can be seen at the same time and the image drawn or painted. The stem can be clamped to a table or supported by the weight of the base. A concave lens interposed between the object and the prism counters short-sightedness and a concave lens between prism and paper long-sightedness.

305. **Cornelius Varley's Patent Graphic Telescope**
The Science Museum

Patented in 1811, Varley's instrument also produces a virtual image which can be drawn, but has the advantage of telescopic magnification (to ×19, according to the Patent Specification): 'My said Invention consists in combining one or two reflecting surfaces with a simple kind of telescope that inverts the object, and thereby gaining an erect image without any additional length to the telescope, placing the telescope out of the way of the image, and apparently projecting the said image flat on a table, so that it may be easily traced on paper, &c., the image being seen by one eye, and the pencil or tracer by the other, or by both eyes, and of a table or stand for supporting and using the same'. The adjustable stand illustrated in the Specification is missing from the example shown here. For two of Varley's own drawings made with the telescope, see No.238. Cotman used a Graphic Telescope in Normandy in 1817 and 1818 but for drawing architecture rather than landscape.[2]

WILLIAM HENRY FOX TALBOT (1800–1877)
306. **Album of drawings made with a camera lucida** 1833
The Science Museum

Talbot's unsuccesful attempts to draw with the camera lucida and the camera obscura led him 'to reflect on the inimitable beauty of the pictures of nature's painting which the glass lense of the Camera throws upon the paper in its focus—fairy pictures, creatures of a moment, and destined as rapidly to fade away. . . . how charming it would be if it were possible to cause these natural images to imprint themselves durably, and remain fixed upon the paper'.[3] He began experimenting with light-sensitive paper in wooden box cameras made by himself—modified camera obscuras—and succeeded in making fixed paper negatives in 1834 and positives in 1839. The exposure required for these early efforts was about an hour. The calotype process which he invented in 1840 reduced the time to a matter of minutes.

307. **Calotype camera** used by W. H. F. Talbot
Lit: D. B. Thomas, *The Science Museum Photography Collection*, 1969, No.12
The Science Museum

308. **Lacock Abbey** 1844
Calotype, $7\frac{7}{8} \times 9\frac{1}{8}$ in., repr. on p.126
The Science Museum

Prints of this subject were included in Talbot's *The Pencil of Nature* (1844), the first book to be illustrated with actual photographs. Lacock Abbey, Wiltshire, was Talbot's country house.

309. **Trees** 1840s
Calotype, $8\frac{3}{4} \times 7\frac{3}{8}$ in., repr. on p.126
The Science Museum

305

307

309

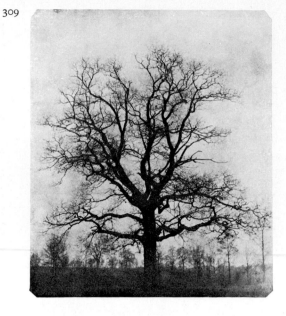

308

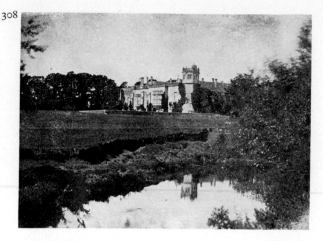

Pre-Raphaelite Landscape

Pre-Raphaelitism is usually presented as a simple 'back to nature' movement, an interpretation which some of the Pre-Raphaelites' own remarks seem to encourage. In his autobiography Holman Hunt talked of 'our original doctrine of childlike submission to Nature'[1] but he also said 'a man's work must be the reflex of a living image in his own mind, and not the icy double of the facts themselves. It will be seen that we were never realists. I think art would have ceased to have the slightest interest for any of us had the object been only to make a representation, elaborate or unelaborate, of a fact in nature.'[2] Their view of nature, drawn in the most direct fashion from Ruskin and Tennyson, was intensely emotional and much of their work avowedly didactic. Whatever its other origins, the key text of Pre-Raphaelitism is surely Ruskin's *Modern Painters*:

> 'whatever influence we may be disposed to admit in the great works of sacred art, no doubt can, I think, be reasonably entertained as to the utter inutility of all that has been hitherto accomplished by the painters of landscape. No moral end has been answered, no permanent good effected, by any of their works. They may have amused the intellect, or exercised the ingenuity, but they have never spoken to the heart. Landscape art has never taught us one deep or holy lesson; it has not recorded that which is fleeting, nor penetrated that which was hidden, nor interpreted that which was obscure; it has never made us feel the wonder, nor the power, nor the glory of the universe; it has not prompted to devotion, nor touched with awe; its power to move and exalt the heart has been fatally abused. . . .'

'It is not, therefore, detail sought for its own sake,—not the calculable bricks of the Dutch house painters, nor the numbered hairs and mapped wrinkles of Denner, which constitute great art,— they are the lowest and most contemptible art; but it is detail referred to a great end,—sought for the sake of the inestimable beauty which exists in the slightest and least of God's works. . . .'
Preface, Vol. I, 2nd edition, 1844; Library Edition, III, pp.21–2, 32

WILLIAM HOLMAN HUNT (1827–1910)

310. **The Haunted Manor** 1849
 Inscribed 'Whh.1849' (initials in monogram)
 Oil on board, 9⅛ × 13¼ in.
 Exh: Liverpool Academy of Fine Arts 1856(307)
 The Tate Gallery (T.932)

In his autobiography Hunt describes a visit to Ewell, Surrey, apparently in 1847, where he was attracted by a stream which 'rippled along, circling in dimples as it was driven under sheltering willows, its banks strewn with long-disused mill-stones, discarded roller-beams, and ruined timber cog-wheels. Soon the flood was imprisoned by sluice gates; close at hand were abandoned huts, shuttered, overgrown, and choked with rank weeds. Here the kingfisher arrowed his way, the wild pigeon chattered and cooed, and the distant cuckoo voice noted the season. Between all could now be heard the plash and cranking of a near water-wheel. Now cut off from confiding trust, not even the lonely angler ventured thus far; the region was out of the

310

ordinary world; being thus beyond the limits of common experience when, in the remoter solitude, a being, black as a creature of dark Avernus, passed by, he seemed fitly to haunt the scene. . . . All this luscious and lonely charm of dell and meadow had very early a fascination for me, and it was natural that I should attempt to register some of its mystery by my art. Accordingly, I began a painting of the pool above one of the first mills, with the sun glistening down and penetrating through every nook of the landscape. The difference between the scene as it was presented to my untutored sight, and any single landscape by the great painters that I knew, suggested the doubt, when I had begun the subject on my drawing-board, whether it was not one which a practical painter should avoid. . . . The fact was that no more than two or three days could be allotted to this work, and to achieve it in the manner in which it was begun would have needed about six weeks. I left off. . . .'.[1] The picture in question is thought to be No.310, and the '1849' inscribed on it may be the date of completion. Millais' destroyed painting 'The Kingfisher's Haunt' was made at the same spot and, apparently, at the same time. The evidence for the dating of the two pictures and the identification of the site is not altogether clear because Millais' painting bore the subtitle 'A Study in Wimbledon Park' when it appeared at auction in 1858. Allen Staley[2] inclines to accept Wimbledon as the place and 1849 as the year when the painting was begun. Hunt's memory of the date of the visit to Ewell described above may, half a century after the event, have been faulty and the '1849' inscribed on his picture could refer to its inception, but his account of the stream at Ewell—a haunted place and the home of the kingfisher —fits both his and Millais' pictures too well for the identification to be easily dismissed.

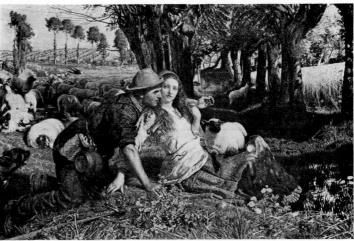

311

311. The Hireling Shepherd 1851–61
 Inscribed 'Whh 1851–61' (initials in monogram)
 Oil on panel, $12\frac{1}{2} \times 18\frac{1}{2}$ in.
 From the Makins Collection
'Sleepest or wakest thou, jolly shepherd?
Thy sheep be in the corn;
And for one blast of thy minikin mouth,
Thy sheep shall take no harm.'

 King Lear, Act III, Scene vi

312. Our English Coasts, 1852 (Strayed Sheep)
 1852
 Inscribed 'W h hunt 1852 Fairlt.'
 Oil on canvas, 17×23 in.
 Exh: R.A.1853(534)
 The Tate Gallery (5665)

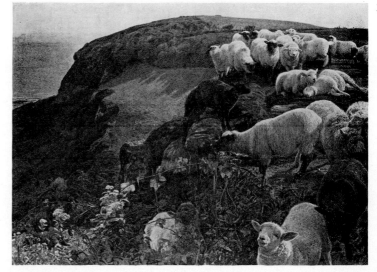

312

No.311 was begun as a sketch for the painting exhibited at the Royal Academy in 1852 (City of Manchester Art Galleries), but was later finished as a picture in its own right. The Academy work was purchased in instalments for 300 guineas by W. J. Broderip, who was introduced to Hunt by Charles Maude of Bath. Maude himself commissioned a repetition of the group of sheep in the picture for 70 guineas, but readily agreed when the artist proposed a fresh composition instead: No.312, for which Maude in fact paid £120.

 'The Hireling Shepherd' was intended as 'a rebuke to the sectarian vanities and vital negligences of the

day'. Hunt explained its meaning in some detail in 1897: 'I have met with some attempts at unravelling the symbolism of the picture. I did have an occult suggestion in mind of a very simple character. Shakespeare's song represents a shepherd who is neglecting his real duty of guarding the sheep. Instead of using his voice in truthfully performing his duty, he is using his "minikin mouth" in some idle way. He was a type of other muddle headed pastors who instead of performing services to the flock—which is in constant peril—discuss vain questions of no value to any human soul. My fool has found a death's-head moth, and this fills his little mind with forebodings of evil, and he takes it to an equally sage counsellor for her opinion. She scorns his anxiety from ignorance rather than profundity, but only the more distracts his faithfulness: while she feeds her lamb with sour apples his sheep have burst bounds, and got into the corn. It is not merely that the wheat will be spoilt; but in eating it the sheep are doomed to destruction from becoming what farmers call "blown". I did not wish to force the moral, and I never explained it till now. For this meaning was only in reserve for those who might be led to work it out. My first object as an artist was to paint—not dresden china bergers, but—a real shepherd, and a real shepherdess, and a landscape in full sunlight, with all the color of luscious summer, without the faintest fear of the precedents of any landscape painters who had rendered Nature before'.[3] The 'constant peril', while 'sectarian vanities' were indulged, was the breakdown of the established church, perhaps even of religion itself. In *Notes on the Construction of Sheepfolds* (1851), which Hunt read while working on 'The Hireling Shepherd', Ruskin emphatically asserted 'That the schism between the so-called Evangelical and High Church Parties in Britain, is enough to shake many men's faith in the truth or existence of Religion at all. It seems to me one of the most disgraceful scenes in Ecclesiastical history, that Protestantism should be paralyzed at its very heart by jealousies, based on little else than mere difference between high and low breeding. . . . and I believe that this state of things cannot continue much longer; and that if the Church of England does not forthwith unite with herself the entire Evangelical body, both of England and Scotland, and take her stand with them against the Papacy, her hour has struck. She cannot any longer serve two masters; nor make courtesies alternately to Christ and Anti-christ. That she *has* done this is visible enough by the state of Europe at this instant. Three centuries since Luther—three hundred years of Protestant knowledge—and the Papacy not yet overthrown! Christ's truth still restrained, in narrow dawn, to the white cliffs of England and white crests of the Alps....'.[4] Such fears were brought to a head in 1850 when Pius IX proclaimed the re-establishment of the Roman Catholic hierarchy in England and appointed Wiseman as Cardinal-Archbishop of Westminster. Frenzied Protestant reaction to this move led Parliament in 1851 to pass an 'Ecclesiastical Titles Bill' prohibiting the creation of Catholic dioceses in England. The threat of anarchy at home was matched by continuing fear of invasion from abroad. When he wrote to Ford Madox Brown in 1852 from Fairlight, near Hastings, where he was painting No.312, Hunt had to explain that a certain meeting he was proposing was '*not* for the consideration

of the better means of defending the English coast',[5] and F. G. Stephens later saw 'Our English Coasts, 1852' 'as a satire on the reported defenseless state of the country against foreign invasion'.[6] The inclusion of the date in the title is important: this, in all its beauty, is an English cliff top as Hunt sees it in 1852, but what of its future? The image is poignant because what it presents is so vulnerable. Ruskin's Protestant white cliffs are unguarded, and behind them the flock is straying.

FORD MADOX BROWN (1821–93)

313. **The Pretty Baa-Lambs** 1852
 Inscribed 'F.Madox Brown 52'
 Oil on panel, $7\frac{3}{4} \times 10$ in.
 The Visitors of the Ashmolean Museum, Oxford
A small copy of the picture exhibited at the Royal Academy in 1852 (City Art Gallery, Birmingham), the background of which Brown altered in 1859 by raising the horizon and adding a view of a distant estuary. No.313, which preserves the original appearance of the background, was sold to the dealer White for £5 in 1854. The larger work remained unsold until 1859, when James Leathart bought it for £126. Of the larger version Brown wrote in 1865: 'This picture was painted in 1851, and exhibited the following year, at a time when discussion was very rife on certain ideas and principles in art, very much in harmony with my own, but more sedulously promulgated by friends of mine. Hung in a false light, and viewed through the medium of extraneous ideas, the painting was, I think, much misunderstood. I was told that it was impossible to make out what *meaning* I had in the picture. At the present moment, few people I trust will seek for any meaning beyond the obvious one, that is—a lady, a baby, two lambs, a servant maid, and some grass. In all cases pictures must be judged first as pictures—a deep philosophical intention will not make a fine picture, such being rather given in excess of the bargain; and though all epic works of art have this excess, yet I should be much inclined to doubt the genuiness of that artist's ideas, who never painted from love of the mere look of things, whose mind was always on the stretch for a moral. This picture was painted out in the sunlight; the only intention being to render that effect as well as my powers in a first attempt of this kind would allow'.[1] Just what 'philosophical intention' is being strenuously denied here is difficult to say but F. M. Hueffer recalled that the work was castigated as 'Catholic Art' and 'blasphemous' at the time[2] and Brown was clearly sensitive about it being misinterpreted as a Catholic picture.

314. **Carrying Corn** 1854
 Inscribed 'F.Madox Brown Finchley 54'
 Oil on panel, $7\frac{3}{4} \times 10\frac{7}{8}$ in.
 Exh: 'Pre-Raphaelite Exhibition', Russell Place 1857(11)
 The Tate Gallery (4735)
Brown records the progress of this painting in his diary during September and October 1854. Some entries are worth quoting at length for the vivid impression

they give of the difficulties of working from nature.[3]

4 September: 'About three out to a field, to begin the outline of a small landscape. Found it of surpassing loveliness. Cornshocks in long perspective form, hayricks, and steeple seen between them— foreground of turnips—blue sky and afternoon sun. By the time I had drawn-in the outline they had carted half my wheat: by to-day all I had drawn in was gone.'

21 September: 'After dinner to the corn-field for about three hours; interrupted by a shower, and somehow did very little. Altogether these little landscapes take up too much time to be profitable.'

3 October: 'To work at the cornfield from quarter past three till quarter to six: did next to nothing. It would seem that very small trees in the distance are very difficult objects to paint, or else I am not suited to this sort of work; for I can make nothing of this small screen of trees, though I have pottered over [them] sufficient time to have painted a large landscape, the men of English schools would say. . . . White does not come; he cannot value my works much, one would think, or he would show more anxiety to purchase, buying at such prices as I offer at. What chance is there for me, out of all the bodies, Institutions, Art-unions, and Academies and commissions, of this country ? Classes, sects, or coteries, nobles, dealers, patrons, rich men, or friends—which one takes an interest in me or my works ? Is it encouraging to go on ? Is it not rather a clear affirmation of my not being required of the British public ?. . . . funds at present 10s. . . .'

11 October: 'The field again.—Sunshine when I did not want it, cold and wind when it went. Worked at the trees and improved them—found the turnips too difficult to do anything with of a serious kind. I don't know if it would be possible to paint them well; they change from day to day. An unpleasant and profitless day'.

12 October: 'Saw my turnips were all false in colour: ruminated over this disgrace, and tried to retrieve it. Put it in some shape, ready to take out in the afternoon. . . . Found the gate nailed up and brambled; had to go round by a *détour*, but in and set to work; but not much good. Tried to get the main tree more in harmony; a little to the swedes— men in the field pulling them.'

13 October: 'Afterwards to the field—for the last time, thank Heaven. I am sick of it; I have now only to work at home at it to put in a little harmony. A labourer came and looked, and, stuttering fearfully, expressed admiration, which ended in his supposing he could not beg half a pint of beer. . . .'

During a period of great hardship, Brown painted several small landscapes of this kind in the hope of a quick return, but the time expended was out of all proportion to what he received. In June 1855 he sold No. 314 to White for £12 and 'The Brent at Hendon' (Tate Gallery) for £10. 'An English Autumn Afternoon', a very much bigger picture and one he worked on over a period of more than a year, fetched only nine guineas at auction in 1854, the frame having cost four. With 'The Hayfield', No.315 below, Brown was more fortunate: Rossetti introduced William Morris to him in 1856 and Morris bought it on the spot for £40.

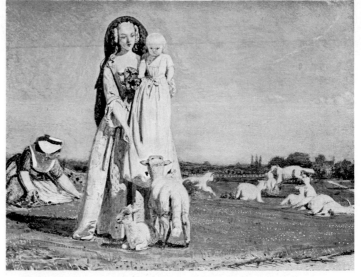

313

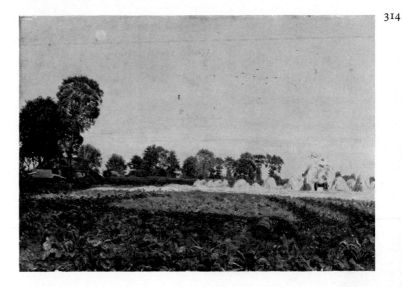

314

315. **The Hayfield** 1855–6
Inscribed 'F.MADOX BROWN, HENDON
1855'
Oil on panel, 9 × 12½ in., repr. on p.132
John Gillum, Esq.

Brown's note on this picture reads: 'The stacking of the second crop of hay had been much delayed by rain, which had heightened the green of the remaining grass, together with the brown of the hay. The consequence was an effect of unusual beauty of colour, making the hay by contrast with the green grass, positively red or pink, under the glow of twilight here represented'.[4] The artist includes a portrait of himself at the end of his day's work in the fields, parasol and camp stool folded away, paint-box closed, resting for a while to watch the harvesters at their labours: another comment, perhaps, on the theme which preoccupied him during the 1850s, Work in all its variety, but at the same time a device to express a feeling of exclusion from rural life. The idea of the outsider self-consciously 'going to nature' is also explicit in 'Walton-on-the-Naze' (1859–60, City Art Gallery, Birmingham), in which a family, no doubt down for the day by train, is shown pausing at the edge of a cornfield to admire a rainbow over the coast while the man, Brown says, 'descants learnedly on the beauty of the scene'.[5]

ROSA BRETT (exhibited 1858–81)

316. **Study of a turnip field with barns and houses beyond** After 1863
Oil on panel, 6 × 9 in.
Private Collection

Rosa, John Brett's sister, exhibited three works at the Royal Academy between 1858 and 1862 under the name 'Rosarius' and six between 1867 and 1881 under her proper name. Her work has not been exhibited since and is almost totally unknown today. The wording of a Winsor and Newton label on the back of the panel indicates a date after 1863; around this time Rosa Brett was living at Maidstone, where No.316 may have been painted.

WALTER HOWELL DEVERELL (1827–54)

317. **The Irish Beggars**
Oil on canvas, 24½ × 29 in.
The Johannesburg Art Gallery

Hunt wrote of Deverell: 'He was an eager reader, and had contracted the prevailing taste among the young of that day, which Carlyle had inaugurated and Charles Kingsley had accentuated, of dwelling on the miseries of the poor, the friendless, and the fallen, and with this special interest he had, perhaps all the more, a general sympathy for all social and human concerns.'[1] 'The Irish Beggars' is the title by which Rossetti referred to this unfinished picture in a letter to the artist's brother

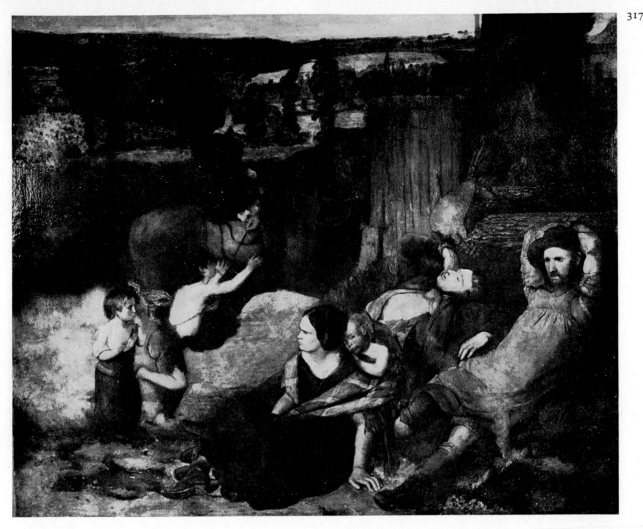

in 1877.[2] Rossetti encouraged Deverell to paint the subject in the first place: 'Rossetti seemed of opinion that. . . . as the subject was so good and important I had better paint it on a larger scale', the artist noted.[3] The picture is sometimes called 'Harvesters by the Roadside', which misses the point altogether: others are harvesting the fields in the background while the unemployed Irish sleep, stare blankly or beg from a lady who rides disdainfully by on a horse. Just as Brown's 'The Last of England' is a picture about the emigration movement, Deverell's is about the immigrant problem. It is also one of the few paintings of the whole period covered by this exhibition in which the agricultural labourer is depicted as anything but a contented or, more usually, quite anonymous character.

JOHN RUSKIN (1819–1900)

318. **Study of Gneiss Rock, Glenfinlas** 1853
Pen, wash and bodycolour, $18\frac{3}{4} \times 12\frac{7}{8}$ in.
The Visitors of the Ashmolean Museum, Oxford

Drawn while Millais was working at Glenfinlas on the background to his portrait of Ruskin and showing the same area of rock that appears at the left of Millais' painting. Ruskin's intense faith in this sort of minute examination of natural phenomena began to turn back on itself fairly early on. The lessons to be learnt from nature became increasingly difficult to bear. Already in the fourth volume of *Modern Painters*, published in 1856, the idea that 'beauty is continually mingled with the shadow of death' is proposed and frighteningly illustrated: the traveller in the Alps, 'as his foot springs from the deep turf and strikes the pebbles gaily over the edge of the mountain road, sees with a glance of delight the clusters of nutbrown cottages that nestle among those sloping orchards, and glow beneath the boughs of the pines. Here it may well seem to him, if there be sometimes hardship, there must be at least innocence and peace, and fellowship of the human soul with nature. It is not so. The wild goats that leap along those rocks have as much passion of joy in all that fair work of God as the men that toil among them. Perhaps more. Enter the street of one of those villages, and you will find it foul with that gloomy foulness that is suffered only by torpor, or by anguish of soul. Here, it is torpor—not absolute suffering—not starvation or

[131]

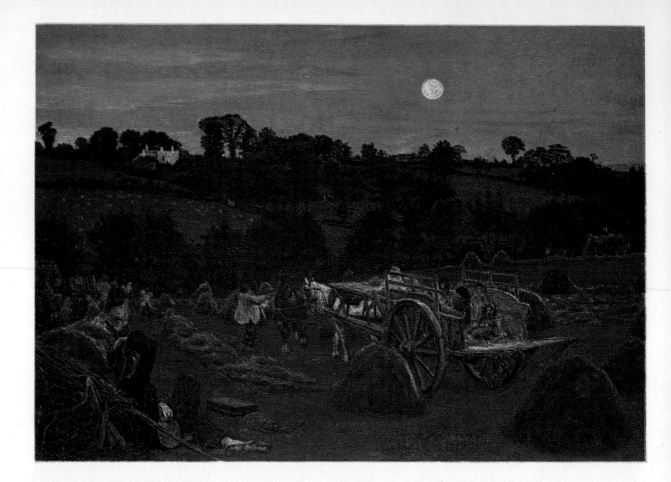

315. F. M. Brown
The Hayfield 1855–6

[132]

disease, but darkness of calm enduring; the spring known only as the time of the scythe, and the autumn as the time of the sickle, and the sun only as a warmth, the wind as a chill, and the mountains as a danger. They do not understand so much as the name of beauty, or of knowledge. . . .'[2]. 'And can we blame them, if, when the rivers are continually loading their fields with heaps of black slime, and rolling, in time of flood, over the thickets on their islets, leaving, when the flood is past, every leaf and bough dim with granite-dust,—never more to be green through all the parching of summer; when the land-slip leaves a ghastly scar among the grassy mounds of the hill side;—the rocks above are torn by their glaciers into rifts and wounds that are never healed; and the ice itself blackened league after league with loose ruin cast upon it as if out of some long and foul excavation;—can we blame, I say, the peasant, if, beholding these things daily as necessary appointments in the strong nature around him, he is careless that the same disorders should appear in his own household or his farm. . . . ?' By 1875 Ruskin felt that 'everything that has happened to me. . . . is *little* in comparison to the crushing and depressing effect on me, of what I learn day by day as I work on, of the cruelty and ghastliness of the *Nature* I used to think so divine'.[4]

319

WILLIAM DYCE (1806–64)

319. **Pegwell Bay, Kent—A Recollection of October 5th 1858** 1859–60
Oil on canvas, 25 × 35 in.
Exh: R.A.1860(141)
The Tate Gallery (1407)

Dyce's 'Recollection' has a curious morbidity about it, what Charles Aitken, in a much-quoted passage, called an 'end of all things feeling'.[1] This is nature pinned down in microscopic detail but quite dead. No gentleman is at hand to 'descant learnedly on the beauty of the scene'—no Sandby line-up to watch the comet pass, only tight-lipped trippers in a Ruskinian wasteland.

320

JOHN EVERETT MILLAIS (1829–96)

320. **Ophelia** 1851–2
Inscribed 'J Millais 1852' (initials in monogram)
Oil on canvas, 30 × 44 in.
Exh: R.A.1852 (556)
The Tate Gallery (1506)

'There is a willow grows aslant a brook,
That shows his hoar leaves in the glassy stream;
There with fantastic garlands did she come,
Of crow-flowers, nettles, daisies, and long purples,
That liberal shepherds give a grosser name,
But our cold maids do dead men's fingers call them:
There, on the pendent boughs her coronet weeds
Clambering to hang, an envious sliver broke,
When down her weedy trophies and herself
Fell in the weeping brook. Her clothes spread wide,

And, mermaid-like, awhile they bore her up;
Which time she chanted snatches of old tunes,
As one incapable of her own distress,
Or like a creature native and indu'd
Unto that element; but long it could not be
Till that her garments, heavy with their drink,
Pull'd the poor wretch from her melodious lay
To muddy death.'

Hamlet, IV, vii, 11.167–83

Ophelia's end 'had long been in his mind as a subject he should like to paint', said Millais' son, and he set to 'while the idea was strong upon him'.[1] The landscape was painted over a period of several months during the summer and autumn of 1851, first at Ewell, Surrey,

[133]

where Millais described himself sitting 'tailor-fashion under an umbrella throwing a shadow scarcely larger than a halfpenny for eleven hours, with a child's mug within reach to satisfy my thirst from the running stream beside me'[2], and later at Worcester Park Farm near Cheam. In London in the winter Elizabeth Siddall posed for the figure, lying in a bath of water. Despite their separate origin, landscape and figure perfectly fuse to represent Ophelia's deadly consummation with the element, her 'fainting ecstacy'[3] as she slowly sinks. Ruskin described the picture as 'the loveliest English landscape, haunted by sorrow'[4] and it is from the complete involvement of a human condition with a state of nature which this phrase implies that 'Ophelia', in this respect faithfully echoing Shakespeare's image, derives its power.

321

321. **Autumn Leaves** 1855–6
Inscribed 'J M 1856' (initials in monogram)
Oil on canvas, 41 × 29⅛ in.
Exh: R.A.1856(448)
The City of Manchester Art Galleries

In her account of the origin of this work, painted at Annat Lodge, near Bowerswell, Perthshire, Lady Millais said her husband 'was irresolute what to do. He first thought he would paint me under the Cedar tree and then in my brown dress in the middle of the Apple tree. He wished to paint a picture full of beauty and without subject but could not decide so he went on drawing on blocks for Tennyson'[5], that is, for the illustrated edition of Tennyson which Moxon published in 1857. Eventually Millais decided to include his two young sisters-in-law, Alice and Sophie Gray, and two local girls carefully selected by his wife for their prettiness. The work is 'without subject' only if a narrative is looked for. Millais told F. G. Stephens that he 'always felt insulted when people have regarded the picture as a simple little domestic episode, chosen for effect and colour': it was meant to arouse 'the deepest religious reflections'.[6] A remark Millais made to Hunt in 1851 has been taken, reasonably enough, as an indication of the sort of reflections he was trying to stir in 'Autumn Leaves': 'Suddenly my companion's attention was arrested', wrote Hunt; 'he turned round and directed his face to another point of the compass; inhaling the perfumes of the soft wind, he exclaimed, "Is there any sensation more delicious than that awakened by the odour of burning leaves? To me nothing brings back sweeter memories of the days that are gone; it is the incense offered by departing summer to the sky, and it brings one a happy conviction that Time puts a peaceful seal on all that has gone." '[7] This is a Tennysonian mood, of the kind expressed by one of the songs in *The Princess*, which Millais read while working on 'Ophelia' in 1851:

'Tears, idle tears, I know not what they
 mean,
Tears from the depth of some divine despair
Rise in the heart, and gather to the eyes,
In looking on the happy Autumn-fields,
And thinking of the days that are no more.

More precisely, 'Autumn Leaves' is a picture about states of womanhood and states of nature: the passing of innocence and the dying of the year, the flowering of womanhood while nature turns to winter—a wistful variation upon the theme of 'Ophelia'.[8]

Notes and References

INTRODUCTION

[1] Jonathan Richardson, *The Connoisseur*, 1719, pp.44–5.
[2] J. H. Fuseli, *Lectures on Painting*, 1820, p.185.
[3] James Barry, *The Works of James Barry*, 1809, I, pp.405–6.
[4] J. H. Fuseli, *op. cit.*, p.179.
[5] C. R. Leslie, *A Hand-Book for Young Painters*, 1855, pp.253, 255.
[6] J. L. Roget, *A History of the 'Old Water-Colour' Society*, 1891, I, pp.78–9.
[7] From the inscription on the back of Francia's 'Landscape Composition, Moonlight' in the Victoria and Albert Museum.
[8] J. L. Roget, *op. cit.*, I, pp.203, 266.
[9] *Repository of Arts*, 1810, quoted in Martin Hardie, *Watercolour Painting in Britain*, II, 1967, p.117.
[10] Walter Thornbury, *The Life of J. M. W. Turner, R.A.*, 1862.
[11] *Ibid.*, I, p.394.
[12] *Ibid.*, I, p.392.
[13] R. B. Beckett, *John Constable's Correspondence*, VI, 1968, p.108.
[14] Thornbury, *op. cit.*, II, pp.59–60, quoting Trimmer.
[15] Anon., 'Anecdotes of Artists of the Last Fifty Years', *Library of the Fine Arts*, IV, 1832, pp.27–8.
[16] Thornbury, *op. cit.*, II, p.35.
[17] *Ibid.*, p.88.

THE OLD MASTERS

CLAUDE (pp.15–16)
[1] Discourse IV, Royal Academy 1771: *Discourses on Art*, ed. Robert Wark, 1959, pp.69–70.
[2] 'Backgrounds' lecture, Royal Academy 1811: Jerrold Ziff, ' "Backgrounds, Introduction of Architecture and Landscape": A Lecture by J. M. W. Turner', *Journal of the Warburg and Courtauld Institutes*, XXVI, 1963, pp.144–5.
[3] W. T. Whitley, *Art in England 1821–1837*, 1930, p.109.
[4] C. R. Leslie, *Memoirs of the Life of John Constable, Esq. R.A.*, 1843, pp.3–4. A copy by Constable was lot 48 in his sale, Foster 15–16 May 1838.
[5] Ed. J. Greig, *The Farington Diary*, I, 1922, p.270.

GASPARD (pp.17–18)
[6] Letter to Lord Hardwicke: Mary Woodall, *The Letters of Thomas Gainsborough*, 1963, p.87.
[7] Letter to Archdeacon Fisher, 1 April 1821: R. B. Beckett, *John Constable's Correspondence*, VI, 1968, p.66.
[8] W. S. Lewis, *The Yale Edition of Horace Walpole's Correspondence*, vol.21, pp.208–9.
[9] *Ibid.*, p.231.

POUSSIN (p.18)
[10] 'Backgrounds' lecture 1811: Ziff, *op. cit.*, p.143.

RUBENS (p.19)
[11] Letter to David Garrick: Woodall, *op. cit.*, p.67.
[12] 'A Journey to Flanders and Holland', 1781, in Edmond Malone, *The Works of Sir Joshua Reynolds, Knight*, quoted from 4th ed., 1809, II, p.422.
[13] 'Backgrounds' lecture 1811: Ziff, *op. cit.*, pp.145–6.

ROSA (p.20)
[14] Letter to Richard West, 28 September 1739: Lewis, *op. cit.*, vol.13, p.181.
[15] Lecture II, Royal Academy 1801: *Lectures on Painting*, 1820, pp.75–6.
[16] Lecture II, Royal Institution 1836: Leslie, *op. cit.*, p.141.

RUISDAEL (p.21)
[17] Lecture III, Royal Institution 1836: Leslie, *op. cit.*, pp.144–5.
[18] Beckett, *op. cit.*, VI, 1968, p.74.

REMBRANDT (p.21)
[19] *An Essay on Prints*, 1768, quoted from 4th ed., 1792, pp.58–9.
[20] 'Backgrounds' lecture 1811: Ziff, *op. cit.*, p.145.

TITIAN (p.22)
[21] Lecture II, Royal Academy 1801: *Lectures on Painting*, 1820, pp.64–5.
[22] 'Backgrounds' lecture 1811: Ziff, *op. cit.*, p.135.
[23] Lecture, Hampstead Literary and Scientific Society 1833: Leslie, *op. cit.*, p.132.
[24] Lecture I, Royal Institution 1836: Leslie, *op. cit.*, 2nd ed. 1845, p.335.

DÜRER (p.23)
[25] A. H. Palmer, *The Life and Letters of Samuel Palmer*, 1892, p.15.

PROVOOST (p.23)
[26] A. T. Story, *The Life of John Linnell*, 1892, I, p.83.
[27] A. H. Palmer, *op. cit.*, p.14.
[28] *The Germ*, no.2, 1850, pp.59–60.

RETROSPECT (p.24)

[1] *Walpole Society*, XXII, 1934, p.118.

HOLLAR (p.24)
[2] Oliver Millar, catalogue of the exhibition *Van Dyke, Wenceslaus Hollar...*, The Queen's Gallery, 1968, p.30.

KIP (p.24)
³ Margaret Whinney and Oliver Millar, *English Art 1625–1714*, 1957, p.270.

CANALETTO (p.25)
⁴ *Walpole Society*, XXII, 1934, p.149.

LAMBERT (p.26)
⁵ *Walpole Society*, XXII, 1934, p.6.

PLACE (p.26)
⁶ *Walpole Society*, XX, 1932, p.54.

LAMBERT (p.27)
⁷ Elizabeth Einberg, catalogue of the exhibition *George Lambert*, Kenwood, 1970, no.5.

LANDSCAPE IN BRITAIN c.1750–1850

WILSON (pp.29–34)
¹ Joseph Farington, 'Biographical Note' of Richard Wilson, catalogue of Wilson exhibition, Ferens Art Gallery, Hull 1936, p.14.
² Ed. A. P. Oppé, 'Memoirs of Thomas Jones', *Walpole Society*, XXXII, 1951, p.10.
³ W. T. Whitley, *Artists and their Friends in England 1700–1799*, 1928, I, p.381.
⁴ Constable, p.125.
⁵ Jerrold Ziff, ' "Backgrounds, Introduction of Architecture and Landscape": A Lecture by J. M. W. Turner', *Journal of the Warburg and Courtauld Institutes*, XXVI, 1963, pp.146–7.
⁶ Anon., 'Anecdotes of Artists of the Last Fifty Years', *Library of the Fine Arts*, III, 1832, p.459, which seems to be the source used by William Sandby, whose version of the story (*Thomas and Paul Sandby*, 1892, p.83) is the one usually quoted.
⁷ J. T. Smith, *Nollekens and his Times*, 2nd ed. 1829, ed. Wilfred Whitten 1920, II, p.186.
⁸ John Pye, *Patronage of British Art*, 1845, p.158. Pye does not name his source or say whether the figure represents takings or profit, nor does he say to what period of time it applies.
⁹ J. T. Smith, ed. W. Whitten, *op. cit.*, II, p.184–5.
¹⁰ Douglas Cooper, 'Richard Wilson's Views of Kew', *Burlington Magazine*, XC, 1948, p.346
¹¹ Edward Edwards, *Anecdotes of Painters*, 1808, p.86.
¹² *The Sun*, July 1814, quoted in Thomas Wright, *Some Account of the Life of Richard Wilson, Esq., R.A.*, 1824, p.93.
¹³ Martin Davies, *National Gallery Catalogues, The British School*, 2nd ed. 1959, pp.108–9.
¹⁴ W. T. Whitley, *Artists and their Friends in England 1700–1799*, 1928, I, p.383.
¹⁵ See Constable, pp.51–2.
¹⁶ Whitley, *op. cit.*, I, p.381.

BARRET (p.34)
¹⁷⁻¹⁸ Ivan Hall, catalogue of the exhibition *William Constable as Patron 1721–1791*, Ferens Art Gallery, Hull 1970, p.44.

ZUCCARELLI (pp.34–5)
¹⁹ Erwin Panofsky, '*Et in Arcadia ego*: Poussin and the Elegaic Tradition', *Meaning in the Visual Arts*, 1955.
²⁰ Michael Levey, 'Francesco Zuccarelli in England', *Italian Studies*, XIV, 1959, pp.19–20.
²¹ In *European Magazine and London Review*, 1790: Quoted by Constable, p.48.

GAINSBOROUGH (pp.38–43)
¹ Woodall, p.115.
² Woodall, p.91.
³ Woodall, p.115.
⁴ Woodall, p.91.
⁵ Woodall, p.35.
⁶ Gladys Scott Thomson, 'Two Landscapes by Gainsborough', *Burlington Magazine*, XCII, 1950, p.201.
⁷ Prince Hoare, *Epochs of the Arts*, 1813, pp.76–7.
⁸ See W. T. Whitley, *Thomas Gainsborough*, 1915, p.40.
⁹ Sir Joshua Reynolds, ed. Robert Wark, *Discourses on Art*, 1959, p.250.
¹⁰ W. H. Pyne in *Somerset House Gazette*, 1824, quoted in Hayes, p.33.
¹¹ William Jackson, *The Four Ages*, 1798, pp.167–8.
¹² *The London Chronicle*, No.4959, August 1788, quoted in Mary Woodall, 'Gainsborough's Use of Models', *Antiques*, October 1956.
¹³⁻¹⁴ W. T. Whitley, *Art in England 1821–1837*, 1930, p.115.
¹⁵ See Hayes, p.6.
¹⁶ Woodall, p.125.
¹⁷ *Somerset House Gazette*, I, 1824, p.8.
¹⁸ Ephraim Hardcastle [W. H. Pyne], *Wine and Walnuts*, 1823, I, pp.295–6.

SANDBY (pp.45–6)
¹ James Gandon and T. J. Mulvany, *The Life of James Gandon, Esq.*, 1846, p.186.
² Peter Hughes, 'Paul Sandby and Sir Watkin Williams-Wynn', *Burlington Magazine*, CXIV, 1972, p.459.

TAVERNER (p.48)
³ *Walpole Society*, XXII, 1934, p.118.
⁴ *Water-colour Painting in Britain*, I, 1966, p.111.

COZENS (pp.49–51)
¹ Oppé, p.167.
² Oppé, p.34.
³ *Joseph Wright of Derby*, 1968, I, p.88.

TOWNE (p.57)
¹ Ed. J. Greig, *The Farington Diary*, I, 1922, p.211.
² *Ibid.*, VI, 1926, p.177.
³⁻⁴ A. P. Oppé, 'Francis Towne, Landscape Painter', *Walpole Society*, VIII, 1920, pp.98–9.

ANTIQUITIES, TRAVEL AND THE PICTURESQUE (pp.58–9)
¹ Ed. J. Greig, *The Farington Diary*, 29 March 1808, quoted in Martin Hardie, *Water-colour Painting in Britain*, I, 1966, p.174.
² Esther Moir, *The Discovery of Britain*, 1964, p.144.
³ Carl Paul Barbier, *William Gilpin*, 1963, p.71.
⁴ *Ibid.*, p.72.

GRIMM (p.62)
¹ Rashleigh Holt-White, *The Life and Letters of Gilbert White of Selborne*, 1901, I, p.326.

ROOKER (p.62)
² Ed. E. W. Brayley, *The Works of the late Edward Dayes*, 1805, p.347.

DE LOUTHERBOURG (p.68)
¹ Arthur Young, *Annals of Agriculture, and other useful Arts*, 1785, quoted in Francis Klingender, ed. Arthur Elton, *Art and the Industrial Revolution*, 1968, p.77.

HAFOD (p.70)
[1] Benjamin Heath Malkin, *The Scenery, Antiquities, and Biography, of South Wales*, 1804, illustrated by John Laporte.
[2] Geoffrey Keynes, 'Some Uncollected Authors XLIV: George Cumberland', *The Book Collector*, Spring 1970, p.39, where David Erdman's identification of Blake as the engraver of the map is also reported.
[3] G. E. Bentley, Jr, *Blake Records*, 1969, pp.177, 424.
[4] A. J. & H. F. Finberg, *The Life of J. M. W. Turner, R.A.*, 1961, p.419.

AYLESFORD (p.72)
[1] Ed. J. Grieg, *The Farington Diary*, V, 1925, p.186.

BEAUMONT (p.72)
[2-3] Ed. Earl Leslie Griggs, *Collected Letters of Samuel Taylor Coleridge*, II, 1956, pp.510–11.
[4] Luke Herrmann and Felicity Owen, *Sir George Beaumont*, [1973], No.P.14.

FARINGTON (p.74)
[5] Lawrence Gowing, *Turner: Imagination and Reality*, 1966, p.9.
[6] Ed. E. Fletcher, *Conversations of James Northcote, R.A., with James Ward*, 1901, p.165.

THE LITERATURE OF LANDSCAPE (p.75)
[1] Letter to Henry Acland, 24 May 1851, Library Edition XXXVI, p.115.

GIRTIN (pp.82–3)
[1] Walter Thornbury, *The Life of J. M. W. Turner, R.A.*, 1862, I, p.117.
[2] Ed. J. Greig, *The Farington Diary*, I, 1922, p.265.
[3] F. Wedmore, *Studies in English Art*, 1876, pp.112–3.
[4] See Girtin and Loshak, p.35 n.2.
[5] *Ibid.* p.45, n.1.
[6] For a summary of the episode see Martin Hardie, *Watercolour Painting in Britain*, II, 1967, p.9.
[7] Edward Edwards, *Anecdotes of Painting*, 1808, p.280.
[8] Quoted in Girtin and Loshak, p.118.

TURNER (pp.85–92)
[1] Ed. J. Greig, *The Farington Diary*, I, 1922, pp.242–3.
[2] W. G. Rawlinson, *Turner's Liber Studiorum*, 2nd. ed. 1906, pp.xii–xiii.
[3] J. Landseer, *Review of Publications of Art*, 1808, quoted in Finberg, 1924, p.xxxvii.
[4] Thornbury, I, p.271.
[5] J. L. Roget, *Notes and Memoranda respecting the Liber Studiorum...*, 1879, p.21.
[6] John Ruskin, *Modern Painters*, V, 1860, Library Edition, VII, pp.432, 434–5.
[7] J. L. Roget, *op. cit.*, pp.73–4.
[8] John Gage, *Colour in Turner*, 1969, p.38.
[9] John Gage, 'Turner and the Picturesque–II', *Burlington Magazine*, CVII, 1965, p.79.
[10] John Gage, *Turner: Rain, Steam and Speed*, 1972, pp.48, 88, n.39.
[11] Quoted in Finberg, p.158.
[12] Quoted in W. T. Whitley, *Art in England 1800–1820*, 1928, p.200.
[13] Thornbury, II, pp.87–8.
[14] C. R. Leslie, *A Hand-Book for Young Painters*, 1855, p.263.
[15] Thornbury, I, p.205.
[16] *Ibid.*, p.211.
[17] *Ibid.*, p.213.

TURNER (continued)
[18] *Ibid.*, p.219.
[19] Ed. J. Greig, *The Farington Diary*, VIII, 1928, p.5.
[20] *Ibid.*, I, 1922, p.273.
[21] John Gage, *Colour in Turner*, 1969, p.143.

WARD (p.93)
[22] Douglas Hall, 'The Tabley House Papers', *Walpole Society*, XXXVIII, 1962, pp.95–6.

CONSTABLE (pp.95–9)
[1] *Correspondence*, III, p.18.
[2] Walter Thornbury, *The Life of J. M. W. Turner, R.A.*, 1862, II, p.79.
[3] *Correspondence*, II, p.32.
[4] Leslie 1843, p.8.
[5] Leslie 1845, p.20.
[6] *Correspondence*, VI, p.98.
[7] Leslie 1843, p.88.
[8] *Correspondence*, III, p.98.
[9] A drawing by Constable of Malvern Hall in the Horne Collection, Florence, is inscribed on the back 'Left Town for Malvern—Saturday July 15 1809'. This is not recorded in L. R. Collobi's *Disegni Inglesi della Fondazione Horne* and I am grateful to Ian Fleming-Williams for telling me of it.
[10] *Correspondence*, IV, p.64.
[11] Martin Davies, *National Gallery Catalogues, The British School*, 1946, p.35.
[12] See Reynolds, No.190.
[13] Leslie 1843, p.18.
[14] *Ibid.*, p.102.
[15] *Correspondence*, III, p.133.
[16] Quoted in W. T. Whitley, *Art in England 1821–1837*, 1930, p.301.
[17] *The Observer*, 10 May 1835.

DUNTHORNE (p.100)
[18] Ian Fleming-Williams kindly drew my attention to this painting, and Conal Shields spotted the connection with 'The Valley Farm'.

VARLEY (p.101)
[1] Catalogue of the exhibition *Cornelius Varley*, P. & D. Colnaghi & Co. Ltd 1973, which prints extracts from 'Cornelius Varley's Narrative written by Himself'.

MULREADY (p.102)
[2] F. G. Stephens, *Memorials of William Mulready*, 1867, p.61.

LINNELL (p.103)
[3] Story thought the apprenticeship began at the end of 1805 or beginning of 1806. The catalogue of the exhibition *John Linnell and his Circle*, P. & D. Colnaghi & Co. Ltd, 1973, gives 1804 as the date of commencement. Linnell certainly became a student at the Royal Academy in November 1805: if he left Varley to go to the Academy, the Twickenham studies of 1806 were made after his apprenticeship to Varley officially ended. Hunt, however, remained with Varley until 1811 and Linnell could have joined him at Varley's summer house in 1806.
[4-5] A. T. Story, *The Life of John Linnell*, 1892, I, p.25.
[6] J. L. Roget, *A History of the Old Water-Colour Society*, 1891, I, p.390, apparently quoting J. J. Jenkins' manuscript account of Hunt.
[7] Story, *op. cit.*, I, p.86.

HOFLAND (p.106)
[8] Letter to Lord de Tabley: Douglas Hall, 'The Tabley House Papers', *Walpole Society*, XXXVIII, 1962, p.77.

COX (p.109)
[1] William Hall, ed. J. T. Bunce, *A Biography of David Cox*, 1881, pp.153–4.

DE WINT (pp.109–10)
[2] *Library of the Fine Arts*, I, 1831, p.410.
[3] J. W. and Anne Tibble, *The Letters of John Clare*, 1951, p.239.

COTMAN (p.110)
[1] Sydney Kitson, *The Life of John Sell Cotman*, 1937, p.143.

CROME (p.114)
[2] *Ibid.*, p.308.

MARTIN (pp.115–6)
[1] Thomas Balston, *John Martin*, 1947, p.39.
[2] Charles Lamb, *The Barrenness of the Imaginative Faculty in the Production of Modern Art*, 1833, quoted in Balston, *op. cit.*, p.41.
[3] Balston, *op. cit.*, p.177.

DANBY (p.117)
[4] Francis Greenacre, catalogue of the exhibition *The Bristol School of Artists*, City Art Gallery, Bristol, 1973, p.60.

COLMAN (p.117)
[5] Greenacre (*op. cit.*, p.206) detects the representation of a small version of the 'St. John Preaching' in Colman's picture 'St. James's Fair, Bristol' of 1824.
[6] Eric Adams, *Francis Danby: Varieties of Poetic Landscape*, 1973, p.148, n.14.

BLAKE (p.119)
[1] A. H. Palmer, *The Life and Letters of Samuel Palmer*, 1892, pp.15–16.
[2] Alexander Gilchrist, *Life of William Blake*, 1863, I, p.297, ed. Ruthven Todd, 1942, p.299. Blake was using a screen of tissue paper to diffuse the lamplight and prevent glare.

PALMER (pp.120–23)
[3] From a sketchbook of 1825, quoted by A. H. Palmer, *op. cit.*, p.15.
[4] From a sketchbook of ?1824, quoted by A. H. Palmer, *op. cit.*, p.14.
[5] *Ibid.*
[6–7] A. H. Palmer, *op. cit.*, p.17.
[8] W. T. Whitley, *Art in England 1821–1837*, 1930, p.91.
[9] Geoffrey Grigson, *Samuel Palmer's Valley of Vision*, 1960, p.28.
[10] Geoffrey Grigson, *Samuel Palmer*, 1947, p.74.
[11] A. H. Palmer, *op. cit.*, p.178.
[12] Grigson, *op. cit.*, 1947, p.115.
[13] *Ibid.*, p.124.

OPTICAL INSTRUMENTS (pp.124–5)
[1] Ed. Paget Toynbee and Leonard Whibley, *Correspondence of Thomas Gray*, 1935, III, p.1079.
[2] See Michael Pidgley, 'Cornelius Varley, Cotman, and the Graphic Telescope', *Burlington Magazine*, CXIV, 1972, p.785.
[3] W. H. F. Talbot, *The Pencil of Nature*, 1844.

PRE-RAPHAELITE LANDSCAPE (p.126)
[1] William Holman Hunt, *Pre-Raphaelitism and the Pre-Raphaelite Brotherhood*, 1905, I, p.132.
[2] *Ibid.*, p.150.

HUNT (pp.127–8)
[1] *Pre-Raphaelitism and the Pre-Raphaelite Brotherhood*, 1905, I, pp.71–2.
[2] Allen Staley, *The Pre-Raphaelite Landscape*, 1973, pp.45–6, 59–60.
[3] Letter in the City Art Gallery, Manchester. Published in part in catalogue of the Hunt exhibition, Manchester 1906, No.3.
[4] Library Edition, XII, pp.556–7. I am grateful to Conal Shields for drawing my attention to Ruskin's pamphlet and for suggesting the line of thought developed in the note on Nos.311–12.
[5] Ford Madox Hueffer, *Ford Madox Brown*, 1896, p.87.
[6] *William Holman Hunt and His Works*, 1860, p.23, quoted in Allen Staley, *The Pre-Raphaelite Landscape*, 1973, p.62.

BROWN (pp.128–30)
[1] Catalogue of the exhibition *WORK, and other Paintings*, 191 Piccadilly, 1865, No.11.
[2] Ford Madox Hueffer, *Ford Madox Brown*, 1896, p.84.
[3] Ed. W. M. Rossetti, *Præraphaelite Diaries and Letters*, 1900, pp.125, 134, 142–3.
[4] Catalogue of the exhibition *WORK, and other Paintings*, 191 Piccadilly, 1865, No.19.
[5] *Ibid.*, No.27.

DEVERELL (pp.130–31)
[1] *Pre-Raphaelitism and the Pre-Raphaelite Brotherhood*, 1905, I, p.197.
[2] Published in C. H. Collins Baker, *A Catalogue of the Neumann Gift to the Municipal Gallery of Modern Art, Johannesburg*, 1912, p.20.
[3] Quoted, apparently from Deverell's diary, in R. Ironside and J. Gere, *Pre-Raphaelite Painters*, 1948, p.28.

RUSKIN (pp.131–33)
[1] *Modern Painters*, IV, Pt.V, Ch.XIX, §13, Library Edition, VI, p.396.
[2] *Ibid.*, §4, Library Edition, VI, p.388.
[3] *Ibid.*, §27, Library Edition, VI, p.410.
[4] Letter to Susan Beever, 21 January 1875, Library Edition, XXXVII, p.154.

DYCE (p.133)
[1] *The Burlington Magazine*, XCI, 1917, p.9.

MILLAIS (pp.133–4)
[1] J. G. Millais, *The Life and Letters of Sir John Everett Millais*, 1899, I, p.115.
[2] *Ibid.*, p.119.
[3] W. M. Rossetti, *Fine Art, Chiefly Contemporary*, 1867, p.211.
[4] *Lectures on Architecture and Painting*, 1854; Library Edition, XII, p.161.
[5] Lady Millais' diary, quoted in catalogue of the Millais exhibition, Royal Academy 1967, p.41.
[6] Unpublished letter, probably of 1856, quoted by Anne d'Harnoncourt in *The Awakening Conscience*, unpublished M.A. thesis, Courtauld Institute of Art 1967, p.23. I am grateful to the author for allowing me to use this reference.
[7] William Holman Hunt, *Pre-Raphaelitism and the Pre-Raphaelite Brotherhood*, 1905, I, p.286.
[8] I owe this suggestion to Conal Shields.

Index

Artists, Engravers, Authors and Places Represented